ART &THE 60s

THIS WAS TOMORROW

ART &THE 60s

THIS WAS TOMORROW

Edited by Chris Stephens
and Katharine Stout

With essays by Barry Curtis,
David Alan Mellor, Simon Sadler
and Andrew Wilson

Contributions by Lizzie Carey-Thomas,
Hymie Dunn, Adrian Glew, Rachel Tant,
Toby Treves and Ben Tufnell

First published 2004 by order
of the Tate Trustees on the occasion
of the exhibition at

Tate Britain, London
30 June – 3 October 2004

Gas Hall, Birmingham Museums and Art Gallery
25 October 2004 – 3 April 2005

by Tate Publishing, a division
of Tate Enterprises Ltd,
Millbank, London SW1P 4RG
www.tate.org.uk

British Library Cataloguing in Publication Data
A catalogue record for this book is available
from the British Library

ISBN 1-85437-522-9 (pbk)

Distributed in North and South America
by Harry N. Abrams, Inc., New York

Library of Congress Cataloging in Publication Data
Library of Congress Control Number: 2004102503

Design & Typography by A2-GRAPHICS/SW/HK
Printed in Belgium

Front cover: Joe Tilson, *Transparency, the Five Senses:
Taste* 1969 (detail, fig.39)

Measurements of artworks are given in
centimetres, height before width

CONTENTS

FOREWORD

Parallels have frequently been drawn between the art and events of recent years and those of the 1960s. In the 1990s the phenomena of Young British Artists and of Cool Britannia seemed to echo that earlier moment of rich creativity and generational change. For artists, photographers and designers, among many others, the sixties have been a seminal point of reference and continue to be. It was against this background that Tate Britain felt it was time to take another look at the art of a period which, for better or worse, changed the physical appearance and the culture of Britain for ever. The exhibition *Art and the 60s: This Was Tomorrow* brings together different types of works by a wide range of artists. Apart from a small number of key pioneers, most of the artists belong to a single generation and all have been selected because they explored new subjects or new languages in their art. For the purpose of the exhibition and this book, 'the sixties' actually refers to a period that begins in 1956 – the year of Suez, Elvis, Abstract Expressionism and *This is Tomorrow* – and ends in 1968 – a year that saw a summer of political protest and an emergent conceptual art.

The sixties was one of those moments when different parts of the culture seemed to converge. For this reason we decided we could not look at the art of the sixties without seeing it alongside examples of the photography that did so much to define the period at the time and subsequent memories of it. Similarly, in the sixties new architecture – both realised and imagined – was frequently discussed in reference to contemporary art, so that too has been introduced. This is probably the first time at Tate Britain that such a multi-disciplinary approach has been taken. The development of the exhibition has been greatly helped by the cooperation and advice of numerous photographers, architects and specialists in those fields, to all of whom we are very grateful.

As well as a vibrant art world, the visual culture of the sixties was also reinforced by the development of television and the growth of colour magazines. It is therefore appropriate that this exhibition has been devised in association with two of the key players of that time, the BBC and the *Sunday Times*. *Art and the 60s: This Was Tomorrow* coincides with a major series of three films launched on BBC 4. When the *Sunday Times* launched the first colour supplement in 1962 it opened a new period of high-quality colour photojournalism. We are, therefore, delighted that the *Sunday Times* is our media partner for *Art and the 60s: This Was Tomorrow*. We are extremely pleased that the exhibition will be travelling to the Gas Hall, Birmingham Museums and Art Gallery, for an extended run and that it will subsequently travel to the National Gallery of Victoria, Melbourne, and Auckland City Art Gallery.

The exhibition has been curated by Tate Britain curators Chris Stephens and Katharine Stout with additional input from Tate colleagues Adrian Glew, Dominic Persad and Toby Treves. I would like to pay tribute to their inspired work, and, especially, to Chris's and Katharine's exemplary leadership of the project, both practically and intellectually. For research assistance they would ask me to thank Sophie McKinlay, who developed the architecture section before joining the Design Museum; Hymie Dunn; Valerian Freyberg; Sofia Karamani; and Linzi Stauvers. The richness of Tate's collection has, ironically, placed an unusually heavy burden on our conservators and registrars in preparing the works for exhibition and an extensive tour. We owe a huge debt, therefore, to Laura Davies, Jackie Heuman, Jacqueline Ridge, Calvin Winner, Brian McKenzie, Matthew Flintham, Rachel Crome, Bronwyn Gardner, Renée Pfister, Lisa Hayes, Catherine Clement, Sarah Wood-Collins, Susan Faulkner, Kate Parsons, Kevin Miles and colleagues at Tate

store. I would like to thank everyone in Tate's Photography department and in particular Dave Clarke who has responded to an unusually large number of requests. We are grateful to Sarah Hyde and Christina Bagatavicius for the exhibition interpretation materials, to Andy Shiel and Terry Warren and his team of technicians for planning and realising the installation, and to Will Gompertz, Nadine Thompson, Ben Luke, Jane Scherbaum and Claire Eva. From within Tate, the conception and delivery of the exhibition has been hugely helped by the advice of Sue Breakell, Beth Houghton, Paul Moorhouse, Roy Perry, Derek Pullen, Nicholas Serota and Piers Townshend. From outside, the curators would like to thank for their advice and guidance Mark Haworth-Booth, Kate Best and Janet Skidmore at the V&A, Eleanor Gawne, Charles Hinde, Sally Kennedy and Justine Sambrook at RIBA, Terence Pepper at the National Portrait Gallery, Guy Brett, Philippe Garner, Sheila Jones, Catherine Kinley, Richard Morphet and John A. Walker.

The exhibition was designed by Stanton Williams and we are grateful to Paul Williams and Claudia Faust in particular. At the BBC we should thank Mark Harrison and Vanessa Engle for their creativity and enthusiasm in this collaboration. At *The Times* and *Sunday Times* we are grateful to Stephanie Clark, Linda Illey and Jane Moore for their help with research and material for the exhibition and catalogue.

From the outset we determined that *Art and the 60s: This Was Tomorrow* should be accompanied by a publication that would have a life beyond the exhibition and which would address different aspects of the visual culture of the period. I am delighted we have been able to secure contributions from some of the foremost authorities in this area: Barry Curtis, David Alan Mellor, Simon Sadler and Andrew Wilson. I am also extremely pleased that smaller contributions have been made by a number of Tate colleagues. I would like to thank all of the authors. This book would never have come about without the cool-headed care of Mary Richards for Tate Publishing and the tenacious picture research of Rebecca Fortey. I should also thank Sarah Derry and Sarah Tucker, and Scott Williams and Henrik Kubel of A2-GRAPHICS/SW/HK for the design of the book and the marketing and exhibition graphics.

Finally, I am extremely grateful to the many lenders to the exhibition for making their works available, in particular to the National Portrait Gallery, the Royal Institute of British Architects and the Victoria and Albert Museum. As we have ventured into unusual territory for Tate many of the lenders are also the originators of the works and we are grateful to them not only for making these objects available for an extended tour but also for providing invaluable advice and guidance for which we are equally thankful.

Stephen Deuchar
Director, Tate Britain

Fig.1
Frank Bowling
Who's Afraid of Barney
Newman? 1968
Artist's collection

THIS WAS TOMORROW

Chris Stephens and Katharine Stout

Forty years on, the sixties and its culture continues to enthral successive generations. The persistent influence of the period in music, fashion, photography, design and fine art demonstrates the resilience of its power to fascinate. It was a period of radical and far-reaching change in Britain, perhaps *the* historical turning point of the second half of the twentieth century. In the sixties the effects of post-war reconstruction and the welfare state were established; Britain's urban landscape, the behaviour of its people and their view of the world changed fundamentally. Compared to preceding decades it seemed to be a time of optimism, of wealth, health and leisure, of liberation and of youth. This was a phenomenon shared with the rest of the western world but Britain, and in particular London, were seen to be the epicentre of the cultural revolution. The term 'Swinging London', coined by *Time* journalist Piri Halasz, typified this view of Britain.[1] *Time*'s famous article proved, however, to be retrospective: towards the end of the decade a perceived establishment backlash took hold and many of the economic and social advances had proved to be short-lived or illusory.

Art was an integral, even central, part of social change in the sixties, participating in, reflecting and influencing the wider culture. A new generation of artists developed ways of dealing with modernity in their work that were radically innovative. Their engagement with the world of the sixties secured an unprecedented position for art and for many of the artists themselves in the eyes of the public. Similarly, the art market and the art world boomed and an air of glamour and cool adhered to it. Largely, this cool, high-profile

art came under the label 'Pop' and many artists were a part of the new 'popocracy'. *This Was Tomorrow* demonstrates, however, that there were other radically new forms of art developing in the period and that divisions between different artistic groups, forms or practices are deceptive. New forms of abstract painting and sculpture could be categorised as 'Pop' as readily as 'new figuration'. Meanwhile, a more subversive, performative art, attached to the 'underground' or counter-cultural movement, was developing. *This Was Tomorrow* seeks to show the way in which art was embedded in the many and various historical and cultural changes of the period, how it engaged with and participated in such phenomena as the sexual revolution and the cult of celebrity and, in particular, how it paralleled and related to contemporary photography and architecture.

Of course, such a phenomenon as 'the sixties revolution' does not fall readily into a tidy ten-year period. As Barry Curtis discusses below, the sixties has been seen to begin as early as the mid-fifties, to end as late as the early seventies, and to be sub-divided in different ways. *This Was Tomorrow* takes 1956 and 1968 as its beginning and end: both dates mark important historical and cultural milestones, and frame a period that began optimistically and ended with reaction and disillusion. In the history of art at least, the dates capture a generation of practitioners as neatly as one might hope.

1956

The idea of the year 1956 representing a milestone in Britain's cultural, and wider, history is well established. The failed attempt to oust Nasser from the Suez Canal zone quickly

came to represent Britain's reduced status in the world and its failure to recognise the new order. As Dean Acheson would later observe, Britain had lost an empire but not found a role.[2] At the same time, the Soviet suppression of the Hungarian uprising was the final disillusionment for many of the remaining left-wing ideologues. In the cultural field, John Osborne's *Look Back in Anger* articulated this perceived loss of ideological clarity and offered a theatrical equivalent to the 'Kitchen Sink' realist painting that had risen to prominence two years earlier.[3] In music and youth culture, 1956 was dominated by Rock 'n' Roll with the appearance of Elvis Presley, who had six chart hits that year, and Bill Haley's film *Rock Around the Clock*. This increasing infiltration of American popular culture was lamented by both the Right, as epitomised by Evelyn Waugh, and on the Left, notably in Richard Hoggart's *The Uses of Literacy*.[4]

In the visual arts, two important London exhibitions signalled change, one retrospective, the other forward-looking, and both, again, demonstrating the growing importance of America. In January 1956 the Tate Gallery hosted *Modern Art in the United States*, a survey that culminated in the first sizeable showing of work by the Abstract Expressionists. Seven months later, *This is Tomorrow* opened at the Whitechapel Art Gallery. There, twelve teams of artists and architects collaborated to produce their visions of imagined future habitations. *This is Tomorrow* was dominated by two broad groups: Constructionists, such as Victor Pasmore, Kenneth Martin and Adrian Heath, and members of the Independent Group, a loose affiliation within the Institute of Contemporary Arts (ICA) that included Richard Hamilton, Eduardo Paolozzi and Nigel Henderson.

THIS IS TOMORROW

The Constructionists continued an aesthetic established in Britain in the thirties that drew upon a Bauhaus-derived belief in the importance of the integration of art and architecture. The pre-war modernist art from which theirs developed was predicated on a utopian belief in the future and a search for spiritual or non-material levels of reality. In contrast, the Independent Group had begun to develop an alternative modernism that engaged with the visual realities and semiotics of contemporary culture, including the popular visual culture of America with its more sophisticated advertising, glamour and apparent wealth of convenience and leisure commodities. In Paris after the war, Paolozzi had collected material from American magazines and assembled them in scrapbooks, some pages from which would later be framed as his *Bunk* collages (figs.43 & 49). In early 1952, in an

event at the ICA seen as the first meeting of the Independent Group, he extended the collages by projecting from an epidiascope a rapid succession of these images of modern domesticity, glamour girls and heroes and superheroes from war magazines and science fiction. In 1956 John McHale returned from America with a trunk load of such material, which featured prominently in the second of the twelve installations of *This is Tomorrow*, a fun house conceived by Hamilton, McHale and John Voelcker and dedicated to visual stimulation and pleasure (fig.2). Through a series of confined spaces the visitor was offered such sensory stimulation as colour war films and television advertisements for orange juice and Pepsi Cola, a collage of food adverts from magazines and a group of Marcel Duchamp's *Rotary Discs*. In a narrow corridor between the pavilion and the gallery wall a disorientating pattern of black and white anticipated Bridget Riley's work of a few years later. On the other side, a curving 'Cinemascope' collage of film posters contained a celebration of sensory pleasure: a juke box, large cardboard cut-outs of Marilyn Monroe and Robbie the Robot from the recent film *Return to the Forbidden Planet*, a giant bottle of Guinness and van Gogh's *Sunflowers* (the National Gallery's best-selling poster).

Each of the twelve groups produced a poster for *This is Tomorrow*. Hamilton made a collage, *Just what is it that makes today's homes so different, so appealing?* (fig.3), that summarised this engagement with a new modernity. The body-builder Charles Atlas and a near-naked woman posing suggestively occupy an interior full of modern furniture and conveniences — the latest vacuum cleaner, tinned ham, a tape recorder and television — and dominated by a view of the moon, a cinema facade and the Ford logo. Hamilton presented a world where the furniture of everyday life and even individual identities were visualised through television and advertising, a world of mass production and mass mediation. His famous summary of popular art highlighted the qualities that he discerned and analysed:

Pop Art is:

Popular (designed for a mass audience)
Transient (short-term solution)
Expendable (easily forgotten)
Low cost
Mass produced
Young (aimed at youth)
Witty
Sexy
Gimmicky
Glamorous
Big business[5]

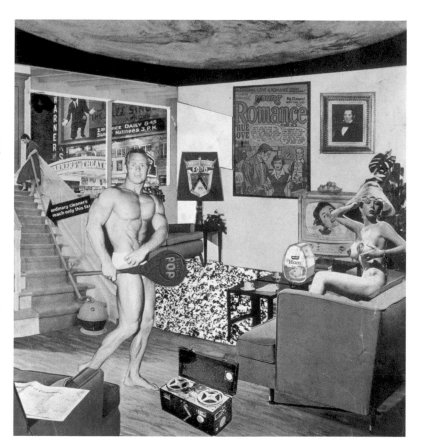

Fig.3
Richard Hamilton
Just what is it that makes today's homes so different, so appealing? 1956
Kunsthalle Tübingen, Germany

This list informed his *Hommage à Chrysler Corp.* (fig.5). Drawing on the idea of a 'rhetoric of persuasion' identified by Independent Group member Reyner Banham in car design and advertising, Hamilton conflates the forms of the eponymous motor car with the female body, a relationship common in car promotion. This approach to modern consumer culture is neither simply affirmative nor critical. As in the later *$he* (fig.45), Hamilton interrogates the association of the eroticised body with the machine and the definition of an archetypal woman through her appliances.

The new mass culture that the Independent Group members analysed and recycled was explicitly dominated by American imagery and production. In 1961 Peter Blake presented himself as a disciple of American popular culture, clad in denim and baseball boots and clutching an Elvis fanzine (fig.52). The definition of self through the identity of one's heroes was a common trope of sixties culture that reached a climax in the cover conceived by Blake and Jann Haworth for The Beatles' 1967 *Sgt Pepper* album (fig.47). Blake's celebration of popular culture was far from confined to that imported from America, however, as he addressed a wide range of British culture, from wrestling to film and the artefacts of childhood. *On the Balcony* (fig.4) shows a group of adult-like children surrounded by a cacophony of ephemera: different views of balconies, from Manet's to the royal family on VE Day, sit alongside high- and low-brow magazines, cigarette packets and sweet wrappers.

In 1939 Clement Greenberg had defined avant-garde art in contrast to mass-produced kitsch; the Independent Group members and figures such as Blake repudiated that distinction by developing a form of modern art that engaged with what they saw as an equally valid expression of modern culture.[6] As the critic Lawrence Alloway explained,

> We begin to see the work of art in a changed context, freed from the iron curtain of traditional aesthetics that separated absolutely art from non-art. In the general field of visual communications the unique function of each form of communication and the new range of similarities between them is just beginning to be charted. It is part of an effort to see art in terms of human use rather than in terms of philosophical problems.[7]

Ironically, *On the Balcony* includes tributes to Blake's friends and influences, some of whom were responding to the arrival in Britain of the American artists that Greenberg had championed. Alongside a 'kitchen sink' still life of breakfast foods and a commemoration of Blake's tutor at the Royal College, John Minton, who committed suicide in January

Fig.5
Richard Hamilton
Hommage à Chrysler
Corp. 1957
Tate

Opposite
Fig.4
Peter Blake
On the Balcony 1955—7
Tate

Fig.6
Gillian Ayres
<u>Distillation</u> 1957
Tate

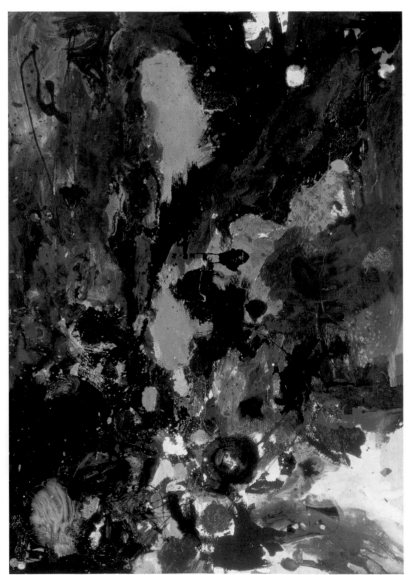

1957, are images of paintings by Robyn Denny and others.

AFTER ACTION

The moment of Abstract Expressionism seems to have passed almost as soon as it arrived in London. The work of Jackson Pollock, Willem de Kooning, Mark Rothko and their colleagues had been much anticipated and was known through the accounts of British artists who visited the 1948 and 1950 Venice Biennales or the United States, as well as through American magazines and Greenberg's advocacy. For an older generation of British artists the Americans validated an existing practice that they had developed out of an earlier modernism, in parallel with such continental European art as that of the Cobra Group and the French *Tachistes*. In 1953, Pollock's *One: Number 31* (1950) had been seen at the ICA alongside work by European-based artists such as Sam Francis, Georges Mathieu, Henri Michaux and Jean-Paul Riopelle.[8] The Abstract Expressionists were assimilated into a broader stylistic phenomenon, as was reflected in the introduction to the 1957 exhibition *Metavisual Abstract Tachiste*, where Action Painting was described as 'the hybrid child of the Frenchman Dubuffet, the German Ernst, the American Jackson Pollock'.[9] For others, this art was clearly American, particularly in the brash confidence of its expansive scale and disregard for surface finish. It was on young painters, mostly still at art school, that these qualities had most impact.

Though Greenberg's formalist account of Abstract Expressionism would come to dominate, it was Harold Rosenberg's focus on the process of painting as an event that seems most relevant to many British artists who emerged in the later fifties.[10] In particular, the physicality of Pollock's painting method, mediated through the film and photographs of Hans Namuth, offered a model for a new transgressive practice in which the process was at least as important as the end product. In this, too, Pollock could be viewed alongside Mathieu, whose method of apparently unconscious, gestural painting reminiscent of the sport of fencing was also known in Britain. Though she was willing to find associative references in the final image, Gillian Ayres's painting (fig.6) owed much to Pollock's apparently unfettered practice and its suggestion of unconscious expression. More notoriously, William Green extended the idea of accident in painting by first cycling over his supports and, later, painting with bitumen and setting it alight in an act that extended the violence that critics had discerned in Pollock's work (see pp.42–5). There were obvious parallels between Green's work and such continental artists as Yves Klein and

Piero Manzoni. The latter, like Green, exhibited in London's New Vision Centre, the first of numerous artist-run galleries that enriched the London art scene during our period. A more literal comparison, in visual terms at least, would be between the gestural practice of Mathieu and Gustav Metzger's application of acid on nylon sheet.[11] For Metzger the process really was the work, as the acid dissolved the fabric to leave behind only fragments of the object. This was a subversion of the market's definition of the artwork as commodity and, as his *Auto-Destructive Art* manifesto made clear, a comment upon the destructive power immanent in the nuclear age.[12]

There were other European and American parallels with British art of this time, notably in the use of techniques such as *décollage* and assemblage. Junk yards and the bomb sites that still punctuated British cities became a source for artists' materials: some artists, such as Bruce Lacey, assembled found objects into junk assemblages, while in 1960 Anthony Caro used sheet steel from junk yards for his first non-figurative sculptures (fig.7). Gwyther Irwin shredded and reassembled advertising posters to create chaotic compositions, such as *Letter Rain*, which seem to speak of a superfluity of words and messages (fig.8). Robyn Denny, for whom Pollock's work confirmed a 'compulsion to break free from ossified conventions', also integrated fragments of words, along with collage elements, into his paintings.[13] His interest in the function of language and signs was demonstrated by his 1957 thesis *Language, Symbol, Image: An Essay on Communication*, the cover of which was a photograph of signs and hoardings on an American parking lot. In *Golem I*, stencilled letters and scraps of corrugated cardboard are embedded in and smothered by layers of paint (fig.9). Text, in the form of books — assembled, charred and later burnt entirely — also featured in the

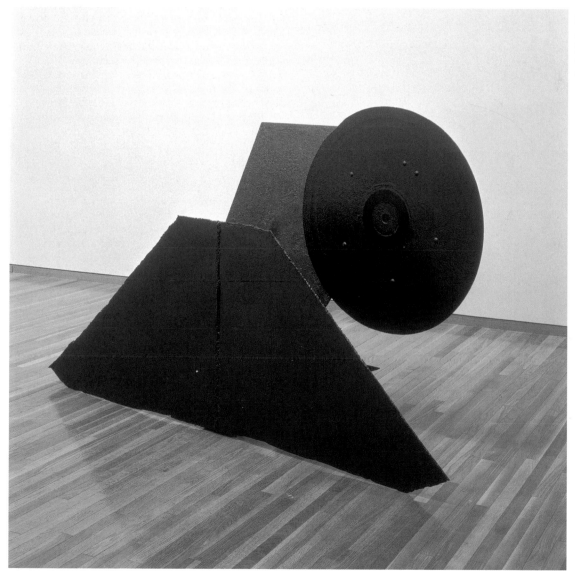

Fig.7
Anthony Caro
Twenty Four Hours
1960
Tate

Fig.8
Gwyther Irwin
<u>**Letter Rain**</u> **1959**
Artist's collection

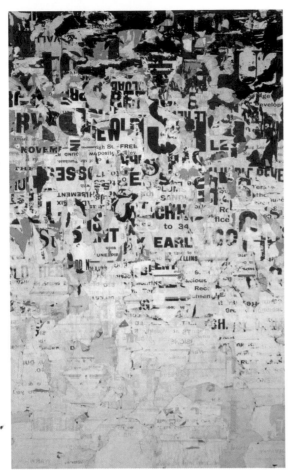

work of John Latham. For Latham, books served a practical function as compositional elements full of metaphorical and symbolic potential, as well as being a taxonomy of information and knowledge (fig.10).

The apparently diverse work of those artists who in the late fifties developed a radical practice in the wake of 'action painting' and those engaging with the imagery of mass culture actually represented a single, significant shift in the relationship between modern art and the external world. Before the war, art had been polarised between modernism and traditional realism, or between Surrealism's fascination with the unconscious and Constructivism's aspiration to a spiritual or non-material realm. In the earlier fifties, the latter values had persisted in the abstract art of St Ives and the Constructionists while the realist tradition was equally resilient though it took on a nostalgic tone. British art of the second half of the fifties engaged with the contemporary material world, specifically the modern world of the city and mass communication and production. Whether through the appropriation of junk and fragmented signs or through the engagement with mass visual culture, radical new aesthetics were explored as a means of developing an art that responded to the reality of the modern moment, whether material or simulacrum.

Fig.9
Robyn Denny
<u>**Golem I (Rout**</u>
<u>**of San Romano)**</u>
1957—8
Tate

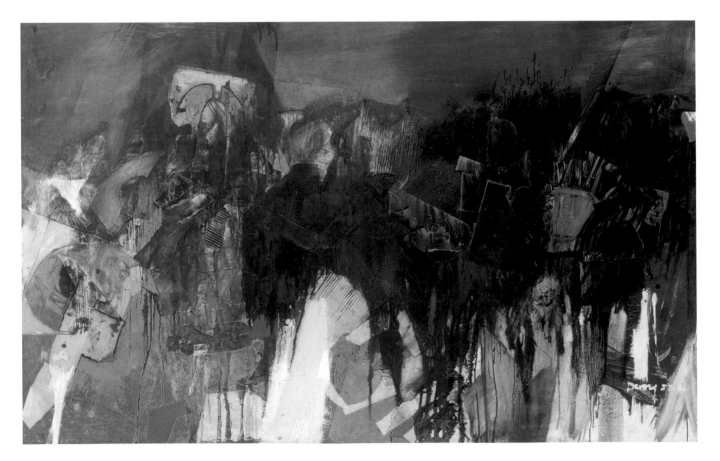

16 Art & the 60s: This Was Tomorrow

IMAGE IN PROGRESS

The early sixties also saw a reappraisal of the relationship between the work of art and its viewer. As the critic and ICA curator Lawrence Alloway wrote of the eclectic group of abstract painters who participated in the *Situation* exhibition of 1960, 'an awareness of the world as something that contains both the work of art and the spectator (rather than the romantic notion of the work of art itself as the world) is at the core of recent developments in London'.[14] He could equally have been discussing an emerging group of figurative artists, influenced primarily by popular culture. Alloway championed both groups, playing a key role in setting up the *Situation* exhibitions and the 1961 *Young Contemporaries*, the exhibition now heralded as launching the 'Pop' artists Derek Boshier, Patrick Caulfield, Antony Donaldson, David Hockney, Allen Jones, R.B. Kitaj and Peter Phillips. These he described as 'artists (mainly at the Royal College) who connect their art with the city ... The impact of popular art is present, but checked by puzzles and paradoxes about the play of signs at different levels of signification in their work, which combines real objects, same size representation, sketchy notation, printing and writing.'[15] In the work of both Situation and Pop artists Alloway recognised that, whether striving to create a new style of figuration or an original abstract language, they were no longer solely interested in the confines of the canvas but understood painting as defined by and dependent on its active relationship with the spectator. In a significant break with tradition, they did not regard their art to be about direct representation, but a comment on or a celebration of a cacophony of forms, signs and imagery taken from the world around them.

Situation artists and Pop artists have generally been treated separately. However, painters such as Boshier, Bernard Cohen, Donny and Phillips shared a controlled treatment of different, often incongruous elements that sit alongside each other on the surface of the canvas. Whether these elements were blocks of form and colour, or fragments of a recognisable 'found' image, the mutual aim was to resist both any illusion of real space and the orthodoxy of an all-over, homogeneous composition. In much of the work there was a dramatic expansion in size, largely owing to the impact of seeing Abstract Expressionist painting at first hand.[16] The ambition and confidence with which these young British artists freely experimented is that of a new generation eager for change and ready to make their own mark on a world changing around them. They were detached enough from the traumas of the Second World War

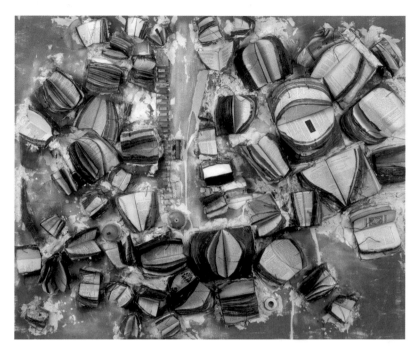

Fig.10
John Latham
Film Star 1960
Tate

Fig.11
Robyn Denny
Life Line I 1963
Tate

Fig.12
Bernard Cohen
Early Mutation Green
No. II 1960
Tate

to embrace, though still question, the emergent consumer society in which, for some, choice rather than necessity determined how an increasing cash surplus was spent. Fascinated by progressive forms of mass communication and technology, they watched closely the rapidly developing worlds of advertising, television and film as well as dynamic new graphic design. Significantly, these disciplines returned this interest by documenting and promoting the rise of many of these new art celebrities, as well as being directly influenced by their work.

SITUATION

The criteria for works selected for the 1960 *Situation* exhibition were that they should be 'abstract (that is, without explicit reference to events outside the painting) ... and not less than 30 square feet'.[17] Motivated in part by the hesitation of commercial galleries to promote such large new works, the intention was to present painting which demanded 'the spectator to be contained and confined by it'. It was argued that such space-hungry works did not automatically require a vast space, but could form an intimate relationship with the viewer, forcing not just the eye to move but the whole body, making the viewer's experience a physical one. Styles varied and, though affiliated to recent developments in American painting, the work possessed an independent sensibility.

From his earlier interest in American popular culture and the urban landscape of graphic signs, Robyn Denny developed large-scale paintings in which he juxtaposed 'hard edged' forms that float on the surface, denying the possibility of a deep figure—ground relationship. An unstable surface is created by a complex system of symmetrical, geometric shapes, painted thinly rather than gesturally in tonally related, muted colours. The scale and form of *Life Line I* (fig.11) give it an anthropometric quality reminiscent of an architectural feature. Its symmetry and centralised motif align it with the work of young American painters (in particular Kenneth Noland) rather than that of earlier British abstract artists who believed in the importance of an all-over image that reached out to the edges of the canvas. This quality was both employed and lampooned by Bernard Cohen who, like the Pop artists, exploited mundane, everyday imagery, though less explicitly, to provoke a sense of recognition. In *Early Mutation Green No. II* (fig.12), the twin discs, set within an arch rising from the base of the canvas, suggest a shallow depth through a cognitive association with domestic details such as knobs on a chest of drawers or dials on a radio. Yet this illusion is immediately denied by the introduction of an incongruous element – in this case a stain-like area of blue

– as the work slips between figuration and abstraction. By playfully mixing up formal and figurative motifs, Cohen's paintings irreverently avoid the heroic nature of their American predecessors and seem to critique the purist formalism preached by Greenberg and practised by Noland.

Richard Smith, another participant in *Situation*, shared Denny's enthusiasm for painting that has an assertive physical, almost sculptural, presence, akin to an urban sense of enclosure. In 1959, they collaborated with Ralph Rumney on the ICA exhibition *Place*, in which paintings were presented as screens standing on the floor to create an environmental installation. In 1961, on his return from two years in New York, Smith's work began to refer more overtly to imagery from commercial advertising and packaging, as seen in *Gift Wrap* (fig.13), which exploits the three-dimensional form of cigarette packets. The scale of this vast work has the arresting impact of billboard advertising or widescreen movies, which Smith had encountered in the States, and aggressively demands a phenomenological response from the viewer. Aware of the writings of Marshall McLuhan, Smith was interested in the success of new forms of communication and the way this was changing the visual landscape: 'My interest is not in the message so much as the method. There is a multiplicity of messages ... Can how something is communicated be divorced from what is being communicated, and can it be divorced from who it is being communicated to?'[18] Indebted to gestural painting, while incorporating commercial imagery, Smith's work can be described as Abstract Pop. In part he was also motivated by the work of the younger artists he taught at the Royal College, whose work he enthusiastically supported. He was one of the first to write about Boshier, Hockney and Phillips in the influential Royal College journal *Ark* in 1962.

YOUNG CONTEMPORARIES

The Royal College was an important centre, with artists such as Blake, Kitaj, Smith and Tilson graduating in the late fifties, shortly followed by Boshier, Pauline Boty, Caulfield, Denny, Hockney, and Phillips. These artists supported each other in their mutual enthusiasm for exploiting mass culture – from American food packaging to media icons such as Marilyn Monroe or Bridget Bardot – as a primary source for their work, revelling in its kitsch and 'low art' status. In this they were surely indebted to several of their tutors, such as Carel Weight, John Minton and Ruskin Spear, who addressed popular culture and everyday subjects in their own work. For the younger artists, however, it was in technique as well as subject matter that

Fig.13
Richard Smith
Gift Wrap 1963
Tate

they set about breaking down hierarchies and inventing a new pictorial syntax and vocabulary for painting.

There was a productive two-way flow of ideas between the Graphic and the Fine Art Schools at the Royal College. Alan Fletcher comments on how many students used both: 'Curiously the crossover came in the litho room, because we all used to meet in there. There was Joe Tilson doing his stencilled paintings with stencilled letters and Peter Blake used to be in there too.'[19] Both Tilson and Blake, also friends, made little distinction between the two disciplines, an attitude that encouraged their younger colleagues. Blake's grass-roots celebration of popular culture was shown by an affectionate and nostalgic attitude towards his sources, whether these were Victorian objects or the latest pin-up girl. His relationship to American art is best displayed in *The First Real Target* (fig.14), which takes a witty swipe at the question of originality by appropriating the subject of Jasper Johns's earlier target paintings, regarded as one of the first examples of American Pop, in a deliberately hand-crafted work that incorporates an actual archery target. In a contribution to the ongoing debate about the relationship of British Pop to its American counterpart, Blake countered Johns's artfully constructed target with an actual item from the wider culture. Tilson also merged 'high art' and craft techniques. He used his carpentry skills to create wooden constructions such as *Vox Box* (fig.15), inspired by the playful and bold imagery of children's puzzles and packaging, in this case depicting an open mouth filled with comic-like exclamation marks. He would later treat a similar motif in a more recognisably Pop manner, when he presented a blown-up photo of a model's lips in *Transparency: The Five Senses: Taste* (fig.39).

Iconic images of celebrities were a common theme amongst artists. The sixties witnessed a huge growth in the cult of celebrity mediated through the mass media. David Bailey's selection of 'in' people of the moment for his *Box of Pin Ups* epitomised the perceived breaking down of traditional class-based hierarchies. An old establishment seemed to be displaced by a new elite of young creative or glamorous individuals. Artists positioned themselves through their association with certain public figures as defined through much-reproduced photographs. The glamorous and tragic figure of Monroe featured especially frequently, but so did British film and pop stars. Blake, in particular, celebrated heroes such as The Beatles as well as the more generic pin-up girls who featured in many artists' work. As the work of a woman, there is a different sub-text to Pauline Boty's

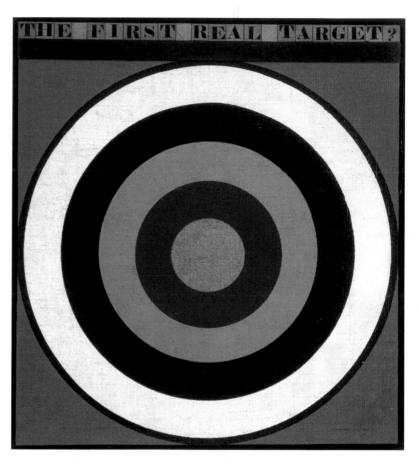

Fig.14
Peter Blake
The First Real Target
1961
Tate

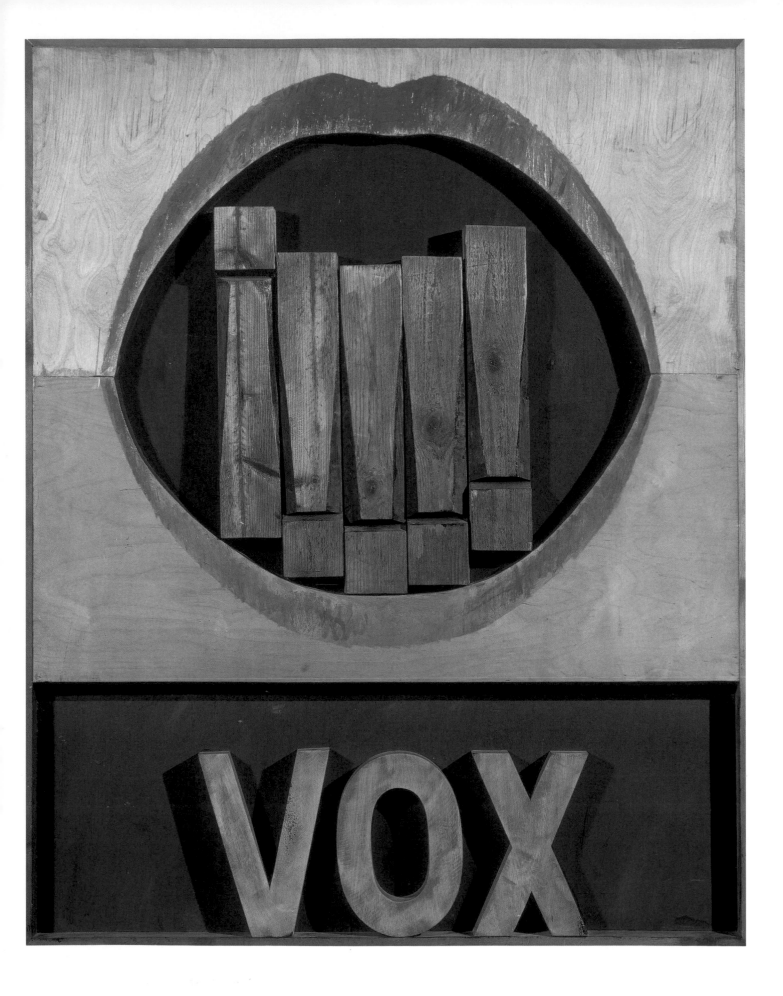

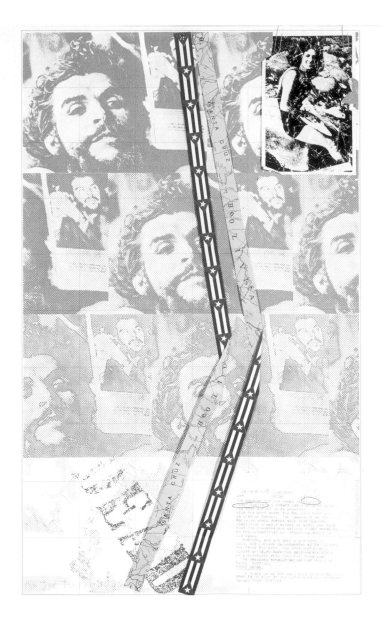

Fig.16
Joe Tilson
Is This Che Guevara?
1969
Tate

representations of the female body, the title of her *The Only Blonde in the World* (fig.55) commenting perhaps on the obsessiveness of Monroe's male fans. Others' choice of heroes suggested a political positioning, though with a focus on exotic foreign icons, with Tilson, for example, making images of the Cuban revolutionary Che Guevara (fig.16), the Russian cosomonaut Yuri Gagarin (fig.56) and Vietnamese Communist leader Ho Chi Minh. Hamilton's representation of J.F. Kennedy as an astronaut (fig.57) and Labour leader Hugh Gaitskill as 'a famous monster of film land' were more acerbic.

These artists' non-hierarchic approach to the art object was radical even for the Royal College, which encouraged experimentation but remained dominated by the Kitchen Sink school. Significantly, Phillips was thrown out of the Painting School because of his experimental approach, moving to the School of Television Design. He was equally influenced by his technical training in Birmingham, his fascination with pinball machines and billboard advertisements, and by early Italian altarpieces: 'My awareness of machines, advertising, and mass communication is probably not in the same sense as an older generation that's been without these factors: I've been conditioned by them and grew up with it all and use it without a second thought ... it's natural for me to use them without thinking'.[20] Phillips's innovations in style and subject matter are displayed in *Motorpsycho Tiger* (fig.17), in which a technically accomplished pencil drawing of an engine sits below a biker figure and tiger-head mascot realistically rendered in oil paint, the narrative underpinned by an abstract pattern resembling hazard tape. Held in position by a clear, organised structure, figurative and abstract images hover uneasily alongside each other on the surface

Opposite
Fig.15
Joe Tilson
Vox Box 1963
Tate

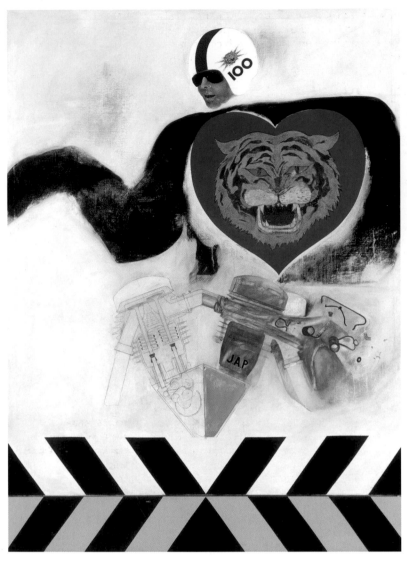

of the canvas. Such a tension also inhabits *The Entertainment Machine*, a depiction of a fruit machine that recalls, at first glance, recent abstract painting (fig.42).

The representation of objects from everyday modern life was certainly not new — in 1954 John Bratby's *Still Life with Chip Fryer* had included a packet of cornflakes; in 1961 Boshier (whose thesis had been on the Kitchen Sink school) tackled a similar subject in *Special K* (fig.18). Yet, unlike Bratby, Boshier did not depict an actual scene but used the iconic logo, enhanced with rocket engines, to animate the canvas, investigating the way strong graphic techniques can manipulate the viewer to sell consumer products and suggesting a parallel between American marketing and the space race. Close friends with Smith, Boshier shared his fascination with the mediated image, exploring what he termed the 'projection' idea in advertising, or how an object can be depicted in such a way as to make the viewer desire it. In his critique, Smith pointed out: 'All the elements in the paintings are taken from material in printed format, nothing from life. This reflects the method by which we acquire facts in these post information explosion days. They are social comment in mad, comic terms.'[21] Boshier's work has a clear critical stance. *The Identi-Kit Man* (fig.44), for example, implies that the advertising strategies of the toothpaste company have been so effective that man has become nothing more than a commodity himself.

Despite being celebrated by the media as at the centre of the 'scene', David Hockney's work was not closely affiliated to that of the other Pop artists. Though deeply enthralled by the American way of life (discovered at first hand in 1961), he rarely used commercial imagery as a starting point. His student work shows a much more personal appropriation of visual culture, adding texts to create homo-erotic works rooted in autobiography. Later, such sexual encounters would be staged in the exotic interiors and swimming pools of wealthy California. Hockney's most recognisably 'Pop' work, *Tea Painting in an Illusionistic Style* (fig.19), presents a packet of tea as a shaped canvas with a figure, loosely painted in a style reminiscent of Francis Bacon, trapped within the frame. Even this has a private meaning: 'It was always Typhoo tea ... my mother's favourite ... The tea packets piled up with the cans and tubes of paint ... and I just thought, in a way it's like still life paintings for me.'[22]

In contrast, Gerald Laing's approach was closely aligned to the group, although he studied at a different college and did not gain public recognition until slightly later.[23]

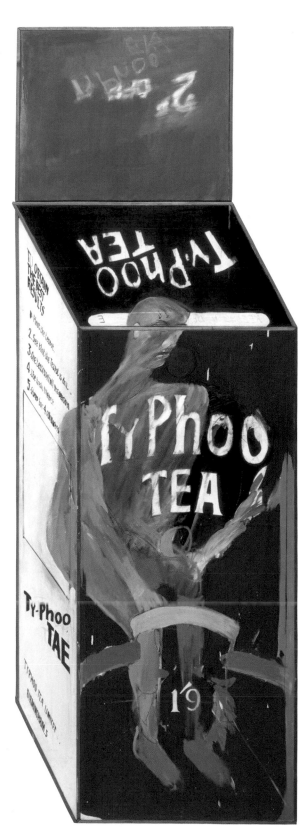

Initially known for monochrome paintings of pop stars and movie icons appropriated from magazine photographs, from around 1963 he began to use shaped canvas to present more stylised imagery. He depicted drag-car racers, film starlets and skydivers 'because', he recalled, 'they are all excellent examples of individuals formalised and rendered in a sense heroic by their accoutrements'.[24] *Skydiver VI* (fig.20) combines his signature technique of using black dots juxtaposed with areas of flat colour, a procedure distinct from Roy Lichtenstein's direct appropriation of found images, though obviously related in its use of Ben Day dots to parody commercial printing. Antony Donaldson exploited similar subject matter — pin-up girls and racing cars — also taken from magazine photographs. *Take Five* (fig.21) repeats images of a model reduced almost to silhouette to create a rhythmic abstract pattern. While it is an impersonal and graphic work, the smooth surface of which denies that the artist's hand need be detectable, the repetition comments, perhaps, on the mass-reproduction of the image of the female form, and its relegation to mere commodity.

The preference of Donaldson and others for a glossy, anonymous surface was echoed in the sculptures of Clive Barker (fig.22). Barker made reproductions of actual objects that could be described as hyper-realistic were they not chrome-plated. The effect is to disguise the familiarity of mundane objects and even to invest them with an almost numinous quality. His choice of subjects and treatment of them also betray a sense of humour, a quality seen in the work of two other 'Pop' sculptors, Nicholas Monro and Jann Haworth. Monro produced sculptures in fibreglass painted with flat gloss paint comparable to the paintings of Caulfield. His subjects were playful and whimsical, frequently employing toys or a child-like view of the world. A ballroom-dancing couple, sand castles, a herd of reindeer and a group of martians typified his injection of humour into the realm of sculpture (fig.23). Haworth's works were often similarly humorous but with, perhaps, a more acerbic edge. Many were figures — Mae West at her dressing table, a housemaid on a sofa, a cowboy and a surfer — but they also included a giant ring and charm bracelet. What most distinguished these works was that they were made in fabrics filled with soft stuffing, giving them some of the quality of the folk art they recalled. She also reproduced such things as a newspaper front page as an appliqué blanket, from which she developed figures that seemed defined by their ceremonial-like robes (fig.24). These works seem to anticipate the reappropriation of such traditional women's activities as needlework by feminist artists of the seventies.

Fig.17
Peter Phillips
Motorpsycho Tiger
1962
Penelope Rosenberg

Fig.18
Derek Boshier
Special K 1961
Penelope Rosenberg

Fig.19
David Hockney
Tea Painting in an
Illusionistic Style 1961
Tate

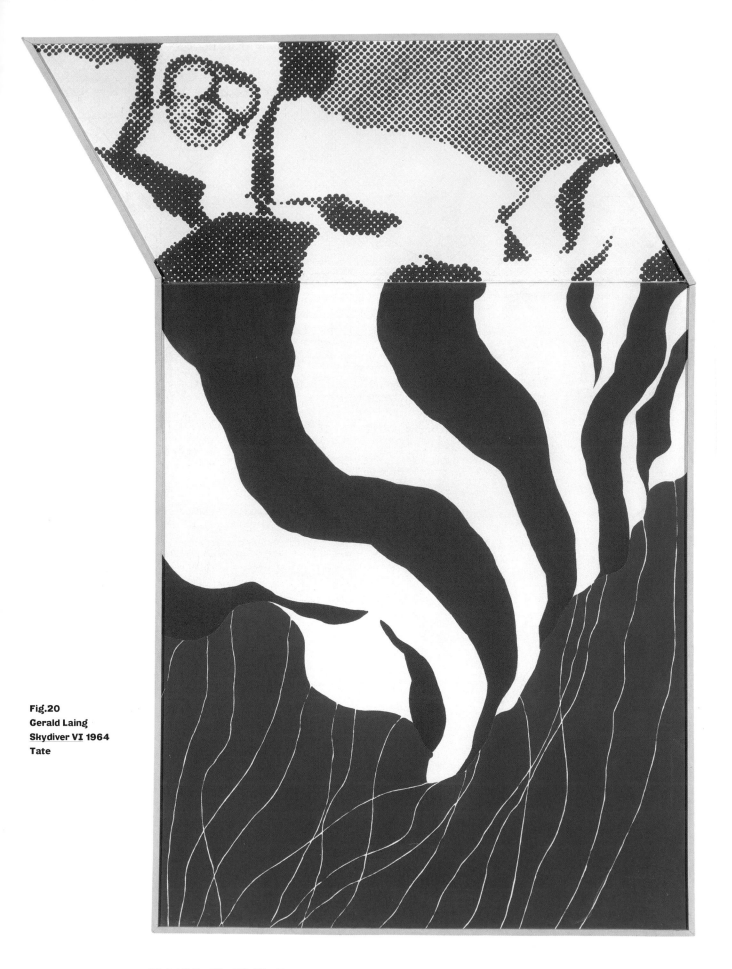

Fig.20
Gerald Laing
Skydiver VI 1964
Tate

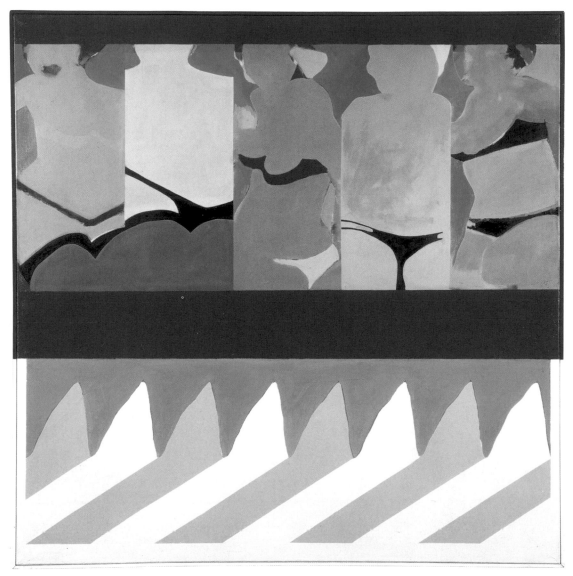

Fig.21
Antony Donaldson
Take Five 1962
Tate

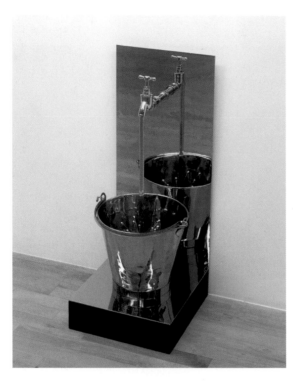

Fig.22
Clive Barker
Splash 1967
Tate

Fig.23
Nicholas Monro
Martians 1965
Collection of
Rupert Power

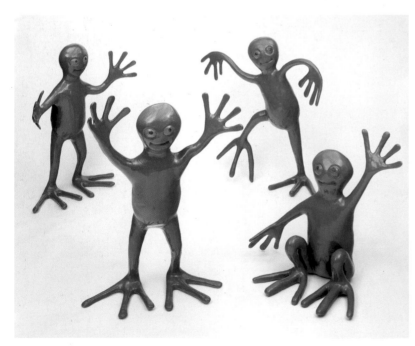

The new 'Pop' artists had been launched to a specialist public with *Young Contemporaries* in February 1961, and within twelve months they were entering a wider consciousness. On 4 February 1962 the inaugural edition of the first Sunday colour supplement – the *Sunday Times Colour Magazine* – included a feature on Peter Blake, 'Pioneer of Pop Art'. The same month the BBC television arts programme Monitor broadcast Ken Russell's film *Pop Goes the Easel* which presented the personalities, work and ideas of Blake, Boty, Phillips and Boshier. The compendious book of portraits by Snowdon of the protagonists of the British art scene, *Private View*, was an indication of how vibrant and broad that scene was felt to be by 1965. The rapid establishment of the younger artists was demonstrated by the inclusion of Hockney, Blake, Jones, Smith and Kitaj in the Tate Gallery's huge survey of recent western art, *54–64: Painting & Sculpture of a Decade*. Two years earlier, *British Art Today*, organised by Alloway, was shown in San Francisco, Santa Barbara and Dallas and included work by Blake, Jones, Paolozzi, Phillips and Tilson.[25] The same year, Alloway had been made curator at the Solomon R. Guggenheim Museum in New York, a key position of influence in the promotion of British art in the States. Throughout this period the British Council also promoted the rising new art stars abroad with exhibitions such as *London: the New Scene*, which toured from the Walker Art Center, Minneapolis, to several American and Canadian venues in 1965. This all contributed to the perception that Britain, particularly London, was the international art centre to watch.

The growth in the London art scene was complemented and aided by an expansion of the art market. In the early fifties, independent commercial galleries showing contemporary art were few and the non-commercial sector was led by the ICA, then still dominated by such figures from the pre-war avant-garde as Herbert Read and Roland Penrose. In the late fifties, the commercial scene was greatly changed by the opening of Marlborough Fine Art and the Waddington Galleries, both of which offered artists greater financial security. Marlborough quickly recruited many of the most senior figures, including Henry Moore and Francis Bacon, who continued to be important presences on the British art scene, and soon opened a second venue, the New London Gallery, to showcase the work of the next generation of British and American artists. While Waddington's stable was initially dominated by the so-called 'middle generation' of Patrick Heron, Roger Hilton and Terry Frost, in the sixties it also showed work by younger British and American

artists. Even established galleries such as Arthur Tooth and Sons were motivated to acknowledge the wealth of new talent. Its *British Painting Today* exhibition in 1962 included the work of Howard Hodgkin and Allen Jones.

The swiftness with which new American art could be seen in London was an important feature of the sixties. The Kasmin Gallery opened in 1963 with a Kenneth Noland exhibition. While Kasmin's choice of British artists ranged eclectically from Hockney to Latham, the American artists he showed tended to be those following a Greenbergian aesthetic. Robert Fraser opened his gallery in London's Duke Street the same year and represented most of the British Pop artists as well as taking more risks by exhibiting Americans such as Claes Oldenburg, Jim Dine and Edward Ruscha.[26] The Robert Fraser Gallery was at the heart of what was dubbed 'Swinging London'; it was a crucial nexus where avant-garde artists, wealthy collectors and celebrities, including American film stars like Marlon Brando as well as the Beatles and the Rolling Stones, could mingle. While Kasmin and Fraser dominated, a number of other galleries offered space to radical young artists, including Victor Musgrave's Gallery One, where Bridget Riley, among others, had her first solo show. The Grabowski Gallery's *Image in Progress* exhibition (August 1962) was the first anthology of British Pop.

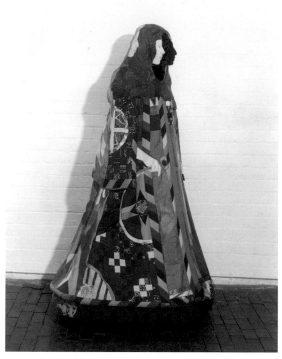

Fig.24
Jann Haworth
Calendula's Cloak 1967
Arts Council Collection,
Hayward Gallery,
London

Fig.25
R.B. Kitaj
The Murder of Rosa
Luxemburg 1960
Tate

COMMUNICATION

The pluralistic avant-garde art in Britain in the early years of the sixties was concerned with more than a shift in aesthetics. It reflected a serious consideration of the language of images and means of communication. Pop Art's fascination with the imagery of packaging, advertising, glamour and celebrity was not simply a renewed engagement with the external world, nor was it necessarily a celebration of a glossy new visual culture. Several artists, Boshier among them, were familiar with Vance Packard's critical analysis of advertisers' methods, *The Hidden Persuaders*. The critic Jasia Reichardt detected 'a sly, bitter-sweet comment on the reality of things, which might one day evolve into a fully fledged satire.'[27] Christopher Finch's early analysis of the Pop-orientated artists indicated in its title — *Image as Language* — the semiological drive underpinning their work.[28]

Though the artists discussed by Finch were principally concerned with mass culture, the cover of his book shows the array of transistors on an electronic circuit board. In the early sixties, considerations of language and communication took a technocratic turn. The technological fantasies of the Independent Group and James Bond became increasingly

Fig.26
David Hockney
The Third Love Painting
1960
Tate

real with the growth in computers and the advent of cybernetics – the science of control and communication. Cybernetics was a key aspect of the 'Ground Course' developed at Ealing School of Art by Roy Ascott with Anthony Benjamin, Bernard and Harold Cohen and R.B. Kitaj. Ascott had studied under Hamilton and Pasmore at King's College, Newcastle, where he encountered the Basic Design course pioneered there and at Leeds. Heavily indebted to the Bauhaus, Basic Design introduced students to the essentials of form and development based on models of growth in nature. It emphasised the individual creativity of the artist and strongly influenced the radical revision of art education in Britain with the replacement of the craft-oriented, vocational National Diploma in Design (NDD) with the broader 'liberal education in art' of the Diploma in Art and Design (Dip AD).[29] This pedagogic shift provided the background to the diversity of teaching in British art schools of the sixties, ranging from the Slade's continuation of the Coldstream-led emphasis on precise observation of the object to the Vocational Sculpture course developed at St Martin's under Caro, and to the interest in communication and games theory of Ealing's short-lived Ground Course.

In its two years (1961–3) the Ground Course fundamentally affected the work of those who taught it and of their students. The Cohen brothers both abandoned the abstract orthodoxy of the cohesive single composition, producing works made up of disjointed or fragmented images. Such an abandonment of formal homogeneity had first been seen in the figurative work of such artists as Kitaj and Hockney. An American émigré, Kitaj was older than his contemporaries at the Royal College, where he made *The Murder of Rosa Luxemburg* (fig.25). Rather than standing for her Marxist politics, Luxemburg is fused with memories of Kitaj's grandmothers to symbolise the murder of the Jews across history. The apparently disconnected amalgam of figurative fragments, abstract gestures and passages of writing reflects Kitaj's belief that a painting could operate like a text, being 'pored over, investigated and read like a map'.[30] A similar dislocation characterises the early works of Hockney, in which Abstract Expressionist influences are combined with texts drawn from poetry and toilet-wall graffiti in a bold statement of homoerotic desire (fig.26).

Like Kitaj, Harold Cohen saw painting in terms of communication and cognition. He compared the mind of the viewer to a computer in which the memory is arrayed on a field rather than in an index and, in retrospect, saw such works as *Before the Event* (fig.27)

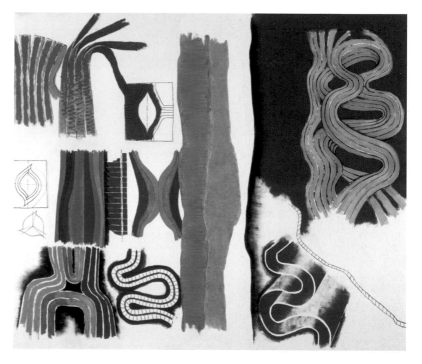

Fig.27
Harold Cohen
Before the Event 1963
Tate

Fig.28
Bernard Cohen
Floris 1964
Tate

as comparable to this conception of a non-linear memory. His interest in a more complex theory of signs and communication, including such cybernetic concepts as feedback and entropy, led to an art that was deconstructive and self-critical in both its imagery and the process of its making. Cohen spoke of art as reflexive — 'painting refers to the outside world: but in seeing, it sees itself seeing ... much of what is communicated is concerned with the mechanics and processes of communication'.[31] Similarly, the cybernetic concept of 'supportive redundancy', conventionalised information that accompanies any message, prompted Bernard Cohen to strip his painting to its bare essentials. The composition of *Floris* (fig.28) was almost self-generating. Cohen began with a small 'symbolic enclave' towards the top left corner, from which radiating profiles developed, then spokes to unite them and, finally, a range of varying pictorial incidents were painted into and over the pattern of red and black lines.[32]

NEW GENERATION

The perceived vitality of British art was demonstrated by the *New Generation* series of exhibitions at the Whitechapel Art Gallery, directed by Bryan Robertson, which began in 1964. These offered a high-profile platform for artists who were 'roughly half-way between leaving art school and becoming established'.[33] Robertson also set out to help the exhibition sponsor, the Peter Stuyvesant Foundation, build 'a strong collection of British art, as it was being made, as a radical sign — and signal for others — of the commercial patronage which was still so urgently needed in England', comparing the example of America where many corporations actively supported modern art with the undeveloped situation in Britain.[34] The third objective was to subsidise artists' travel by awarding bursaries that both acknowledged their need to go abroad, especially to the USA, and avoided graded prizes with 'their underlying assumptions of superiority and inferiority'.[35]

The first *New Generation* exhibition of painters in 1964 in fact presented artists who were reasonably well established: ten out of twelve had already had commercial exhibitions and Hockney and Riley were becoming media celebrities. In *New Generation* Hockney's work was loosely categorised, along with that of Boshier, Donaldson, Jones and Phillips, as 'new figuration' or, as David Thompson wrote, 'in other words, the much publicized, ill-named "Pop Art"'.[36] By 1965 'Pop art' was already being mythologised and critics were arguing over the origins and definitions of the movement.[37] Jones was another artist peripherally associated with the group, though stylistically he was at odds with his Royal College contemporaries. His work of

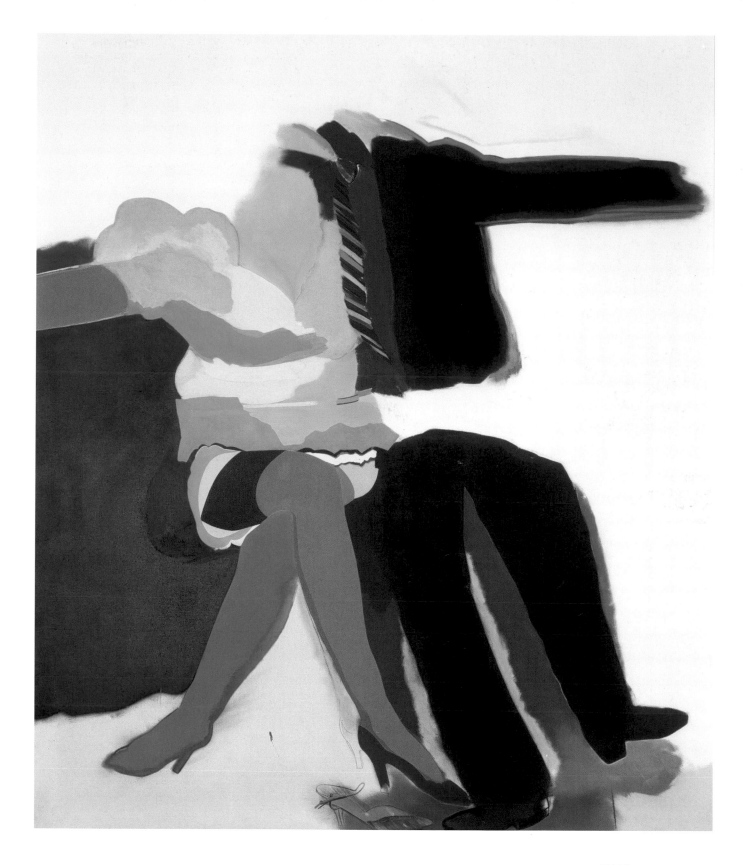

Fig.29
Allen Jones
<u>Man Woman</u> 1963
Tate

this period diminished the importance of his subject – buses, cars, aeroplanes or hermaphroditic couples – by dissolving the image to the point of obscurity. The loose improvised style of *Man Woman* (fig.29) shows an instinctive application of colour, creating a vibrant pictorial composition through a complex fusion of male and female anatomy.

The work of other artists in the show revealed new developments in abstract painting. Only Hoyland had participated in the *Situation* exhibition four years earlier. Affiliated with 'hard-edged' abstraction through his angular and dramatic works such as the 1962 painting *No.22, 20.2.62* (fig.32), his more recent work pursued a more whimsical, fluid investigation of the figure–ground relationship through colour. Bridget Riley's optical paintings had already taken London by storm with her Gallery One exhibitions of 1962 and 1963, and by 1966 she would have an exhibition of her drawings at the Museum of Modern Art in New York. Notably, she was the only woman selected for the *New Generation* series. Her work also stood apart from the other *New Generation* artists as forging a radically new departure for painting that came to be known as Op art. *Fall* (fig.30) was made during Riley's black-and-white period of 1961–4, and creates a field of shifting optical frequencies through the repeated feature of a single black curve. These paintings have an extraordinary visceral effect on the spectator, as the eye tries to make sense of the intense and unsettling perceptual experience, an effect deliberately manufactured by the artist to represent a volatile state of mind.

One figure who cannot easily be categorised was Patrick Caulfield, who had left the Royal College only the year before. *Black and White Flower Piece* (fig.31) typically presents a banal motif in a flat, stylised and completely unsentimental manner. Caulfield re-examined familiar images, often taken from art history, such as Delacroix's *Greece Expiring on the Ruins of Missolonghi*, or the ubiquitous bowl of flowers, reducing them to their essential components and using a restricted palette of bold colours applied with a smooth finish. The resulting paintings seem cartoon-like but display a highly sophisticated style for an artist at this early stage of his career.

The second *New Generation* exhibition in 1965 presented a group of sculptors who were nearly all associated with St Martin's School of Art, having studied there under Caro.[38] For the most part, they learnt from his recent innovations in making completely abstract sculptures that stood directly on the floor, creating a complex relationship with the horizontal axis of the ground and inviting an immediate dialogue with the viewer.

Fig.32
John Hoyland
No.22, 20.2.62
1962
Tate

In the same spirit as their peers who chose to work on canvas, they liberated sculpture from having to refer literally to something outside of itself. These young artists were making a significant break from Henry Moore's dominance over British sculpture despite the fact that three of them had been his assistants. They rejected traditional materials and techniques, using steel after Caro and David Smith, but also employing a range of new synthetic materials, especially fibreglass, to create large works that possess a confrontational physical and visual presence. They used colour imaginatively and, like Caro, were indebted to the work of the American 'colour field' painters such as Morris Louis and Kenneth Noland whose work, along with Caro's, was being promoted by Kasmin.

Bryan Robertson acknowledged that the sculptors shared a 'concern for a certain kind of shape, and movement' with recent developments in painting. The bold, linear works of Annesley, such as *Swing Low* (fig.34), offer forms and colour relationships in three dimensions which parallel those set up by contemporary abstract painters such as Hoyland. William Tucker and Tim Scott juxtaposed materials such as glass, Perspex, plastic and wood with an inventive use of colour to create works that extended and challenged sculptural convention. These artists used colour as a skin to minimise the importance of their materials — another break with the modernist adherence of truth to materials and the fifties' fascination with the surface texture of bronze. Their attention was given to producing interesting forms, often through repetitive units, though these shapes were further complicated by the use of glass or Perspex to disrupt the hard, clear lines of the other elements.

Like many of their contemporaries these sculptors wanted to deny the idea of the artist

Fig.33
Tim Scott
Peach Wheels 1961—2
Tate

Fig.34
David Annesley
Swing Low 1964
Tate

Fig.35
William Tucker
Anabasis I 1964
Tate

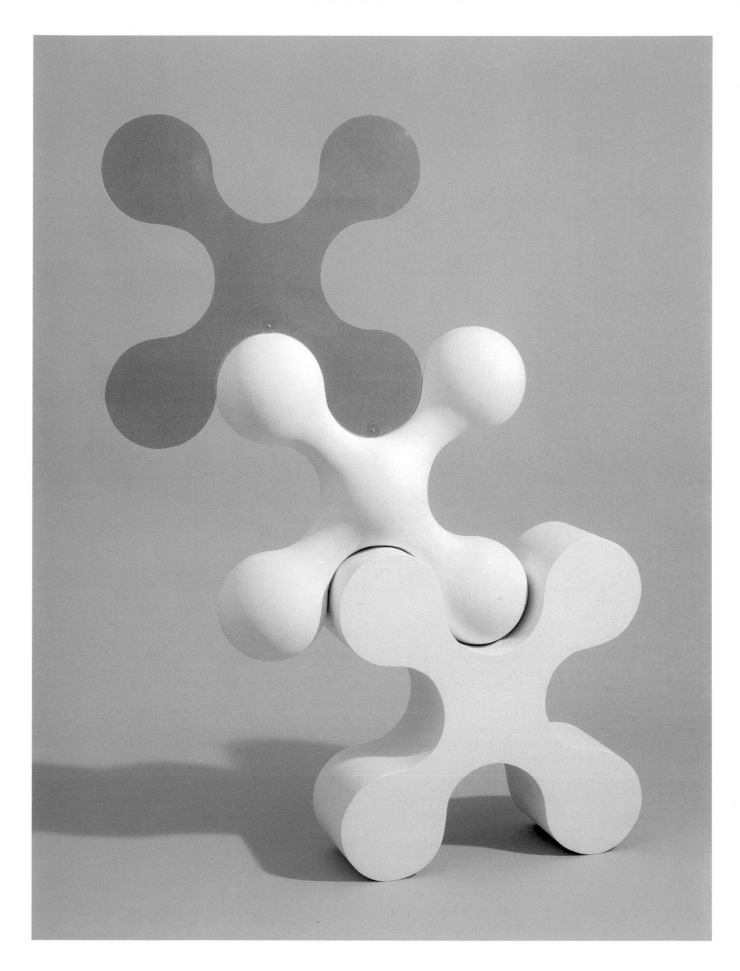

Fig.36
Peter Sedgley
Yellow Attenuation
1965
Tate

as a sophisticated craftsman or spontaneously expressive creator. Tim Scott declared, 'I want to create a sculpture which would be shapeless — a sculpture which would be free from my personal imprint. That is why I use semi-geometric forms that everyone knows beforehand. I do not use them because I'm interested in some Platonic world of ideas, but because I want them to be recognized and then forgotten so that the basic concept underlying the sculpture can be seen without distraction.'[39]

Phillip King had been taught briefly by Caro in 1957–8 before Caro's seminal shift into constructed steel sculpture. A visit to Greece prompted King to abandon the organicised human figures of Moore to pursue a sculpture that related to the earth as the Parthenon did. Drawing on surrealist as well as figurative sculpture, new materials and bold colour allowed him to make such works as *Tra-La-La* (fig.76). Its fluid ascendancy challenges the

orthodoxy of the monolith with a witty interpretation of the stacked form pioneered by Brancusi.

IMAGE IN REVOLT
In 1957 Alloway had been able to divide abstract painting into two categories: geometric and gestural.[40] The sixties saw a wider-ranging debate over the potential of abstraction, its relationship to signification and the possible range of its sources and theory. The *Situation* painters had reinterpreted the formalism and scale of American abstraction; the painters of Ealing had brought communication theory to bear on the genesis of their images; others had explored the phenomenological relationship between the work of art and the viewer, notably the artists involved in the 1959 *Place* exhibition and Op artists Bridget Riley and Peter Sedgley. Like Riley, Sedgley initially made paintings of stripes of such width,

Fig.37
Ian Stephenson
Parachrome 1964
Tate

colour and tone as to create visual interfer-
ence and instability. From these he developed
a series of rotating circular canvases which
used fluorescent paint and dedicated lighting
to expand the illusory potential.

In his idiosyncratic paintings Ian Stephenson
was also concerned with the viewer's engage-
ment with the work, but primarily with
the painted surface. His paintings are made
up of a skein of dots and flicks of paint, the
density and texture varied by the occasional
use of stencils and spray guns. Descendants
of Seurat's, his compositions are at once
homogeneous and constantly in flux. In
Andrew Forge's estimation, they are 'pictures
of nothing which are about everything'.[41]
Stephenson's concern with an abstract
painting that remained 'localized in things'
led to work that raised questions about
visibility and representation. His canvases
appeared in the seminal sixties film *Blow-
Up*, their surfaces echoing the way the

photographs became increasingly illegible
as they were enlarged in the hope of revealing
more detail.

A questioning of the relationship between
abstraction and representation occurred
in others' work. Frank Bowling was a Royal
College graduate and had shown with Boshier
in Grabowski's *Image in Revolt* in 1962. At
that time, he brought a Pop sensibility to a
pictorial style reminiscent of Francis Bacon,
and his theme was violation, personal and
political. In the later sixties he addressed
issues of post-colonialism using flags, maps
or, in one case, a parody of Barnett Newman
with three loosely painted vertical stripes
(fig.1). Such statements by a British Guiana-
born artist at the time of colonial unrest
and decolonisation were radical and unique
in British art. In the mid and late sixties
Howard Hodgkin also made paintings that
negotiated the area between abstraction and
representation, their titles announcing them

to be portraits of individuals or couples despite their apparent abstraction. The degree to which human figures or interior spaces could be discerned varied. The paintings were evocations of a moment involving, in the artist's words, 'particular people in relation to one another and also to me'.

SCULPTURE'S EXPANDING FIELD

The emphasis in Ealing's Ground Course on cybernetics and behaviourism profoundly affected one 1961 student, Stephen Willats. Taking on Ascott's enthusiasm for the diagram as a means of visual communication, he applied behaviourist theories to such processes as the habitation of tower blocks and the nature of social interaction. In 1963 he produced the first of a series of works that used lights to explore the cognitive nature of vision. In his *Visual Automatics* coloured lights flash in a totally random pattern, which the viewer's mind seeks to fashion into a regular rhythmic configuration (fig.91). The audience thus became an integral part of the work in a development from the Cohens' fascination with the slippage between intended meaning and the viewer's interpretation of a work of art.

Willats's work was located into a wider phenomenon of kinetic art and, like much of that work, related to the illusory movement and phenomenological effect of Op art. As Michael Compton pointed out, both Op and kinetic works shared common parentage in Duchamp's Rotary Discs that had been reprised by Hamilton in *This is Tomorrow*.[42] Compton positioned kinetic art within a Constructivist tradition, yet the rejection of sculpture's stasis in favour of an art of chance, temporality and change was fundamental. In Liliane Lijn's *Liquid Reflections* (fig.92) two coloured spheres move at random on a rotating clear plastic disc within which liquid condenses into droplets. Light and balance are the primary concerns of the work: lit by a single lamp to one side, the different clear plastics and the liquid reflect and refract the rays to lyrical effect.

The definition of sculpture was similarly challenged by a number of other artists. In 1965 Barry Flanagan, then a student at St Martin's under Phillip King, produced such works as *aaing j gni aa* (fig.75), which subverted the dominant idea of sculpture as a unified, solid object. The piece consists of five discrete soft elements, which become a single work by virtue of the enclosing circle on the floor. David Medalla's assault on sculptural orthodoxy was even more piercing. In his *Cloud Canyons* (fig.88) soap suds spew continually from wooden boxes, moving according to external and internal forces, formless, impermanent and contingent,

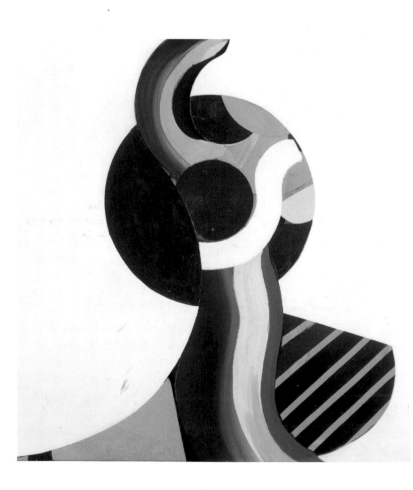

Fig.38
Howard Hodgkin
Mrs Nicholas Monro
1966—9
Tate

the precise opposite to the traditional fundamentals of sculpture. Medalla described himself as 'an hylozoist … one-of-those-who-think-Matter-is-Alive'.[43]

Medalla was co-founder of Signals Gallery in 1964, and contributed to its house journal, *Signals*, both of which presented a refreshingly international kinetic art, bringing European and South American artists together with those from Britain. Such radical work and alternative spaces were not peripheral to the apparently more mainstream art of the abstract and Pop painters and sculptors. The Indica Gallery, another testing ground for kinetics that exhibited the work of Willats, Lijn, Medalla, Mark Boyle and others, was as much a part of the art–celebrity matrix as the Robert Fraser Gallery. Run by John Dunbar, husband of Marianne Faithful, backed by Paul McCartney and the place where John Lennon first met Yoko Ono, Indica was an important point of conjunction between the underground art scene and a pop-subculture.

Amid the pluralism of the art of the sixties, the boundaries between different art forms became porous. Bruce Lacey's humanoid sculptures, assembled from the detritus of the city, and often of the Second World War, were exhibited at Gallery One and the Marlborough New London Gallery, but also belonged in the world of satiric and comic film and theatre. Lacey had worked with The Goons, collaborated on films, including the seminal *Running, Jumping and Standing Still Film* (1957) and The Beatles' *Help* (1965), performed with anarchic musical group The Alberts (in particular in *An Evening of British Rubbish*, 1961) and alongside Allen Ginsberg and others at the International Poetry Incarnation at the Albert Hall in 1965. As Andrew Wilson discusses, Lacey was part of a movement of artists, writers and performers practising an inter-disciplinary assault on artistic and political convention in a range of forms and sites, including literature and poetry conferences in Edinburgh and London and the Destruction in Art Symposium in 1966.

1968
This counter-cultural movement reached a peak in 1968, a year marked by radical and violent protest across the western world. Despite the violence of the anti-Vietnam War protests in London in October 1967 and, especially, March 1968, Britain's contribution was muted. The most obvious comparison with international political events was the civil rights movement in Northern Ireland, where riots in Derry in the summer of 1968 would turn out to mark the start of thirty years of The Troubles. In England,

actions in universities and colleges, including the art schools of Guildford, Croydon and, most notoriously, Hornsey, echoed but never matched the student protests in Europe and America. These British protests were underpinned by the anti-imperialist and anti-capitalist sentiment of the New Left and specifically engendered by the Vietnam War. There was, in addition, the perception of an establishment backlash against the progressive liberalisation of the sixties, typified by the draconian sentences imposed on Robert Fraser, Mick Jagger and Keith Richards for possession of drugs in 1967. A year earlier, Gustav Metzger had been fined for organising an 'indecent exhibition' as a result of Herman Nitsch's contribution to the Destruction in Art Symposium, a firm establishment response to what seemed an increasingly strong counter-culture.

By the end of the sixties there was a perceptible sense of disillusionment and disappointment. Artists predominantly sought 'the dematerialisation of the art object', to achieve an art that was ephemeral, temporal and often non-commercial, performative and conceptual. At the same time, against the backdrop of the economic and political crises of the seventies, there emerged an art that engaged more directly with the struggles of gender and class politics, aligning itself with those who had failed to gain from the promises of the consumer society that had determined so much of the sixties.

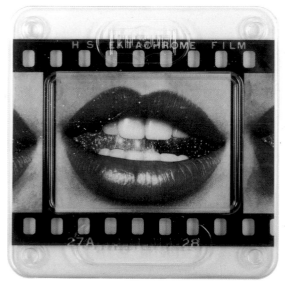

Fig.39
Joe Tilson
Transparency, the Five
Senses: Taste
1969
Tate

WILLIAM GREEN

Toby Treves

'I have seen, and heard, much of Cockney impudence before now; but never expected to hear a coxcomb ask two hundred guineas for flinging a pot of paint in the public's face.' Eighty years after John Ruskin wrote that famous attack on Whistler's *Nocturne in Black and Gold* another artist was attracting similar criticisms. His name was William Green.

Green entered the public consciousness in 1958, while a student at the Royal College of Art. His sudden fame stemmed from a highly unorthodox and athletic painting technique that placed him squarely in the informal school of abstract art. Instead of applying paint to canvas with brush or knife, Green flung bitumen, sand, acid and paraffin onto a large, primed sheet of board on the floor. He then disturbed the black, oily dribbles and splashes with whatever means were available (most notoriously by dancing on the board and riding his bicycle over it) and set fire to the paraffin. As the bitumen burned, it blistered and bubbled, creating the dark, thick crust of such paintings as *Untitled* (1958, Tate). This process amounted to a series of events

directed by the artist that cultivated chance and accident as pictorial tools, the outcome of which Green described as 'a pattern formed by a series of attacks and gestures at the surface'.[1]

Although he worked with various media and in different disciplines, it was for this extraordinary process that he became known. His celebrity, or infamy, was heightened by a number of short films made in the late 1950s and early 1960s. The first of these was Ken Russell's *Making an Action Painting*, broadcast by the BBC. The sight of a student at one of Britain's most prestigious art colleges behaving in such a way provoked considerable media interest and earned Green a distinguished position in the history of avant-garde scandals.

For all the ridicule his work attracted in the mainstream press, a few critics and artists acknowledged it as a serious endeavour, or at least one that warranted serious discussion. The twin precedents for his strain of informal abstraction were generally cited as being

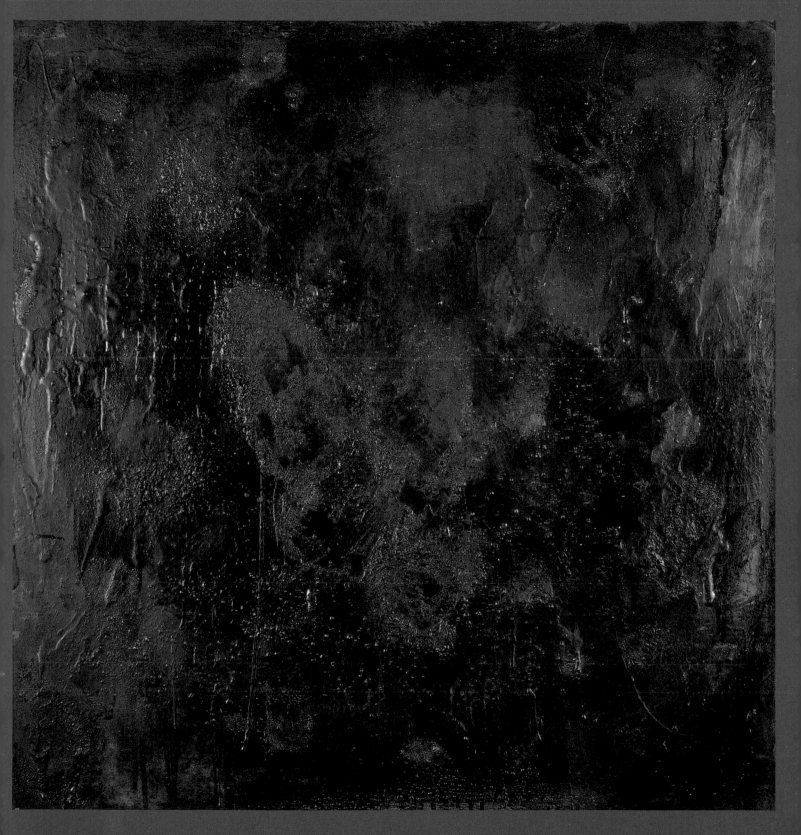

Fig.40
William Green
Untitled 1958
Tate

William Green 43

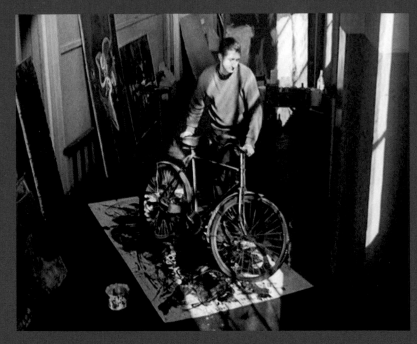

Fig.41
William Green
ITN archive

European tachisme or gestural abstraction and American action painting, particularly the work of Georges Mathieu and Jackson Pollock.

Mathieu, who had developed a highly theatrical form of high-speed abstract painting, placed great emphasis on the unpremeditated gesture as an act of self-expression. In the summer of 1956 he had painted for an audience at the ICA the large abstract picture *Battle of Hastings* in under two hours, while reportedly wearing period costume.[2] The same summer Green made a series of abstract drawings titled *Battle* that shared the frenzied linear motifs of Mathieu's pictures but without the attendant theatricality of his method or the French nationalism of his titles.[3] A year later Green painted *Napoleon's Chest at Moscow* (destroyed), which in its title and scale (5 x 8 feet) was also partly indebted to Mathieu.

The Mathieu show had been preceded earlier in the year by the Tate Gallery's exhibition *Modern Art in the United States*, one room of which concentrated on 'Contemporary Abstract Painting'. The experience of seeing a number of works from the New York school together in one room made a strong impression on many artists of Green's generation. Of the works exhibited, the surface complexities, all-over aesthetic and grand scale of Jackson Pollock *Number 1 1948* seem to have had a direct effect on such paintings as *Napoleon's Chest at Moscow*.

While the formal and technical precedents for Green's work were understood to lie within international abstraction, its content was more elusive. In the absence of narrative or representational depiction some critics struggled to discern any content at all. Lumping all the various strains of informal painting together as 'Action Painting', John Berger, a left-wing critic, characterised it as an art of incoherent protest, one that was impossible to judge by the usual aesthetic criteria or to know what its 'smouldering spirit of revolt' stood for, other than 'the dumb discontent of James Dean'.[4] Others, however, found clues in the allusive titles of the pictures and extrapolated from them a latent Pop sensibility.

Green's enjoyment of consumerism and popular culture, particularly the American variants, was manifest in both his public persona and work. A well-publicised taste for American cars was complemented by picture titles that referred to such icons of US culture as Errol Flynn, Elvis Presley and 'Cotton' Owens (a champion stock car racer) and such noir events in recent American history as the Bobby Greenlease murder.

It was in this context of mass culture media-
ted by film, music and magazines that Green's
work was embedded.

Lawrence Alloway considered Green's paint-
ings, like those of Robyn Denny and Richard
Smith, to be 'an analogue of the man-made
environment'.[5] In his essay '"Pop Art" since
1949', the painterly abstraction of Denny,
Green and Smith was understood to allude
to the visual stimuli of the mass-media urban
environment and to represent the second
phase of Pop in Britain. He wrote: 'It was
not the sunset the abstract painters wanted,
but the flow of neon, the dazzle of high-
style fashion, the envelopment of big-screen
cinema, realized not by one-to-one references
but by colour and scale.'[6] While Green's black
bitumen paintings certainly did not borrow
from the bright pantones of billboard adver-
tising, they were at least in colour, texture
and material closely linked with that ubiqui-
tous matter of the urban scene: grit, oil and
tarmac. More significantly, the elements of
chance and accident which Green's technique
exploited were metaphors for the constant
visual bombardment and unplanned interac-
tions of city life.

Yet while his titles validated these associa-
tions, Green's primary interest remained the
considered disturbance of material, whether
caused by the action of throwing bitumen
onto a board or by fire (or any other element)
as it cracked and cratered a surface. Although
the absence of political radicalism frustrated
Berger, Gustav Metzger was later to cite
Green's activities as a source for his own
auto-destructive art. This acknowledgement
by an artist who developed a coherent theory
about the role of art as an instrument of
political opposition in modern society does
not alter the nature of Green's own apolitical
aims and interests. Green's paintings were
concerned with physical transformation and
change, not with destruction. They offered
an alternative vision of how art might be
made, and far from challenging the basic
tenets of modern society they alluded to
an urban sensibility that revelled in them.

Fig.42
Peter Phillips
The Entertainment
Machine 1961
Tate

'A HIGHLY MOBILE AND PLASTIC ENVIRON'

Barry Curtis

After 1956 British art began to be made and seen in contexts where the signs of a new consumer culture were everywhere apparent. 'Art' was one aspect of a new cultural spectrum shaped by youth, techno-logical and ethical change and the impact of American culture and 'permissiveness'. 'The sixties' is a term used then and now to describe the effects of a long post-war economic boom, a period of optimism, of enthusiasm for modernity, before the economic crises and cultural pessimism of the following decade. In Britain new art was a vivid component of a mass disseminated iconography of innovation.

Kristin Ross's analysis of the modernisation of France in the same period characterises the experience as 'headlong, dramatic and breathless',[1] accompanied by intellectual 'structuralism'. In Britain there was no substantial pre-war avant-garde available for re-evaluation. In many respects British artists were 'absolute beginners', energised and given courage by the scale and boldness of American painting, but they also drew on the reserves of British documentary empiricism and an enthusiasm for science and technology, as well as an ironic and mock-heroic sense of what it meant to 'be British'. The British response to modernisation in the visual arts lacked the methodical politics of structuralism but was profoundly semiotic and was fascinated by the transformation of images and processes of representation.

It is hard to recapture the strong sense Pop culture conveyed at the time of being on the side of those who found art unrewardingly difficult. Pop was colourful, immediate and a release from seriousness and aesthetic values. Like previous avant-gardes, it was assumed by its critics to be indistinguishable from the commercial art of the near past, lacking any meaningful intervention by the artist. This kind of objection has faded with time, but Andreas Huyssen has recently commented on an ambivalence which is now more visible, suggesting that Pop art images were neither representational nor fully simu-lacral. Instead they registered a dimension of anxiety, melancholy and loss.[2]

THE LONG SIXTIES

The period 1958–74 has been described by Arthur Marwick as 'the long sixties',[3] a period which can be subdivided into a prelude which lasted until 1963,[4] the stereotyped 'swinging sixties' or 'high sixties' which lasted until

1968,[5] followed by an aftermath during which the cults and enthusiasms of the earlier periods were widely disseminated and accepted. The 'long sixties' ends with the economic problems associated with the oil crisis and a widely perceived mood of disillusionment and entropy.

These subsidiary 'micro sixties' have been characterised in a number of ways. The radical *International Times* famously reviewed the counterculture as starting like a dove, metamorphosing into a peacock and ending as a hawk. There is an enormous literature, film and discography which testifies to the persistent interest in this period as the origin of many of the preoccupations of the present. Some accounts see it as a glorious rebellion, others as a travesty of the consensus which went before. It was a coming into being of new subjects of history – women, gays, the third world, the working classes and youth, and a turning point in the relation of individuals to the state. For some commentators it was 'a psychic epidemic',[6] 'an impossible utopian dream'.[7] Some regarded it as a triumph of the cultural superstructure over the economic base, an unbinding of capitalism, a necessary restructuring to prepare the ground for the ultimate triumph of consumer culture: Regis Debray saw May 1968 as 'the cradle of a new bourgeois society'.[8] One theorist in the introduction to a book of essays on the sixties suggests that 'The sixties is merely the name we give ... to a disruption of the bourgeois dream of an unproblematic production-controlled consumption.'[9]

Few disagree that the period was marked by a drive towards new kinds of freedom. Berenice Martin, an adversary of the subliminal tendencies of the time, considers most of its freedoms as illusory, involving an unravelling of necessary social bonds. However, even she concedes that the result was an expansion of the frames within which expressive possibilities had been contained. Without doubt, it was a period of liberalisation. There was a programme of 'colonial emancipation' during which the British Empire released its grip on its possessions. Obscenity and discriminatory laws were relaxed. In the demonology of the Right the sixties has remained the decade that gave birth to and nurtured 'enemies within'.

It is significant that Raymond Williams, the last chapter of whose 1961 book *The Long Revolution* was devoted to a consideration of the sixties, formulated a way of seeing social and cultural forces as simultaneously residual, dominant and emergent.[10] He notes the onset of an emergent 'loss of respect' – a refusal both to share opposite points of view and a rejection of existing hierarchies. Williams's dialectic, anthropological approach

related to a number of observable tendencies in the late fifties. He rejected the notion of art as a separate lofty sphere, seeing it as an integrated aspect of more mundane human activities, and he sensed change in the post-war generation. Kenneth Allsop suggested that the end of the fifties in Britain was 'one of History's big traffic jams, with all the combined turbulence of new forces of philosophy, religion, politics and science boiling up against the banks of hardened obsolete thinking'.[11]

Allsop also echoed the widely shared belief that the fifties was the age of 'The Organisation Man, the well adjusted, hedonistic, orthodox committee man', and that the duty of the artist was to 'humanise', to 'exalt the spirit', to maintain communication between the 'free' and to respond to the 'bigger metabolism' of the times — qualities he found lacking in the generation of 'angry young men'.[12] W.T. Lhamon, writing about the fifties in America, rejects the common characterisation of that period as a conformist 'found generation', and notes how 'People were coming out of hibernation'.[13] Lhamon challenges what he calls the 'sixties chauvinists' who fail to recognise that 'In the sixties and after, people ratified the insights of fifties cultural life, popularising them into mass movements'.[14]

Britain in the early fifties was a bleaker, more war-torn place than America. Already familiar with Hollywood, the British public was exposed to transatlantic mass culture both directly through the presence of Americans in Britain and indirectly through images and narratives.[15] There was a samizdat culture of magazines, food, clothes and music which continued to make an impact when imported after the war. Rationing was in force on clothing and certain foods until the middle of the decade and there were severe legal and cultural constraints on behaviour and self-presentation. For a decade after the war American goods and images of goods were magical, 'other' evidence of self-expressive freedoms, but also signs, for some, of degeneration and a portent of 'levelling down'.

YOUTH AND LIBERATION
Britain became a younger country in the years after the war. There was an increase in the birth rate and a focus on education and youth. Between 1956 and 1963 in the time between the Suez crisis and the Profumo affair, the number of fifteen to nineteen-year-olds increased by twenty per cent. The interests and tastes of youth were beginning to interest manufacturers as well as journalists and sociologists. Between 1951 and 1964 British national identity and authority were put in question by a number of events and shifts of power and perception — by

Americanisation, decolonisation, immigration and European integration. Furthermore, the Cold War compromised Britain's pretence to world leadership. This confusion may have contributed some of the creative energy which characterises the times: 'Britain, shorn of its world-wide responsibilities for keeping the peace, has turned its energies previously dissipated in running the colonies inward towards personal self expression.'[16]

Breaking free of constraints, both personal and social, was a priority for the celebrated young cultural producers and interpreters of the period. Hire purchase and an abundance of new goods changed the public's relationship to consumption. Private cars doubled in number between 1955 and 1958, the year that the first parking meters appeared. The last National Service conscript was demobbed

in 1963 and the birth control pill became available from 1961. The labour market was growing and diversifying, with new service industries. Incomes, especially for young people, rose significantly, there was more job security, and a generous system of grants for those in higher education. Angela Carter remembered Britain in the sixties as 'a low rent country with relatively low wages and high taxes',[17] a place where experiments in living frugally could be supplemented by a cosmopolitan awareness of how things were done in other countries and cultures.

There are many testimonies to a shared sense of liberation. The young East End actor Terence Stamp remembers those years as 'like coming out of prison',[18] a metaphoric emergence from a world of monochrome to one of colour. Colour supplements and their photo-features had a particular significance. Colour carried a subliminal charge. The art of the period was particularly extravagant in this respect — no longer tonal but primary and uncompromising. Colour and scale engaged the viewer in more confrontational relationships with objects and images.

Another sign of the times was the use and mood of synthetics which reflected an indifference to conventional materials and the distinctions they implied. The orthodoxies that sustained taste hierarchies were based on notions of appropriate materials and forms. Synthetics destabilised these proprieties and proclaimed convenience, classlessness and homogenisation. The lyrics of The Who's song 'Substitute' speak of the confusion and social anxiety that come with substitution and a suspicion of loss. Making sense of the new promotional culture required a willingness of the artist to inhabit a 'general field of communication',[19] a malleable continuum which could be reshaped without commitment to natural forms and appropriate materials. John McHale has commented on the far-reaching implications of this new simulacral fluidity: 'How may we now regard the expendable replicas of permanent and unique objects? How may we evaluate the ways in which symbolic 'value' may be transferred in different forms, materials and at different sizes and time-scales in quite different media?'[20] McHale goes on to link the rate of change with the profusion of images and stimuli and their function in helping people to locate, learn and adapt, concluding: 'The constant re-creation and renewal of such images matches up to the requirements of a highly mobile and plastic environ.'[21]

The sixties was not simply a time of youth rebellion against an implacable establishment. Political discourses linked affluence with individuality and new kinds of informality.

Fig.46
John Plumb
Edgehill 1962
Tate

Harold Macmillan embraced television as a political medium and celebrated the definitive entry of Britain into a consumer culture with the slogan 'Life is Better under the Conservatives', and there was an enthusiastic promotion of 'Tory Futurism'.[22] With the resurgence of Labour in the early sixties, Harold Wilson and other key members of his party claimed in their modernising rhetoric that the country was living in a jet age but being governed by an Edwardian establishment. They referred to the uneasy tension between tradition and innovation noted by Anthony Sampson in his successive surveys of the British scene.[23] Labour's identification with technological progress and the cause of youth foresaw the need for a kind of cultural conscription: 'This is a time for a breakthrough to an exciting and wonderful period in our history, in which all can and must take part. Our young men and women especially have in their hand the power to change the world. We want the youth of Britain to storm the new frontiers of knowledge, to bring back to Britain that surging adventurous self-confidence and sturdy self-respect.'[24]

In Britain, as in the USA, there was a developing awareness of the dangers of conformity and the necessity for creativity and spontaneity in shaping a new consumer culture. Thomas Frank has comprehensively examined 'the rise of hip consumerism' in America, claiming that the sixties was a time of fantastic ferment in managerial thought and corporate practice.[25] Conformity was the enemy of a thriving consumer culture. He describes the 'cosmic optimism' that fuelled the youth rebellion. The mood of Pop in Britain was by contrast ambivalent. Like other manifestations of British popular culture it was simultaneously futuristic and nostalgic, 'a sense of Englishness which had one foot in the future and one in the past, one half of the brain engaged with the banality of daily life in rainy old England, the other pioneering within extreme states of mind to bring back reports from the edges of consciousness'.[26]

MASS AND POPULAR CULTURE

Opponents of mass culture were particularly critical of its capacity to over-simplify and over-elaborate. Indifference and inappropriateness were seen as the reprehensible characteristics of commercial culture and America was deemed the chief source of a contamination that involved cultural texts being subject to planned obsolescence and generic production like any other mundane consumer product. Richard Hoggart was particularly critical of the fantasy element in the relationship to American popular culture, writing of the new sub-cultural youth of the late fifties:

Their clothes, their hair styles, their facial expressions all indicate (that they) are living to a large extent in a myth world compounded of a few simple elements which they take to be American life.[27]

Those artists who enjoyed the products of American culture raised a number of objections to this way of thinking. Firstly, it showed no interest in the 'same but different' nature of genre production that many young artists found fascinating for its combination of mythic themes, grandeur and detailed mise en scène. Secondly, the critics of mass culture were rarely interested in the way it was consumed and assimilated. Thirdly, there was no acknowledgement that mass culture was more than an entertainment or a passive dream world. For Lawrence Alloway, it was a 'treasury of orientation, a manual of one's occupancy of the twentieth century', a necessity in a world where access to new media and travel seemed to be accelerating the rate of information and change.[28]

For the avant-garde to establish priorities and programmes, some kind of pantheon of influential precursors has always been necessary. Many seminal texts of the sixties contain imposing lists or complex collaged information about makers and markers. Richard Hamilton's well known *Just what is it that makes today's homes...* (fig.3), Peter Blake's *Sgt Pepper* cover (fig.47), Adrian Henri's poem *Me* and popular books set the scene for protest and alternative cultures.[29] Transgression needs to draw on diverse sources and there was little access to those through conventional education. Even at university level most syllabuses stopped well short of the present day, and one of the key demands of students in the unrest leading up to the protests of 1968 was for contemporary

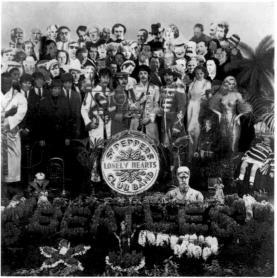

Fig.47
Cover for The Beatles'
Sgt Pepper's Lonely
Hearts Club Band 1967
Photograph by Michael
Cooper, conceived by
Peter Blake with Jann
Haworth

Fig.48
David Hockney
<u>**Man in Shower in**</u>
<u>**Beverly Hills 1964**</u>
Tate

relevance and an interdisciplinary approach to learning. Their protests were met by an increase in modular and contextual studies.

The generation of the sixties had new ways of using culture. Deploying everyday ideas, objects and experiences as creative sources and materials indicates a rejection of Matthew Arnold's formulation of culture as an uplifting model of the best. The popular culture of the sixties saw a re-evaluation of transformative notions that drew on the tradition of Oscar Wilde and an engagement with art as a model for everyday life.

As has always been the case for the culturally or socially excluded, many sixties artists were informally educated autodidacts and their random approach to knowledge is evident in the strange juxtapositions in their work. There was substantially improved access to original texts through key bookshops like Tiranti's, Better Books and Compendium[30] in London and small eclectic traders in cities and towns throughout Britain, as well as to a growing 'underground press'.[31] Reyner Banham, writing of the early days of 'reprocessing culture', uses the agricultural metaphor of 'tilth' to describe this matrix

of dense information and the activity of cultivating new hybrids: 'They [the Goon/Pop generation] were vastly better informed about a vastly greater range of art than any previous generation because of Penguin, Skira, Phaidon and the public library system.'[32]

HUMOUR AND PLAY

The voices of public authority and the way they pronounced on morality and culture were prime targets for humour in the sixties, from the absurdity of the Goons to the satire of Beyond the Fringe. One of the imperatives when making any break with tradition is to judge what is to be taken seriously and what, therefore, becomes absurd. Lawrence Alloway suggested that a reassessment of what was worthy of attention and respect was required, 'to take Pop culture out of the realm of "escapism", "sheer entertainment", "relaxation" and to treat it with the seriousness of art'.[33] For many of the would-be participants in the newly visible culture the opportunities for self-presentation and expression were eagerly sought but difficult to manage. Much of the mainstream humour of the sixties was situational and based on the contradictory nature of striving and pretention. Hancock, Steptoe and the mock heroics of the cultural outsider provided an ironic commentary on the differences between classes and generations. The middlebrow was particularly vulnerable to the mockery of both the vulgar and the intelligentsia.

Humour became a significant factor in visual art at a number of levels. The most obvious humorous disruption was in the introduction of trivial or marginal objects into an artistic milieu, and many other kinds of transgression and irony resulted. Humour took the form of unexpected juxtapositions of objects and satirical comment.

Play also came into prominence as a creative strategy, as conventions of maturity were dismantled. Playfulness as an aspect of creativity gained significance with a move towards sensual and tactile pleasures, a shift which theorists like Marshall McLuhan and later Susan Sontag favoured into a more phenomenological relation to life and art. In psychoanalytic theory play was a way of dismantling the components of the world and reconfiguring them. In the influential book *Homo Ludens*, read by members of the Independent Group of artists, including Hamilton, Paolozzi, Banham and Alloway, play was conceived as a poetic process, a mental activity distinct from thought, divorced from interpretation. Play was closely allied to the impact of new technologies, which, it was felt, restored the centrality of bodily states and impulses. It did not seek to discriminate or define. Richard

Hamilton described this turn towards acceptance: 'What is needed is not a definition of meaningful imagery but the development of our perceptive potentialities to accept and utilise the continued enrichment of visual material.'[34] Although 'gaming' had some fascinating, if uneasy, associations with military technologies and planning, there was a re-evaluation of play — an acknowledgement of the innocence and directness of childhood as an escape from social conventions and constraints. Mary Quant described this mood in a statement about her approach to designing: 'Children were free and sane and grown-ups were hideous.'[35]

COLLAGE AND CONSUMPTION

Collage was a visual register of the playful aesthetic and often demonstrated the artist's interest in words as pictorial objects. Collage enjoyed a long and subversive history in modernist art, but its characteristic use in Britain

Fig.49
Eduardo Paolozzi
It's a Psychological
Fact Pleasure Helps
Your Disposition 1948
Tate

Fig.50
Colin Self
Bomber No.1 1963
Tate

in the post-war years in graphic design and fine art drew attention to the abundance and variety of the material culture from which the images were drawn. Collages not only gathered and travestied objects of mass culture, but also replicated their densely textured and random appearance as a backdrop to everyday life. Terry Atkinson made the point that the British tended to be more eclectic, personal and whimsical than Americans in their art strategies.[36] In the context of the period 1958–74, collage served as a format for transgressions of boundaries of taste and classification. It also established a solidarity with the informal art of the streets and with the practices of delinquents and children. On the other hand, it was in complete conformity with the work of the intelligent consumer, gathering information from a number of sources, making comparisons and judgements. It is perhaps significant that *Which?* magazine, first issued in 1957, arranged images of consumer goods for comparison, albeit in a more orderly and pragmatic fashion.

The process of collage enabled artists to comment not only on objects and their inter-relations, but also to compare various processes of representation. Pop art mediated between individual taste and mass consumption and the works frequently served as commentaries on appearance and performance. Richard Hamilton described the complex multi-media process of making a 'painting': Work began as an assemblage assisted with paint, was then photographed, the photography modified and a final print made, which was then added to paint and collage.[37]

The 'intelligent consumer' was a vital new social phenomenon, which artists could identify and propagate through their work.

One of the characteristics of sixties culture was the participation of the audience. This was most vividly played out in the theatre and the Brechtian baring of the technology of television studios pioneered by the popular peak-hour programmes *That Was the Week That Was* and *Ready Steady Go*. The agency of the viewer was promoted in a number of ways reflected in the popularity of terms like 'focus', 'close-up' and 'point of view' which began to appear in popular journalism to direct attention to situations and events. The new satirical magazine *Private Eye* revelled in the insights of investigative journalism, particularly of the new photo-journalism that emerged in this period. Audiences developed new forms of expertise, new niche enthusiasms and skills of interpretation. Greg Taylor has made the point that film audiences acquired some of the critical expertise that had previously been the preserve of avant-garde critics. He describes the shift that took place as an 'empowering culture of decentralized institutions, destabilised discourses and dispersed audiences'.[38]

New ways of looking which were incorporated into the artworks of the period involved a rediscovery of earlier modes of subjectivity. Reyner Banham's advocacy of Futurism which informed his PhD and his seminal post Purist re-evaluation of Modern architecture was indicative of a new way of inhabiting the dynamic imagery of the everyday urban landscape.[39] In very much that mood Robert Freeman accompanied a collection of his photographs of city life by a commentary in which he described the environment as: 'Not a landscape ... but a shifting complex of visual experience ... a continuous fusion of things seen.'[40]

The 'image' was in the process of becoming economically as well as culturally significant in this period. The use of the term reflects the increasingly conceptual nature of social goods and the way they were used to create 'a Look'. The growing influence of television and magazines in providing information and aspiration was confirmed by the introduction of commercial television. The 'image' was increasingly associated with a sense of presentational and promotional detachment from the object. As photographs became increasingly disseminated and began to diverge from a longstanding realist style, new kinds of camera — 35mm single lens reflex, faster exposure film and longer and wider lenses — provided more subjectively formatted, unfamiliar and unresolved images.

British artists had strong interests in science and technology. This is particularly evident in the work of the Independent Group, in

their reading and in the technological raiding that was so characteristic of their exhibitions held at the ICA and the Whitechapel Gallery in the fifties. The 1953 *Parallel of Life and Art* exhibition was dedicated to dissolving the differences between nature and culture and art and science. It was an extension of the tradition of popular understanding of science that was so much a part of the Festival of Britain in 1951, but it was also highly attentive to the avant-garde of military industrial innovation — a notable feature of the work of Colin Self but also characteristic of many other artists. The enthusiasm for the imagery of mass culture was accompanied by a sophisticated awareness of the technologies which mediated it. Richard Hamilton's art was informed by his interest in such phenomena as technicolour and wide-screen film formats, as well as polaroid cameras and car engineering.[41]

Another way of accessing marginal and transgressive approaches to mass and elite culture was through contact with established and almost inevitably middle-class members of British Bohemia. As Mick Jagger has testified, 'The sixties didn't come out of nowhere — gay and art loving Soho and Mayfair — educated and prepared to pass it on.'[42] The art dealer Robert Fraser, a well-educated ex-Guards officer, was one of the many conduits, as was Alexander Plunkett Green who helped Mary Quant focus her creative energies, and Kit Lambert who guided The Who. Nigel Henderson was well connected both to the Bloomsbury Group and the work of the Mass Observation artists. His mother ran the Peggy Guggenheim gallery in London and through her he gained access to many of the major figures of European modernism. Henderson, an ex bomber pilot, with Reyner Banham, who had trained as an aircraft engineer, Richard Hamilton, who had worked as a draughtsman, and Toni del Renzio, an art editor and well-connected writer, together provided the generous range of reference and creative energies in the formative activities of the Independent Group, and contributed to its extensive influence. Almost any investigation into the inspirational and material sources for the creative work of the period shows similar complex syntheses across class, regions and disciplines.

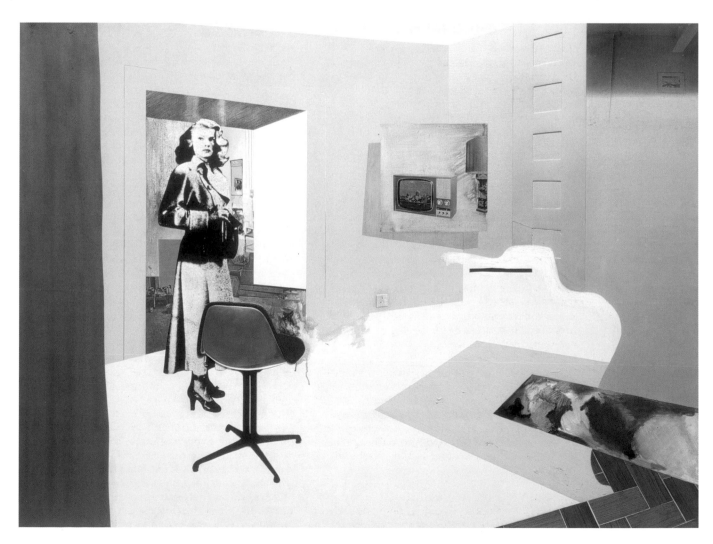

Fig.51
Richard Hamilton
Interior II 1964
Tate

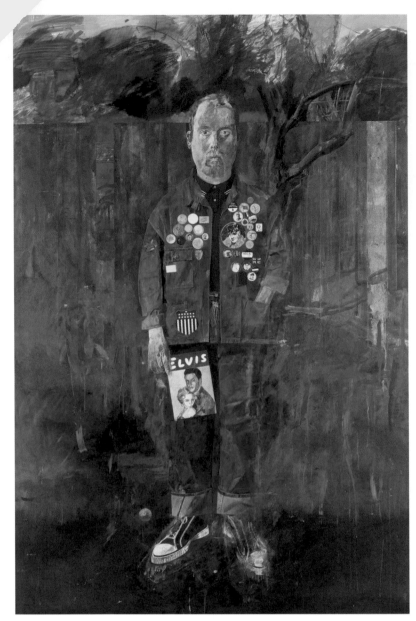

Fig.52
Peter Blake
**Self-Portrait with
Badges** 1961
Tate

between art and advertising: 'Ads are packed with information – data of a way of life and a standard of living which they are simultaneously inventing and documenting.'[45] Art became an area of research and development for new public commercial imagery. There were strong links between the worlds of two generations of British Pop art and the advertising and media production industries. The Independent Group sessions at the ICA often drew on the expertise of record producers, industrial designers and magazine publishers. Students at the Royal College of Art, at the time when public attention was being focused on their success as 'young British artists', were encouraged to cross departmental boundaries. As a result, some of the students from the graphics course, who took their imagery and style into the growing commercial sector of magazine design, had been in close contact with fine art students. Other Royal College students became influential teachers who promoted an interdisciplinary approach in art colleges throughout Britain. Thomas Crow has cited the breakdown of formal artistic and commercial boundaries as a distinctive characteristic of the period, resulting from a willingness to withdraw 'from the heroic model of artistic selfhood'.[46] Artists were free to admire, learn from and contribute to everyday design projects and to assimilate and be assimilated by a consumer culture.

Consumer goods and shops in Britain were changing. In 1958 there were 175 supermarkets in Britain, by 1960 there were 367, and by 1971 there were 4,800.[47] As in America, goods were increasingly presented as lifestyle choices that expressed the identity of the consumer. Packaging became dedicated to competitive impact, and was less to do with contents and increasingly intended to relay messages about values that were reinforced by images and ideas generated in other media. Visual promotions of goods, which presented products in ideal situations of consumption and use, were the subject of fascination for many young artists at the time. Consumer goods were increasingly offering intense and immediate satisfactions (and disappointments).[48] Max Kozloff described the art of the time as sharing with products 'an emotional veneer' which promoted a new kind of consuming detachment.[49]

URBAN REALISMS

Pop was largely a London-based phenomenon, mediated easily through magazine cover images, studio photos and interviews. It is evident from articles in the popular press that the artists, often posing in front of their paintings and sculpture, could be presented in similar ways to pop groups, film stars and other media celebrities. Pop and its

Colour supplements were particularly important in the ways in which they disseminated cultural information to a larger audience.[43] They provided a context within which the art of the period could find wider audiences and they embedded painting and sculpture in a context of interior decoration and 'lifestyle'. Andrew Ross has pointed out that from the early fifties, television in the US started acquiring and showing the back catalogue of Hollywood studios so that what had been the viewing practices of esoteric cultists became accessible to all.[44] For British artists and designers in the immediate postwar years, advertisements were magically condensed fragments of information. They constituted the material for Eduardo Paolozzi's foundational collages. The architects Alison and Peter Smithson were fascinated by adverts and the relationship

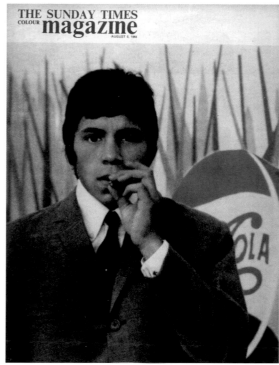

Fig.53
Robert Freeman
Covers for The
Sunday Times
Magazine, 8 April 1962,
2 August 1964
The Sunday Times
archive

accessories sat easily among advertisements and articles on domestic consumption. The large format book *Private View*, edited jointly by Bryan Robertson, John Russell and Lord Snowdon, was an ambitious survey of British art at a time when London had suddenly become one of the world's three capitals of art.[50] The opening essay celebrates the vitality of London in the mid-sixties, and the book stresses the 'permissiveness' of the milieu — the development of an artistic practice which is hybrid and interactive.

ART AND THE SELF

For young people with limited resources, dress was an immediate way to establish a personal artistic practice. The 'apeing' of Hollywood fashions had been the object of much cultural criticism. The 'Teddy Boys' were an early sign of working-class youth appropriating a fashionable style intended for upper- and middle-class men. Pearl Binder, in her study of masculine dress, was alert to this: 'What is worth noting is that it is a real attempt at gentlemanly dress ... something far more in common with the dandies of the last century that might have been expected from this generation of youth brought up entirely on American tough movies and American comics.'[51]

Many of the artists of the sixties were modernists who were interested in style. Like other young people they were aware of shops which sold American clothing, or catered for gay consumers. In 1956 Cecil Gee's shop in Tottenham Court Road started stocking Italian clothes. A year earlier Mary Quant had opened 'Bazaar', and the following year John Stephen opened his first shop in Carnaby Street. Inspirational modern jazz performers appeared in London wearing 'Ivy League' clothes — covetable, smart, perfectly cut and detailed jackets and shirts, themselves a translated version of British aristocratic clothing.

An emerging youth culture assimilated elements from both gay and West Indian style. By the mid-sixties, Peter Burton's descriptions of the gay culture of the West End — its tastes, styles, drugs and language — were one aspect of a wider subculture shared by thousands of young people and transmitted to countless others by dedicated elements of the new media.[52] As Jonathan Rose has remarked, Bohemian cultures had always served the bourgeois as a laboratory for research into new sensibilities.[53] What was new in the sixties was that the research was more widely disseminated and became inspirational to ordinary people. Kevin Davey has described how 'mods' 'improvised a popular transnational habitus ... After work at the weekends they vacated wherever possible the residual spaces of Imperial and Churchillian Britain where the colonial imagination still held sway.'[54]

For young artists the importance of dress and haircuts was an aspect of their identification with professionalism and an implicit rejection of the dilettantism and amateurism which they felt had such a strong hold on

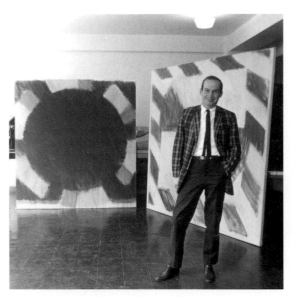

British painting and the traditions of British art education. The Coldstream Report, a late reaction to Cold War anxieties about the superior technological progress of the Soviet Bloc, sought to professionalise art education. One aspect of this was to increase students' awareness of the history of art and related subjects.

EDUCATION AND COMMUNICATION

Sixties artists were mostly working class and almost exclusively first generation college students. By 1969 there were three times as many universities as there had been thirty years earlier and four times as many students. State contributions to higher education totalled £7 million in 1946, rising to £157 million in 1966. The number of students doubled in the sixties from 7 to 14 per cent of the population and there was a particular increase in arts subjects. It was a period in which art colleges constituted an extraordinary state-funded experiment: 'Britain had by accident bred a class of young people from ordinary homes who now had some idea of the privileges previously enjoyed only by boys from upper-class families.'[55]

Art colleges experienced a period of rapid change in the fifties and sixties, sharing in the general expansion of higher education and energised by tensions between traditional studio teaching and new enthusiasms for popular media. Thomas Crow has characterised the work of the sixties generation as distinctively different from previous art workers, concerned as they were with condensing 'concepts into dense visual icons, non linear arrays of objects in space, unrepeatable events and activist interventions'.[56] From the mid-fifties there was a widely shared awareness of the presence of a dynamic new musical, visual and literary culture originating in America.

Robyn Denny, then in the Fine Art Department at the RCA, commented: 'Something was happening which had nothing to do with received values ... which was our own property that wasn't something we'd been told or learned about.'[57] A culture of youth was emerging, and there was a new emphasis on experience and engagement in a complex, interactive, sensory way with the visual messages that were becoming part of everyday life. The development of a mature consumer culture, the increase in hire purchase (the hire-purchase debt increased tenfold in the fifties) and a more comprehensive range of goods and services changed the nature of consumption and its relation to personal expression. The future that young people were facing was not the unproblematic process of ageing and resignation they perceived as their parents' fate, but involved mobility and aspiration underpinned by the forward march of technology and empowerment. Students were objects of interest to the general public. Articles on the new universities and the new art-student celebrities appeared in the colour supplements and on television. There was a particular demand for subjects which could help to make sense of the prominence and ubiquity of media and communications.

The articulation of mechanism, fantasy and volition is apparent in the Archigram Group's formula of 'control' and 'choice'. This was the dynamic promise of consumer capitalism. American culture was an object of interest for young creative people in the sixties. The previous generation had seen the infiltration of American culture as a sign of aggression and indifference, but in the sixties access to American art and culture had a powerful effect on artists who discovered new models of scale and ambition. In 1975 Robert Hughes described what American culture offered to Richard Smith: 'When Englishmen of Smith's generation (he is now 44) started looking to America, what caught their eye was less the painterly heroics of abstract expressionism than the 'media landscape' ... Though as a painter he was not interested in the icons of popular culture, Smith was fascinated by its mechanics.'[58]

Pop was a complex phenomenon, and is increasingly so as it recedes in time. It was particularly concerned with what Lawrence Alloway described as a 'drama of possessions' – the realisation of the environment as a mise en scène and an education in how to participate as a consumer. Pop art and its objects aspired to the pleasures associated with goods, the aethetics and tactility of colours, forms, edges and surfaces. Anthony Caro among others appreciated the professionalism of American art and design and expressed a need to move away from 'encrusted art-like

objects'.[59] The desire for art to occupy an intermediate space between art and life was expressed in many ways, through its subject matter, the different modes of its mediation, and even through its dissemination by way of multiples and new processes of reproduction – all of which effaced the facture of the artist and outmanoeuvered the auratic status of art.

The world that artists and their audiences were seeking to assimilate was not the vapid, passively consumed 'phantasmagoria of passing shows and vicarious stimulations'.[60] They sought to incorporate it materially and knowledgeably as a highly detailed environment which could be sampled and remixed. In the process, the practice of art tended to shift from the confessional to the observational. Pop artists reflected a more general mood, described by Susan Sontag as 'against interpretation'. Allan Kaprow, reacting against the sublimity of the New York School, urged artists: 'We must become preoccupied

with, and even dazzled by the space and objects of our everyday life.'[61] His attitude was repeated in statements by Rauschenberg, Oldenberg, Robert Venturi, Archigram and other practitioners of the sixties. Although much more critical of the spectacular appearances of consumer capitalism, there was a similar underlying tendency in French radicalism that was derived from the influential work of the philosopher Henri Lefebvre.

The centrality of the theories of 'comunication' became an important justification in the sixties for revising the role of the artist and the scope and format of artwork.[62] The ideas of Marshall McLuhan had been particularly important, not just through his books, starting with *The Mechanical Bride* in the early fifties, but through the many reviews and interpretations of his work. McLuhan drew attention to the full context of message creation at a time when artists were

Fig.55
Pauline Boty
The Only Blonde
in the World 1963
Tate

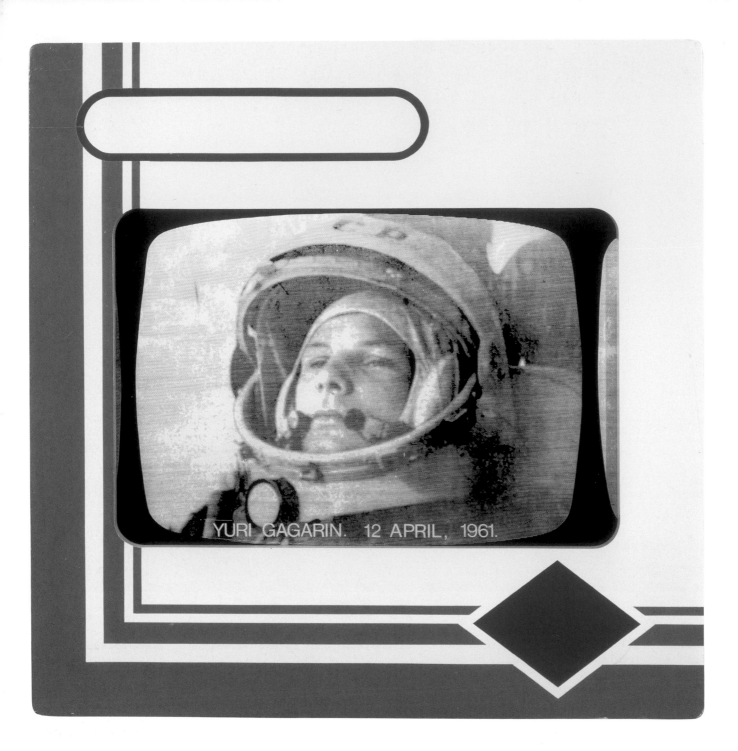

Fig.56
Joe Tilson
Transparency I: Yuri
Gagarin 12 April 1961
1968
Tate

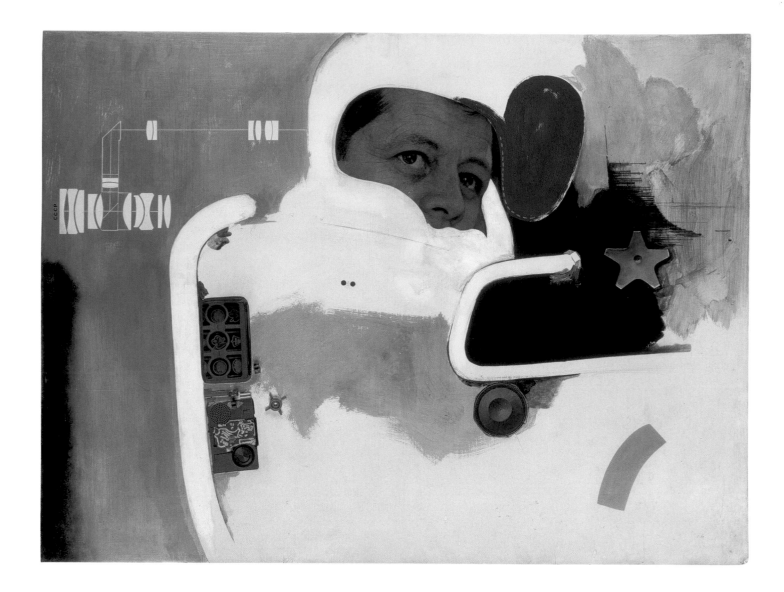

increasingly responsible not only for producing their work but managing its dissemination and participating in its exhibition and interpretation. When the term 'communication' first appears in contemporary literature it bears a meaning that is both efficient and technical but at the same time promises no less than a restoration of the imaginative enchantment of primitive wholeness. Communication stressed the importance of transcending category boundaries in art and responding to the accelerated technologies of travel and information transfer that were driving the generation and consumption of goods and images.

It was McLuhan who noted a shift in technology from the hardware to software, from rockets to digits: 'As the technologies of men converted the planet into a garbage dump, Sputnik pushed the process to the reversal point, bringing in the age of ecology and programming.'[63] This distinction is visible

in art in the later sixties in an increasing concern for systems and process over materials and images. Derek Boshier suggested a similar kind of progression, which is also characteristic of a number of the artists in the current exhibition. Of his abstract work in the mid-sixties, he stated: 'My (recent) paintings are still a continuation from earlier, more figurative work, but the formal qualities have changed. All the images I use in this new work are very much to do with "presentation", the idea of projection — rather like the phrase "Twentieth Century Fox presents" in the movies. All these images come from a social condition or set up notably in advertising — the blown up images, the "larger than life" kind of production.'[64]

Where the medium is the most important determinant of meaning, the object of representation becomes relative. Pop art reflected this tendency through its fascination with multiples and the banal. Pop practitioners

Fig.57
Richard Hamilton
Towards a definitive
statement on the
coming trends in men's
wear and accessories
(a) Together let us
explore the stars 1962
Tate

Fig.58
Cover of Living Arts 2
(1963). Photograph
by Robert Freeman of
Richard Hamilton and
the tableau he arranged
to accompany his
article 'Urbane Image'

renounced the authority of the artist as well
as the idea of an art object as unique and
scarce. The consequences of the work of
groups like Fluxus, Destruction in Art and
Arte Povera were to make art commonplace
and disposable. The idea of 'communication'
forced artists to examine their responsibilities
and function. The experience of living in
a world of eye-catching imagery is a theme
that many of them return to in explaining
the drive to juxtapose or investigate media-
tion, surfaces and impact. They describe
a kind of technological synaesthesia which
parallels the growing interest in alternative
states of mind and psychedelia.

Marshall McLuhan also suggested a particu-
lar role for the artist: 'A whirling phantas-
magoria can be grasped only when arrested
for contemplation and this very arrest is also
a release from the usual participation.'[65] The
ways in which pop art made these 'arrests'
implied the interdependence of images within
a matrix. The democracy of images, which
Alloway and the Smithsons advocated, was
reflected in the new metaphors for 'studio' —
factory, office, shop — and in a new aesthetic
of archival retrieval, cut-and-paste and avatar
which was a premonition of the computer
age. The 'studio art' which Pop was reacting

against was recognisably conventional in terms of the way that artists and critics discussed the sublime and spiritual elements in their work. Harold Rosenberg's notion of painting involving 'risk that leads to the farther side of the object and the outer spaces of consciousness' is consistent with the heroic language of new frontiers, the cold war, and the space programme.[66] Pop, however, was already entering a realm of information and interchangeability.

The Independent Group was interested in form and organisation from very early in the post-war period. In the fifties exhibitions which they curated and organised, there is a clear ideal form and mechanical evolution, following the lead of writers like Kepes and Moholy Nagy, who underwrote Modernist art practice by reference to biological and chemical forms. Increasingly the entry into a Pop mode of reference places more emphasis on organisation as a provisional and dynamic activity — more in keeping with the commercial practices of planned obsolescence, what Reyner Banham called 'fantastic realism'.[67] Art in the sixties was exploring the density and ambivalence of visual information at a time when Norbert Weiner was suggesting that the more entropic and unpredictable the message, the more information it provides.[68] Pop was at the cutting edge of experimentation in increasing the density of messages by integrating the artists' personal gestures with the shared mythos of modern industrial society.

❉

What does it mean to look back forty years to the sixties? One of the lasting legacies of Pop was the release of artists from the expectation of particular kinds of originality and, after Duchamp, indicating ways in which s/he could become a medium, a bricoleur, an irritant, an ironist, a curator — someone who draws attention to what is specific and what is indifferent in the world of objects and sensations. The art of the sixties was fascinated by the tensions between image and the ways in which they were made public, tensions which have probably been resolved and integrated in a more seamless media environment. The ideologues of Postmodernism commented on the 'flattening' and 'loss of affect' which much sixties art had already commented on, and probably contributed to.

There was no neat conclusion to 'the sixties' but by the early seventies a number of other aspects of our present began to appear. Many attempts to summarise the new decade of the seventies used metaphors of 'hangover' and 'aftermath'. The most distinctive change was a result of the Yom Kippur war of 1973 and the fourfold increase in the cost of oil which was one of the causes of inflation and the worst world recession since 1945. Another theme which emerged in the late sixties was a sense of entropy with regard to the environment — ecology and conservation brought about a questioning of the long-term visionary optimism which had accompanied technological change. New problems emerged for artists in representing the immaterial and analysing the software of existence. This prompted a more intensive, complex and contradictory challenge to the principles of Modernism. One of the reasons for the continuing sense of 'the sixties' as a uniquely influential period was already evident to a number of commentators writing at the end of that decade. Christopher Booker claimed in 1969:

> It was hardly suprising that this phase of exhaustion should have come about in the late Sixties. For the further the years 1955–66 faded into the past, the more clearly they could be seen as an inevitably violent phase of transition between one sort of Britain and another, the coincidence of a series of factors, social, political and psychological which could never be repeated.[69]

COLIN SELF AND THE BOMB

Ben Tufnell

On 6 August 1945 the first atomic bomb was dropped by an American B-29 bomber on the Japanese city of Hiroshima, causing 135,000 casualties. Three days later a second bomb was dropped on Nagasaki, ending the Second World War. In the ensuing decades the United States, Russia, Britain, France and China all carried out extensive nuclear testing and by the end of the 1950s the Cold War meant that stockpiling of nuclear weaponry had reached frightening proportions.[1] In 1958 the first American nuclear missiles were deployed on British soil, at Lakenheath in Suffolk.

Earlier that year, on 17 February 1958, the first public meeting of the Campaign for Nuclear Disarmament (CND), at the Central Hall, Westminster, was attended by 5,000 people. This was followed at Easter by the first of the annual peace marches to the Atomic Weapons Establishment at Aldermaston. CND grew quickly and by 1960 there were 500 local groups, 100 college branches and 160 youth groups. At Easter 1960, 100,000 demonstrators gathered in Trafalgar Square. In 1962 the worst fears of the protesters were almost realised as the Cold War entered its most terrifying phase. On 22 October Kennedy announced that Soviet nuclear missiles had been discovered on Cuba, just ninety miles off the coast of Florida, provoking a diplomatic crisis. After a tense face-off during which Cuba was blockaded, the situation was resolved by Khrushchev's undertaking to decommission the missiles, and a reciprocal agreement by the Americans to withdraw missiles from Turkey.

Given this context it is perhaps surprising how little nuclear imagery appears in the art of the period. Sexuality, civil rights, Cuba, the Vietnam War and other issues appear in work by Hockney, Hamilton, Kitaj, Tilson and others, but the nuclear threat is conspicuous for its absence.[2] One possible explanation is that the bomb was perceived as American and many of the British artists aligned with Pop were engaged with a celebration of American culture.[3] Richard Hamilton, a committed protester who marched to Aldermaston and who was arrested at the CND Holy Loch 'sit down' protest in 1961, resolved this personal conflict of interests by reportedly marching with a life-size cut-out of Marilyn Monroe.

However, there were two British artists for whom the issue was central. Colin Self and Gustav Metzger each responded to the arms race in radically different ways. For Metzger who, with Bertrand Russell, was a founding member of the Committee of 100,[4] the nuclear threat was one of a series of conditions that motivated and informed his theories of Auto-Destructive Art, in which the predetermined disintegration of the work mirrors the status of a society careering towards extinction. As he said, 'Auto Destructive art is an attack on capitalist values and the drive to nuclear annihilation.'[5] In David Alan Mellor's analysis, Metzger's acid-on-nylon works powerfully articulated nuclear paranoia: 'The tattered threads of nylon fabric attacked by hydrochloric acid carried a parable of the body under nuclear threat.'[6]

Fig.59
Colin Self
Leopardskin Nuclear
Bomber No.2 1963
Tate

Metzger's work addresses the nuclear threat obliquely and conceptually. In Self's work, however, atomic weaponry, the prospect of Mutually Assured Destruction (MAD) and the fear it induced became the frame of reference through which the world was visualised. Indeed, nuclear paranoia pervades his work from 1962 to the end of the sixties. It is like a dye that colours everything he does. Thus cars, furnishings and even hot dogs become symbols of the nuclear age: an entire society and its artefacts is irradiated by fear. Against a backdrop of imminent annihilation Self saw his work as a visual diary, documentation of the cause of extinction.

Unlike many of his contemporaries, Self didn't read any of Bertrand Russell's texts arguing against the bomb, such as *Has Man a Future?* (1961). He was too scared. For the same reason he wasn't a member of CND and he didn't go on the marches: the issue seemed too vast to confront directly. Every time he watched television or opened a newspaper it seemed there was something about Russian nuclear tests or further deployments of American missiles. The nuclear threat appeared to be omnipresent. For Self, 'it

was as if there was nowhere to hide'.[7] Unable to speak to anyone about his fears, he experienced a kind of 'psychological shut-down' that only lifted when Kennedy and Khrushchev exchanged peace documents after the Cuban Missile Crisis in 1962. This moment of hope 'acted like a drop of oil on a machine that was seized up', and afterwards he began to address the subject directly in his work.

Self's work from 1962 onwards is characterised by an extraordinary intensity. In it the facts of everyday life and contemporary obsessions with glamour are juxtaposed with images of mechanised weaponry and animal aggression to produce powerful statements about the fragility and absurdity of contemporary society. His works addressing this theme include paintings such as *Two Waiting Women and B58 Nuclear Bomber* (1963, Private Collection); sculptures such as the horrific *Nuclear Victim* (1966, Imperial War Museum) – the charred, blackened corpse of a glamour model – and countless prints and drawings. In the *Mortal Combat* series (1963–6), humans and animals are deadlocked together in combat. In the hyper-detailed pencil drawings of the *Fall-out Shelter* series (1965), scenes

from contemporary American life — a woman eating a hot-dog, another on an exercise machine — are depicted with the signs for fall-out shelters, reminding us that the threat is all pervading and ever-present.

The grotesque, feral *Leopardskin Nuclear Bomber No.2* (fig.59), and the hallucinatory *Guard Dog on a Missile Base No.1* (fig.60) are two of Self's most effective evocations of the nuclear theme. In the summer of 1959 Self had stayed on a farm near the American Base close to Brandon in Norfolk. Huge Thor nuclear Intercontinental Ballistic Missiles were clearly visible on the base, pointing at the sky, impressive and terrifying. The farm was close enough that at night Self could hear the guard dogs howling 'like wolves'. Thus 'the conceptual idea of nuclear warfare became mixed with that of animal nature and aggression'. Inspired by that incident, the drawing, in which the dog lunges forward at the viewer against a backdrop of schematised Bloodhound Surface-to-Air missiles, presents a powerful image of Cold War militarism. The bomber is a more visceral imagining, a mutant collision of animal and military aggression. As well as a threatening presence, it is also disturbingly sexual, its tapered fuselage pink and phallic. These works appear now to be powerful indictments, yet Self did not conceive of them as acts of protest; they were rather intended as a record of a time and a way of thinking.

Such attitudes colour Self's work from 1962 onwards. At the end of the decade he made the ambitious work which represents his most complete engagement with the theme, *1,000 Temporary Objects of Our Time*. This vast series — over 1,000 insubstantial images made using spray guns — seem to document a civilisation in the process of vaporisation. One of the most striking images is that of a nude. Hunched, compressed, it recalls the thermal shadows of objects and people photographed at Hiroshima in the aftermath of the bombing there. This extraordinary attempt to document and articulate the realities of the post-nuclear age has yet to be exhibited in its entirety.

Fig.60
Colin Self
Guard Dog on a Missile
Base No.1 1965
Tate

REALISM, SATIRE, BLOW-UPS: PHOTOGRAPHY AND THE CULTURE OF SOCIAL MODERNISATION

David Alan Mellor

British photography between 1956 and 1968, came to represent different social spaces and identities, and showed emerging forms of cultural politics which disrupted established modes. By examining four successive moments from across this period – a time of Realism; the disjunctive episode of satire; the production of Pop and finally the crisis of the late sixties – we might be able to trace some transformations in photographic form and its social roles.

KINDS OF REALISM, 1956—68

ROGER MAYNE AND THE CITY STREETS

In the late fifties and early sixties three photographers, Roger Mayne, Don McCullin and David Bailey, were working within a Realist framework. Implicit in their shared language of urban Realism was a negotiation of the challenges of a society which was undergoing a process of modernisation,

a process both dislocating and exhilarating. The dancing vitalities of the North Kensington inner-city streets, made into a visual urban folklore by Mayne's attention to patterns of children's games and play, together with informal portraits of Teddy Boys, lent a lyrical and visceral aspect to Mayne's photographs in 1956. *Photographs from London* was the title of Mayne's first one-man exhibition in the Members' Room at the Institute of Contemporary Arts in Dover Street in July 1956, an exhibition which was likely to have been authorised by Lawrence Alloway, the formulator of an emerging body of critical writing around the area of mass media and popular culture. Theories of urban games were to be important in the development of a form of Situationist-based art at the end of the decade, but Mayne's photography, in its rough mapping of social behaviour and costume, also related to an older tradition of photographed and filmed anthropological

Fig.61
John Cowan
Flying High (Jill Kennington) 1966
Philippe Garner,
Courtesy John Cowan
Archive

social documentary typified by the late 1930s Mass Observation movement. The sedimentation of history and social experience was now under threat from one of the key elements of post-war Welfareist modernisation: re-housing. Five years after his open and informal street documentary of Southam Street in North Kensington, Mayne photographed the constrictions of perhaps the most ambitious civic project of high-rise housing at Park Hill, in Sheffield.

It was significant that Southam Street suggested a countervailing view to that of modernisation. Mayne's photographs summoned up a particularly Romantic model of an urban community — Italianate, ruined, picturesque — the peeling columns and plasterwork acting as a sort of scenography of post-imperial collapse. This sweet declining environment was what Colin MacInnes designated, in *Absolute Beginners* (1959), as 'our London Napoli'. It possessed the ambience of Italian Neo-Realist cinema, while the fast stepping, the inclined heads, the leaning and diving of wide-pacing young bodies, suggested Cartier-Bresson-like intervals between the human and urban space. Mayne's photographs also invoked animate dimensions of graffiti, of child's-play, of song and nonsense rhymes, activities which were the subjects of Iona and Peter Opie's important study, *The Lore and Language of School Children* (1959).

Play was an area of great significance for British culture: the motifs of children's games, so prominent in Mayne's photographs of Paddington and Sheffield, would become universally present in the poetic Realist British genre of 'kitchen sink' cinema.[1] It was also to be a significant element in the Beatles' later projects, particularly in respect of that urban play that was so evident in Don McCullin's 'Mad Day Out' assignment with the Beatles in July 1968. This was, perhaps, the last flourish of this ludic strategy, with its series of improvised games and actions across the map of London. Mayne and the Opies had established the credentials for a specific kind of urban vernacular visual style. Certainly, by the time of Karel Reisz's *We Are the Lambeth Boys*, which was shown as part of the final 'Free Cinema' programme at the British Film Institute in March 1959, the spectacle of inner-city young people in states of vibrant mobility, whether children or teenagers, moving through their ambiences of clubs and streets, was well established. The images were a counter and rebuke not just to techniques of social modernisation, but also to the social geographies of power and privilege.[2] Mayne's photographs of a youth club, similar to the one in Reisz's film, appeared across three issues of the *Observer* in December 1958, with text by the same writer who accompanied Don McCullin on his urban youth and youth club assignments, Clancy Sigal.

MAYNE AND THE CATASTROPHES OF THE FUTURE

One of the vectors driving this kind of Realism was a photography of hystericised movement, as in the animated movements of figures in Dick Lester's short film made with Peter Sellers, *The Running, Jumping and Standing Still Film* (1959), which possessed 'a speechless, feverish energy that suggests an early newsreel'.[3] The other factor was the drive to represent symbolic contestations of power in what was being recognised as a post-imperial condition, a condition that was on display in the insubordinate stances of *The Guv'nors*, McCullin's Finsbury Park gang portrait of 1958 (fig.62), as well as in Mayne's CND documentations for the embryonic constituency of the New Left.[4] It was the Pacifist journal *Peace News* that commissioned Mayne's CND photo-reportages, along with the *Observer*, which was not a unilateralist newspaper, but had famously taken a sceptical line in November 1956 over the Prime Minister's decision to try to seize back the Suez Canal. The CND March to Aldermaston and the great rallies in Trafalgar Square, from 1958 to 1961, are represented by Roger Mayne as events containing a dark gravity. His photograph of the marchers in 1958, represents them as hooded, wet and bedraggled, holding their

Fig.62
Don McCullin
The Guv'nors 1958
Artist's Collection

curving banners silhouetted against the sky, evoking those enduring solidarities against adversity to be found in the elemental world of Kurosawa's *Rashomon* (1950).[5] At Turnham Green on the 1958 march, Mayne had portrayed three grim-faced CND partisans head on (fig.63). The overcast *misérabilisme* of these ascetic pilgrims is carried forward in the Brutalist high contrast between the black-and-white political signs and their ashen faces. The absolute seriousness of their presences — in the face of their intimations of thermonuclear doom — are repeated in Mayne's larger scan of individuals standing at the front of the Trafalgar Square protest in 1959. Now there are more faces, differently aged but all dark and harrowed, facing the speakers and facing prospective doom.

It is this uncanny political dimension which is contained in Mayne's photographs of Park Hill in Sheffield, in 1961.[6] These photographs can no longer fully accommodate lively bodies in an urban setting, since, in the main, the geometries of the mega-structure estate and its zones and shadows, produced regulating tracks which were essentially restrictive. The delimiting walkways and passages obliterate possible sites of games, even when the games are played outside the flats themselves,

on the ground, in a recreation area. In one photograph from Mayne's series, boys and adolescent footballers follow the ball, running and kicking into the shadow from the flats which consumes the right-hand diagonal of the photograph.[7] In another photograph, on a 'sky-deck', darkness vertically sandwiches the broken windows giving on to a lift and stairwell, where two young girls look away and hide.[8] In other photographs from the series, Mayne placed his generic children behind the steel bars of the safety bannisters of the vast, Piranesian external fire escape.

DON MCCULLIN: CRIME AND MORAL PANIC, REALISM AND GOTHIC HORROR

The scaffolded juxtaposition of bodies, on platforms and rostra, had made a riveting fiction out of McCullin's portrait of a young male gang arranged in a bombed-out Finsbury Park house. McCullin's naturalism, at its very point of origin, was an operatic spectacle of dereliction akin in its way to the urban picturesque of Mayne's Southam Street. But McCullin formalised his figures: 'The Guv'nors' were contained and mounted in a setting, a kind of gallery with niches, elevated in what local folklore judged to be 'the worst street in London'.[9] They become brutally heroic, like the imagined street gangs who

Fig.63
Roger Mayne
**Aldermaston March,
Day 1 — Turnham Green**
1958
Artist's Collection

lived in the fiction of *West Side Story*, which was premiered on the London stage a couple of months before McCullin's photo was published and at a time when the movements of exotic delinquents, framed by metropolitan spaces and discourses of delinquency and moral panic, had come before a British public. Between 1955 and 1959 offences by young people under twenty-one had leapt from 24,000 to 45,000.[10] The moral panic over youth delinquency intensified after the fatal stabbing of a policeman at Gray's Dancing Academy in Tottenham during a dance attended by the Guv'nors gang, which gave an imperative news frame to the *Observer*'s February 1959 reproduction of Don McCullin's photograph.[11]

McCullin's portrait would lay down a template for very many of the stark monochrome young pop groups posing as delinquents, such as the Rolling Stones, around 1963–5. Their manager, Andrew Loog Oldham, closely art-directed Gered Mankowitz's photographic shoots of the Rolling Stones from 1965. As he later testified, 'In general Andrew wanted the photographs to promote the Stones as sullen, moody, dark and mysterious ... He'd stand in the background telling me he wanted everything stark and gritty'.[12] Close to the Guv'nors, if not an actual member himself, McCullin personified the sub-cultural gang strategy of insubordination.[13]

What was being progressively uncovered was a zone of the metropolitan social bizarre that had fantastic overtones. Like Bill Brandt, in the thirties and forties, McCullin located and pictured an English social uncanny which was atavistic.[14] Weird forms of resistance to the lure of the late fifties Tory promise of a 'property-owning democracy' could be discovered in the transgressive aura around such figures as McCullin's photographs of the *Head Hunter of Highgate*. Publically, in the professional photography press, there was outlined a form of spectatorship based on the associations of Romantic darkness in these photos: 'The photographer is strongly drawn towards the violent or the macabre ... [the photograph portrayed a] ... friend of the photographer who collects old skulls and bones and is deeply interested in black magic.'[15] It was this Gothic horror sensibility which qualified McCullin's naturalism in his early sixties reports from a world of deprivation and racism in Britain with its rising spectres of Fascism,[16] prior to his self-election to the role of war photographer in his visit to Cyprus in 1964.

Grand guignol and the catastrophic were elements of the epoch of McCullin and of Harold Pinter. In his defence of *The Birthday Party* in May 1958, the drama critic Harold

Hobson wrote about the sense of catastrophe which underpinned contemporary existence and which Pinter had 'got hold of ... One sunny afternoon, whilst Peter May is making a century at Lords against Middlesex and the shadows are creeping along the grass and the old men are dozing in the Long Room, a Hydrogen Bomb may explode.'[17] As with Pinter, it might be said there were two kinds of horror in McCullin: 'behind the sinister gunmen and terrorists, behind the violence, the menace behind all these menacing images is the opaqueness and precariousness of the human condition itself'.[18] In the latter category, here, in terms of opacity, are those shadowed and traumatised US Marines whom McCullin photographed during the terrible siege of the North Vietnamese-occupied citadel at Hue in February 1968.

'THE YOUNG IDEA': DAVID BAILEY

The period was haunted by the search for an impossible synthesis — one partially dramatised in *Blow-Up* — of the hermetic and perfect photography drawn from fashion, such as David Bailey's had come to represent, with the profane street Realism of Mayne and McCullin. *Vogue* tried to appropriate Mayne's studies of teenagers, using them in a short feature in December 1959 titled 'The Teenage Thing'. Anticipating the aggressive dandyism of male 'front' in Bailey's *Box of Pin Ups* of six years later, the article also reflected contemporary strands of visual representation: the culmination of Mayne and McCullin's reportages and the emergence of the masculinist Kitchen Sink cinema: 'Pop teenage styles ... may be expressing a reaction from feminism: the boy is arrogantly chic, the girl waif-like and submissive'.[19] What was being pre-figured was the scenario created by the eruption of David Bailey and Jean Shrimpton into New York in 1962, when Shrimpton was represented as a pale female dandy, clutching a teddy bear (fig.64).

The occasion was Bailey's New York 'Young Idea' commission from British *Vogue* in February 1962. It produced an immediate appropriation of some of the most recent visualities current in New York art. Bailey's photographs mimicked the oblique and detached 'urban glance' that Robert Rauschenberg had been developing. His inclusion of a series of rectilinear 'found' texts not only emphasised a planar composition, but also anchored the photographs to Pop music and specifically to the Twist, which Bailey said 'was the most important thing going on in New York at the time'.[20] The possibilities for the graphic incorporation of street signage and promotional typography in the photographic work of William Klein was instrumental for Bailey and he may have looked at Klein's book, *Life is Good and Good*

Fig.64
David Bailey
Young Ideas Go West:
TWIST 1962
Artist's Collection

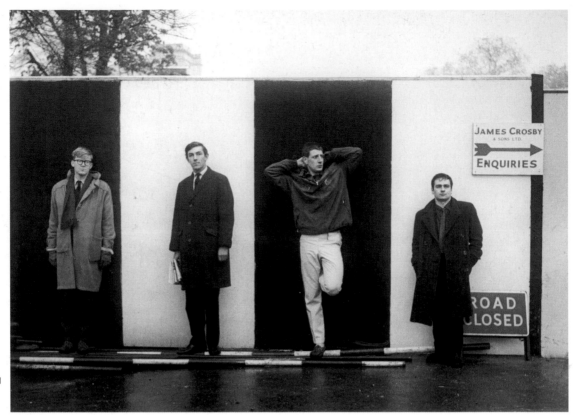

Fig.65
Lewis Morley
Beyond the Fringe
(Alan Bennett, Peter
Cook, Jonathan Miller
and Dudley Moore) 1961
National Portrait
Gallery, London

for You in New York, a publication which had already made a major impact on the British Situation artist Robyn Denny, who had bought it in Rome in 1958, a year after he had begun his RCA thesis with a large reproduction of promotional signs at a San Francisco car sales site.

Bailey's New York was no longer the systematic machinist metropolis photographed by Paul Strand, or that featured in the sordid melodramas of Weegee; it is a dispersed, subjectivised, undifferentiated city, oblique and cool, a city where variant kinds of identity are found. For example, the street hustler walking past in the 'Twist' photograph for *Vogue* belongs to that New York sub-cultural community to which Bailey and Shrimpton were introduced by Nicky Haslam.[21] As would be the case when McCullin had descended amongst the vagrants of Aldgate in 1965, or Mayne into North Kensington in 1956, a low social geography was crucial.[22] But here, with Bailey, the contingencies and abrasions of the city were being directed not towards social Realist protocols, but those of fashion marketing.

SATIRE AND PHOTOGRAPHY, 1961—4
Towards the end of the fifties and the beginning of the sixties, a new ethos of patrician modernisation was being shaped within the institutions of London journalism and broadcasting. Older magazines — such as

Fig.66
Lewis Morley
Christine Keeler 1963
National Portrait
Gallery, London

Queen — were revitalised by entrepreneurs such as Jocelyn Stephens. At the *Observer* David Astor had already been taking an exceptionalist and liberal line. The development of a critical and sarcastic view of the reigning Tory political hegemony, set against a modernising culture, began to build towards the cultural deluge of the Profumo scandal, a scandal in which photography — or more precisely one photographer, Lewis Morley — would play a central part.

THE CARNIVAL OF BRITISH CULTURE
Lewis Morley's 1959 debut produced a systematically grotesque feature of photomontaged gurning faces of uneven-toothed showmen.[23] He would develop this kind of satirical carnivalesque representation through the early sixties in concert with that broader wave of satire that began to gather with the London debut of *Beyond the Fringe* in 1961. It was Morley who produced publicity photographs of the 'Fringe' team (fig.65) — not on stage, but in street conditions, as an uplaceable 'group', part comic grotesque and part ready-for-trouble Guv'nors, in an exercise in graphically structured eccentric, dissentient masculinity, hanging around ironwork supports.[24] Morley displayed them making visual gags which corresponded to grotesque scenarios — pretending to vomit, eating rubbish and performing actions which disrupted and suspended the ideal, well-contoured and disciplined body of British authority. Morley's

publicity was an augury of the change of political and cultural climate that was to be initiated by *Beyond the Fringe*. In many ways the paradigm of the English satire boom of the first half of the sixties had been anticipated by the great Russian theorist of the carnivalesque, Mikhail Bakhtin: 'carnival celebrates temporary liberation from the prevailing truth of the established order; it marks the suspension of all hierarchical rank, privileges, norms and prohibitions'.[25]

During the course of Roger Mayne's street project in the late fifties in North Kensington, the statutory structures of house ownership and renting were being transformed. On the heels of the Conservative government's relaxation of Rent Control in 1957, the landlord Peter Rachman began to acquire run-down properties in the area and to exploit tenants. This was a vital component of the Profumo scandal, which overtook the Conservative government in 1963. Rachman's mistress, Mandy Rice-Davies, shared a mews flat in Marylebone with Christine Keeler, John Profumo's lover. The scandal revealed the corrupt and decadent undersides of a metropolitan society and culture and became the object of satirical journalists. This was to be the context for the photographer Lewis Morley's portraits of Keeler.

SATIRE AND LOW PERFORMANCES

For a studio, Morley rented rooms in an upper floor of 18 Greek Street, in what had previously been the striptease club The Tropicana, but which had in the summer of 1961 mutated into The Establishment Club, becoming the performing centre of the 'satire boom' until the advent of the BBC TV revue programme *That Was the Week That Was*, in the following Autumn. In January 1963, a small film production company, intending to make an exploitation film, commissioned Morley to make publicity shots of a naked Christine Keeler. The session, above The Establishment, produced what is arguably the most emblematic photograph of the period (fig.66), one riven with the ambivalences and contradictions of this critical moment. By the time the political Profumo scandal broke in the summer, the photograph had already been stolen and sold to the *Sunday Mirror* tabloid. The photograph became the key referent for the scandal, such that the painter Pauline Boty produced her painting *Scandal '63* using Morley's portrait of Keeler, together with snatched news pictures of Peter Rachman and others, 'to give them a photographic harshness'.[26] These connotations, together with the scandal of nakedness, were in part a consequence of the low genre the photograph replicated. The picture worked within the contemporary conventions of the front-of-house black-and-white photograph for

Fig.67
Lewis Morley
Joe Orton 1965
National Portrait
Gallery, London

Fig.68
Robert Whitaker,
Photograph of the Orgy
Scene from the film
Performance 1970
Artist's Collection

a strip club, or pin-up photography itself. Here is a moment from 'an intimate revue', a moment from clubland sexual display and from cabaret, the very world in which Christine Keeler had worked with Mandy Rice-Davies from 1960.[27]

Morley's style was embedded in a strand of satiric stage performance which was exemplified by the theatre of Joan Littlewood with its narrative tableaux of anti-Establishment local and national histories. Equally, Morley literally occupied the space of The Establishment Club in Soho, with its comedy sketches. Morley's work amounted to a revue format with brilliantly comic turns. The theatre was a staple of work of several of the photographers of the sixties: it was present in several of McCullin's *Observer* commissions and Roger Mayne was closely linked to the Royal Court theatre, both professionally and personally. Morley's portrait of the playwright Joe Orton

(fig.67) followed on from his publicity photographs for *Entertaining Mr Sloane* (1964). A year later Orton performs a particular Pop role as muscleman,[28] with the complicity of Morley, following on from the typecasting of Christine Keeler as pin-up. Orton's bodybuilder, in a kind of naked performance which embodies a strand of queer counterculture, is a low and vulgar challenge to genteel, established roles of the playwright. Orton himself had used photography to jumble up literary gentility and make it something strange and grotesque. Scavenging for published photographs, beginning in 1959, and following a satiric intention, he and Kenneth Halliwell had made neo-Dada photomontage substitutes of authors' cover photographs, mischeivously mixing them and gluing them into Islington Library books, an activity for which they were both gaoled in 1962. Morley himself made photomontages for *Private Eye* magazine which carnivalised public figures, such as the Prime Minister, Sir Alec Douglas Home, and The Duke of Edinburgh, turning their decorous roles upside down, perching them on lavatory bowls, or presenting them as vagrants.[29]

The culture of satire, from 1961 to 1964, was televisual as well as photographic and theatrical. It looked for precedent to earlier modernist forms of satire — to that of John Heartfield, for example. As the Director General of the BBC was reported as saying of *That Was the Week That Was*, 'What I really wanted was something reminiscent of Berlin in the 1930s.'[30] Certainly the use of back-projected film extracts to counterpoint songs or sketches, a technique introduced at The Establishment Club in 1962 and transferred to the BBC TV satirical revue, recapitulated the technologies in Berlin cabarets and in the productions of Berthold Brecht. Satiric Berlin culture was a powerful reference point for other artists such as Roger Law, who did George Grosz-influenced giant caricatures at The Establishment. Even the intersection of scandal, cabaret and the display of the naked female body — in Lewis Morley's portrait of Keeler — had its pedigree in the 'tingletangle' clubs of late-1920s Berlin.

From the summer of 1963 The Establishment Club fell into the hands of Raymond Nash, who introduced gaming and allowed violent assaults on audience members by his bodyguards. He had, in Lewis Morley's words, an 'underworld aura'.[31] A new *demi-monde* metropolitan culture of gangsterism was impinging on emancipated and sophisticated London media elites, a tendency particularly pronounced in the new beat group entertainment management cultures. It was precisely this *demi-monde* that David Bailey incorporated in his *Box of Pin Ups*, complete with the

appearance of the Kray Brothers (fig.71). It was this cultural zone which was to provide the armature of Nicolas Roeg and Donald Cammell's film *Performance* (1968), with its excesses of flesh, violence, Pop and exoticism, a film whose making was documented by Cecil Beaton and Robert Whitaker's still photographs (fig.68) which would construct, parallel to the film itself, a certain fantasy of a decadent London, performed on set.

POP, 1962—8

If Mayne and McCullin represented a moralising Realist photographic discourse, disclosing those excluded from the cultures of affluence, and Morley's position was one of cold satire, then David Bailey and Robert Freeman's photography was, to the contrary, nurtured by the spare sensibility of animation set against the 'waning of affect'. Their Pop sensibility was a function of being among the most salient agents of a photography geared to 'new forms of marketing-led production',[32] as the process of the post-war modernisation of British society intensified.[33] Affordable consumer goods, urbanism and decolonisation can perhaps be seen as defining the experience of fifties and sixties modernisation and photographers were everywhere enrolled in this process, whether marketing, purifying, resisting or witnessing the drama of the transformation. The bodily flows of celebratory, playful bodies standing out from dismal ambiences — a staple of those late-fifties depictions of the young in photography and cinematography since Mayne's Southam Street project and Lester's *Running, Jumping and Standing Still Film* (1959) — codified the 'marketing-led' representations of Pop in Britain.

'A SHARP GLANCE...'

The cover of the first *Sunday Times* colour section in February 1962 displays a footballer interjected into contact-sheet-like subdivisions of eleven shifting colour portraits by David Bailey of Jean Shrimpton modelling a dress. An athletic, working-class figure is elided with images of fashion-as-modernity. The balletic footballer, arms out, is absorbed in the act of kicking, an asserted promise of visceral movement in a muted Britain. This kind of movement was at the heart of Tony Richardson's film *The Loneliness of the Long Distance Runner* (1962) with its insubordinate working-class hero racing across English landscapes and escaping repressive social bonds. The percussive segmentation of the *Sunday Times* cover, in its closeness to the syncopated 'restless trickery' of the maturing style of the 'Kitchen Sink' film cycle,[34] can be read — as it was in the cinema — as a 'turning away from Realism'.[35] The 'sharp glance' announced on the first *Sunday Times* colour supplement cover in the headline —

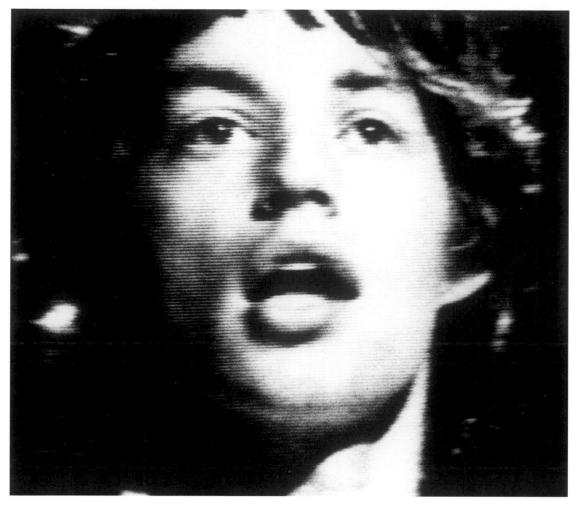

Fig.69
Cecil Beaton
Mick Jagger on
the television 1965
Cecil Beaton archive
at Sotheby's

'A sharp glance at the mood of Britain' – in February 1962 – is the acidic optical mode for a new photo-graphic sensibility as well as setting the agenda for national scrutiny. It is, of course, 'sharp' in the sense of fashionability, but it is also formally 'sharp'. And it is here that there are parallels with Kenneth Tynan's contemporary aesthetic programme of 'high definition performance',[36] and the pictorial style of 'hard edge' in the work of the Situation painters, the crisp affectless edges which Bailey would put to work in his *Box of Pin Ups*.[37]

In its severe definition, Bailey's black and white photography can be thought of as defining itself against the slurred and scanned contingencies of television. The period 1956–68 saw the advent of television in Britain as the dominant visual public medium. Photography, it could be said, was preoccupied from the late fifties onwards in England (and especially in the USA) with developing responses to this central visual form of the time. The great photo-journalistic vehicles for social reportage of the thirties and forties became extinct and TV programmes such as *Tonight* (with former *Picture Post* staffers),

Panorama and *World in Action* commandeered their investigative styles. Paradoxically this coarse scanning of the world or the human face by 405 electronic lines (until the advent of the higher definition BBC2, with its 625 lines) had a countervailing appeal to some artists and photographers such as Richard Hamilton and Cecil Beaton. It was the latter who grabbed Mick Jagger's portrait from the TV screen (fig.69) as he sang and performed in one of Loog Oldham's choreographed television appearances: screens and spectacles framed the real in Pop.

ROBERT FREEMAN AND THE TRIUMPH OF POP

Robert Freeman embodied the redefined and modernised, post-social Realist photographer, an individual who had capacities to span both the culture and early sixties theorisations of Pop Art, as well as the marketing and commercial design worlds of the expanding Pop music and fashion industries: he was at the nexus of the emerging Pop cultures of 'beat' music and Pop Art. The ICA's Lawrence Alloway had enthused him at the end of the fifties during a lecture at Cambridge University where Freeman was studying

Overleaf
Fig.70
Robert Freeman
Photographic design
for the film poster for
A Hard Day's Night
1964
Artist's Collection,
Courtesy Bruce Karsh

English Literature, confirming his suspicions of the power of a new and usable paradigm of American pop culture.[38] Freeman's discipleship resulted in his editing an issue of *Cambridge Opinion*, which acted as a platform for Alloway's aesthetics of Pop. Moving to London in 1960, he was given the task of acting, during Alloway's absence, as a Programme Director at the Institute of Contemporary Arts and he came into contact with painter associates of Alloway, like Dick Smith, and other Situation painters, such as Robyn Denny.

The recurring iconographic topic in Freeman's photography, in its first flowering from 1959 to 1963, was the glass and steel tail fins of American automobiles. It was these culturally 'low' forms which Roger Mayne had stigmatised in a cover photograph for *Schoolmaster and Women Teacher's Chronicle* in the guise of the shiny vulgarity of the

tamer Anglo version of a Ford Zephyr saloon, standing outside a cinema showing the horror film *The Fly*.[39] The photographed presence of the provocative Americanised car was a token of another moral panic: the debate over the threat to what were perceived as high moral European and British values by an Americanised Pop culture.

Freeman, Bailey and Mayne, too, were among the cameramen who were drawn from still photography towards a larger sphere of promotional audio-visual productions, those of television commercials and public event spectaculars. Freeman filmed the Elida Shampoo advertisement in 1966, which gathered together figures from the elements of the nascent 'Swinging London' iconography: the blonde model (Patti Boyd), the white E-type Jaguar. Freeman orchestrated a kinesis of fashionable bodies and consumer technology. He had the capacity to itemise,

anatomise and compose in a forceful manner the components of the then current consumer culture and had done so most succesfully in collaboration with Richard Hamilton in his assemblage photograph for the cover of *Living Arts* magazine in 1963 (fig.58). As a media artisan Freeman worked to realise the 'graphic hyperboles'[40] of the London advertising and public relations worlds: his portraits of the Beatles on their 1963 and 1964 albums were developments of his telephoto visual sandwiching of the leading figures of the Fletcher, Forbes, Gill advertising agency. (It would not be for nothing that a satirical episode in *A Hard Day's Night* involved an encounter between George Harrison and an advertising executive trying to deduce the timings of fashion trends.)

The stark silhouetting of the Beatles on Freeman's cover and title designs for *A Hard Day's Night* developed a model of contemporary portraiture from American practitioners such as Richard Avedon (perhaps best displayed in his 1964 publication *Nothing Personal*) and Andy Warhol (in his silk-screen portraits from 1962 onwards). The distinctive physiognomies of the Beatles were thrown against a studio blankness, 'a white background, a soft sidelight and the Beatles wearing black'.[41] What the film and Freeman's photographs and sequences mobilised were two very different visual languages: the Realist docu-drama of reportage *ciné-vérité*, and the abstract and symbolic portraiture of designed and schematised bodies and faces against studio voids.

In his work for *A Hard Day's Night*, Freeman was to suggest the moving, multiple identities of the Beatles, as if they were – like Peter Sellers's contemporary performances – a compressed series of carnival voices and postures: 'The cover for the soundtrack album, like the film poster, used photographs with a variety of expressions to reflect the zaniness of The Beatles ... an element I didn't feel could be reflected in one image.'[42] Instead, the animation of fast dissolves in the film's title sequence, and the shifting of their expressions, became a tabulation of screens and subscreens, like a gridded lexicon of facial types, heavily delineated and contrasted, thrown up against a studio void. Freeman described a technique for these portraits that indicates his debt to those industrialised commercial portrait practices – such as the Photomaton and the Polyfoto – which had standardised the portrait photography product for a mass market since at least the third decade of the twentieth century.[43] The use of industrialised techniques of de-personalisation in order to market charismatic 'offbeat'[44] eccentricity in a modernising culture, was similar to Warhol's contemporary procedure of sending his sitters to a particular Photomaton machine on 42nd Street, where they would perform themselves. For the first time, a pop group was marketed and displayed to the world with a sense of modernised ironic staging based on repetition and seriality. Freeman's screens held, fixed and repeated the fetishised faces of the Beatles as they ran a gamut of changing expressions in a bleak light. But Freeman's next step, as colour consultant on Lester's follow-up film *Help* (1965), was to create much of the ground for that polychrome arabesque style which would carry all before it – psychedelia – in the period from 1966 to the decade's end.

DAVID BAILEY'S BOX OF PIN UPS: A TRANSGRESSIVE PANTHEON

The dissolution of naturalistic representations in Bailey's photography of 1964–5, which was especially prominent in the *Box of Pin Ups*, was linked to the unleashing of overwhelming amounts of cold hard light in his portrait sittings, generated through a 1-kilowatt Mole Richardson 'Scoop' lamp.[45] Bailey had taken notice of the way in which lighting in current television and film had gravitated towards harshly contrasted divisions of dark and light. This overlighting was most effectively seen in the techniques of Gilbert Taylor, Dick Lester's lighting cameraman. Embodying that fretted, silhouetted contrast of Warholian fetishised portrait heads which Robert Freeman had made the inescapable feature of the graphic promotion of *A Hard Day's Night*, Taylor had discovered that 'By using absolutely white backings and a key light, we could make the people who played against this "white-out" environment take on the definition of steel engravings'.[46] The agitated cast of the *Box of Pin Ups*, like the Beatles, therefore stood out. In the vernacular of social hierarchies, they had no background and there could be no *juste milieu* account of their social place. They were, in Frances Wyndham's words, 'self sufficient'.[47]

It could be said that Bailey reached a particular summit in *A Box of Pin Ups*. He had attained that camp waning of expressivity and affect which Susan Sontag had recognised as the pressing, present mode of representation in creative activities such as the *Nouveau Roman*, something 'impersonal, expository, lucid and flat'.[48] This 'new sensibility'[49] was also an offshoot of camp, a mode of cultural presentation with which Bailey's *Box...* could be aligned in photographs which were decoded and stigmatised as strange and aberrant by their detractors. The camp chic which structured Bailey's *Box...* developed from a number of sources: his ironised 'rough-trade' persona made massively heterosexual; his encounter with Warhol on his second visit to New York in 1963 ahead of

any British artists and his first viewing of the monumental and impassive *Elvis* silkscreens. Additionally, there was Bailey's nostalgia for a disappeared Hollywood forties star system and for the dead genre of musicals — especially Astaire's. Perhaps the provocative element of the *Box...* for conservative commentators and journalists (of the political Left and Right) was a strategy of de-idealising the appearances of exemplary contemporaries. Bailey did not accomplish this in a harsh and naturalistic manner. What destabilised traditional viewers was the flat and claustrophobic confrontation with dandified and knowingly camp figures, such as the effeminately posturing but readily violent Andrew Loog Oldham.[50] The roster of those portrayed defined the contours, in Pop culture, of a nascent post-Imperial and post-Churchillian culture.[51] Moralised standing was dismissed in Bailey's *Box...* for, as Sontag remarked, 'Camp is a solvent of morality. It neutralises moral indignation, sponsors playfulness'.[52]

If a moral panic surrounding young male delinquency had been the primary discourse fixing McCullin's group portrait of the 'Guv'nors' in 1958, then Bailey's *Box of Pin Ups* entered the territory of the backlash against the new, permissive Pop culture of the metropolis in its visual forms, with their imaging of sexuality, blasphemy and social

Fig.72
Don McCullin
Two Soldiers with
Viet Cong 1964
Victoria and Albert
Museum, London

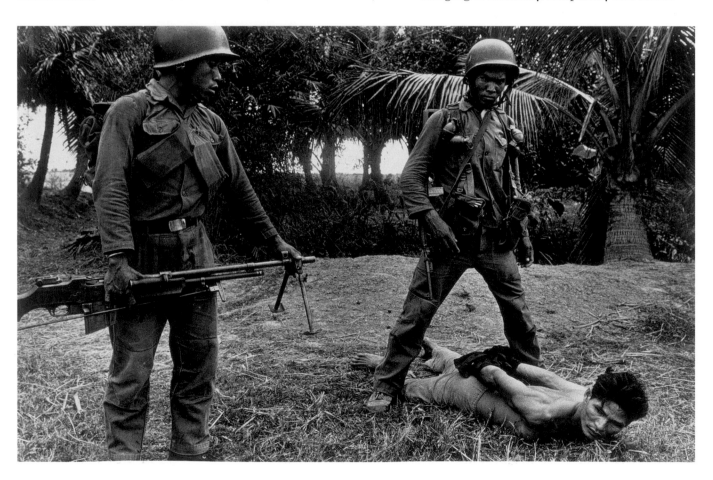

Realist TV plays.[53] Complaints about Bailey's portrait gallery centred on the unbounded, promiscuous mix of individuals and types: royalty and gangsters, artists and models. In this respect it harked back to that satirical carnival parade, directed by Lewis Morley, in 1963 and immediately after. To juxtapose Lord Snowdon with the Kray brothers, as happened in the *Box...*, suggested an annex to that disorderly world of Bohemian vanguard art and an adjacency to 'die Londoner Gangster'[54] in the crucible of pop music, which continental critics had been noticing as a suppressed thematic in British culture since 1957.[55] The *Box of Pin Ups* represented the production of a demi-monde for wider media consumption, in the headline of what Robert Pitman, writing in the conservative *Sunday Express* called a 'Strange Company'.[56]

HYPERBOLIC BODIES, 1966–8

JOHN COWAN AND THE FLIGHT OF MODERNISED ANGELS

The spectacle of fashion marketing over-leaping and over-reaching itself is prominent in John Cowan's hyperbolic *Flying High* series of 1966 (fig.61),[57] whose weightless scenographies depended on supplementary melodramatics of technology and contemporary architectural structures. Cowan had perversely adapted the ascensional rhetoric of sky ambulation proclaimed by the reformist utopian architects, the Smithsons, whose sky-deck elements Roger Mayne had photographed at the Park Hill estate in Sheffield in 1961. Social geography and the renovated environment of Battersea played their part in John Cowan's photographs. Unlike his earlier, more aristocratic, images of mobility – of models juxtaposed with light aircraft, horse racing, and motor sports – in this feature for *Queen*, Cowan chose a GLC high-rise block as the background to Jill Kennington's leaping and suspended body. The point block was Sparkford House, an index of that modernisation of Battersea which forms the muffled background to Nell Dunn's contemporary reportage of the area.[58] In this way Kennington's body joins that period iconography of young women isolated against the newly forming worlds of council estates, like Barbara Windsor in Joan Littlewood's screen adaptation of her stage-play, *Sparrows Can't Sing* (1963).[59] But Cowan's rapturous female bodies in flight, hovering against contemporary point block housing, contrast with Roger Mayne's earlier representations of bodies within the ambience of housing estates. Mayne's Realist figures remain literally grounded within their social milieu. The technocratic sublimity of Cowan's white-clad bird women, spasmic in falling flight, are part astronauts, part angels.[60] The erotic lyricism of high-rise buildings

had been articulated by the young photographer hero of Colin MacInnes's *Absolute Beginners* (1959), when, from Derry and Tom's roof garden, he descibes London as a cinematic panorama: 'like Cinerama, you can see clean new concrete cloud-kissers, rising up'.[61] But on 16 May 1968, this kind of modernist transcendentalism abruptly became unthinkable. On that day the catastrophic collapse of the GLC's two-hundred-foot high Ronan Point flats, after a gas explosion, marked the end of a modernist aerial dream in the British visual imagination; a dream which would not be revived until the 1980s.

THE DECLINE OF THE WEST: DON MCCULLIN, 1966–8

The poignancy of the transition from the naturalisms and documentaries of the late fifties to a fully modernised Pop dawned on McCullin in the Spring of 1966, when Michelangelo Antonioni drew him into the production of *Blow-Up* : 'Style had become everything now that we had left the social realism of the angry young man behind.'[62] And it was perhaps ironic that not only were McCullin's early sixties Aldgate reportages included within the film, but also that he made the series of successive enlargements of parkland that play a decisive part in the film's narrative as the enigmatic visual

Fig.74
Robert Whitaker
George Harrison at
Chiswick Park, "Way
Out" 1966
Artist's Collection

instruments of existential doubt which overtake Thomas, the photographer protagonist: 'I produced the blow-ups for his film *Blow-Up*.'[63] With these photographs McCullin could be said to have overtaken the mannerist photography of the new Pop culture that had David Bailey at its apex, and reached another territory, a zone unknown, where he created proto-Conceptualist photographs that exhausted the mappings of local space and place and medium.

This plunge into the metaphysics of the photographic image had actually been foreshadowed. Before his remaking as a 'war photographer' at the time of the Cyprus conflict in 1964, Don McCullin appeared as a photographer possessed by grim mortality. In his autobiography, McCullin has subsequently presented himself as a product of the horrors of the Blitz in London and the culture of wartime violence inflicted upon the body: 'Gruesomeness of this sort was par for the course for Londoners.'[64] As McCullin has recounted, his encounters with mortality in battle and massacre, and the turmoils of a post-colonial world, entailed, for him, a struggle with the forceful signs and rituals attending Christian — and particularly Catholic — religious forms: the candles at his father's laying out, or the US Marine chaplain offering him the last rites at Hue. These are signs which 'spooked' him,[65] containing uncanny power in a martial and abject world. Perhaps the Gothic power of McCullin's *Head Hunter of Highgate* arose from some sense of being 'death's permanent companion',[66] in the phantasmagorias of the West's apocalypse, an apocalypse which encompassed the bombed out squalor and brutalities of Finsbury Park as well as the broken walls of the citadel at Hue. There is, additionally, a persistant iconography of Christian suffering in McCullin's Hue photographs: as Susan Sontag recently observed, 'It would be hard not to discern the template of the Descent from the Cross in several of Don McCullin's pictures of dying American soldiers in Vietnam.'[67]

Despite his ambivalence and his consistent refusal to be partisan during a number of post-colonial conflicts, McCullin's experiences in Biafra, in 1968, culminated in a definite public gesture that went further than the intelligent use of his photographs in the *Sunday Times* colour magazine. In that year of heightened cultural and social contestation — the student revolts at the Sorbonne and LSE and the great street demonstrations in Grosvenor Square — McCullin determined on his own, idiosyncratic, form of 'direct political action'.[68] Juxtaposed with one of McCullin's most disturbing published photographs — of an emaciated Biafran mother with withered breasts unable to feed her baby[69] — was an agitatory caption by Francis Wyndham: 'Biafra, the British Government Supports this War. You the Public Could Stop It.' It was a caption which exceeded the frameworks of comment possible in the *Sunday Times* colour magazine. McCullin transformed this agitational image and text into a poster which he, his wife Christine, and Francis Wyndham fly-posted across London, paying 'special attention to our own area of Hampstead Garden Suburb, where the Prime Minister, Harold Wilson, had his home'.[70] It was a small, but precisely targeted, piece of protest at the costs of a neo-colonial war.

Perhaps the twilight of The Beatles, in the medium of a photography designed to promote them, is first figured in the elegiac portraits of the group made by Robert Whitaker, during the filming of their video promotion for the single, 'Paperback Writer', in Chiswick Park, in May 1966. Within this series George Harrison appears as a Brandtian figure (fig.74); oneiric, weird, possessed, as Gothic as Don McCullin's *Headhunter of Highgate*. And with The Beatles' request to McCullin to photograph them in London, in the sour wake of psychedelia and its utopianism in July 1968, the closure of many narratives is made felt. The shoot was designated 'A Mad Day Out', a deranged urban voyage, like a distant echo of that animation and abandon which they had admired in Dick Lester's *Running, Jumping and Standing Still Film*, which itself had been the motor for *A Hard Day's Night*, or the experimental film which McCartney had presided over the previous summer, *The Magical Mystery Tour*. Over the course of 28 July 1968, McCullin accompanied the Beatles to a number of locations, some of which he appears to have chosen, or which fitted his Brandtian agenda of London's darker places — St Pancras Church, Highgate Cemetery and Wapping Pier Head. McCullin was dressed in the same combat fatigues that he had worn at the siege of Hue, nearly six months before, while George Harrison borrowed his US GI-issue helmet.[71] At the final location, on the wharves at Wapping, John Lennon played dead (fig.73), his stasis embodying the fading and posthumous sense of not only the day's session, but also that period of radical modernisation of the sixties, which was drawing to a close in a welter of far-away wars.

SCULPTURE AT ST MARTIN'S

Rachel Tant

In 1965 the Whitechapel Art Gallery held its second survey exhibition of young artists whose emerging talent represented the 'New Generation' in British sculpture. These surprising works looked like 'nothing that had ever been seen before':[1] smooth and seamlessly finished, the bright and strongly coloured abstract forms stood directly on the floor and were human in scale. Constructed in plastic, fibreglass and metal, they confronted the spectator with 'a radically new and different concept of sculpture'.[2] The exhibition augured an exciting period of experimentation that, in reacting against the naturalism of carved and modelled figure sculpture, provided the basis for much subsequent work of the 1960s.

Significantly, six of the nine artists selected to exhibit (David Annesley, Michael Bolus, Phillip King, Tim Scott, William Tucker and Isaac Witkin) were associated with St Martin's School of Art. They had all been pupils of Anthony Caro there in the late 1950s, and had gone on to teach with him on the 'advanced sculpture course' developed under the enlightened regime of Frank Martin, head of the sculpture department since 1952.

In an attempt to avoid the restrictions imposed by the National Diploma in Design (which assessed students on the basis of figurative work), the advanced sculpture course was developed by Martin to create an open and exploratory environment where experimentation with abstract sculpture was specifically encouraged. Without official validation, the course remained 'vocational' and relatively independent of institutional requirements. The school's application for accreditation as a postgraduate centre for sculpture was rejected. Despite their varying degrees of experience, students were therefore considered 'potential artists' and encouraged to 'break new ground' rather than 'fit into an existing art situation'.[3] Indeed, Caro made it clear that, as equals, 'we were all engaged on an adventure, to push sculpture where it has never been'.[4]

Caro's experience of America in 1959 – his exposure to abstract painting and the assemblages of David Smith – compelled him to change his working methods and shift from bronze to steel. American influence was also fundamental in precipitating a belief at St Martin's that 'abstraction was most important to the advancement of teaching art'.[5] With the introduction of a departmental welding shop, traditional materials and tools were eliminated from one of the studios in order to free up 'an area of study away from figuration completely'.[6] A clean, empty workshop allowed the 'New Generation' artists to approach sculpture with their minds free from preconceptions, regarding nothing as impossible. Caro recalls, 'we invented things. We would make sculptures of impossible things. I would say, make a sculpture of the street, or make a sculpture of a scream or a shout.'[7] Moreover, encouraged to try anything once, the students realised that any material, particularly the synthetic materials of manufacturing, was acceptable for sculpture.

Phillip King was one of the first artists to work with plastics. In 1958 he became the first of many students who were invited by Frank Martin to join the teaching staff after completing his studies, ensuring a level of continuity within the department that shored up a spirit of like-minded enquiry that became characteristic of the school.

Fig.75
Barry Flanagan
aaing j gni aa 1965
Tate

Fig.76
Phillip King
Tra-La-La 1963
Tate

Encouraged by the ethos at St Martin's, King and his contemporaries rejected the 'great heroic struggle with matter'[8] that had epitomised and confined sculpture for so long. Eschewing the 'additive' techniques of welding, King was acutely aware of the challenges and limits that new materials presented to him. Plastic in particular provoked an interest in colour and opened up an enquiry into the distribution and articulation of colour in space.

King expressed sympathy with the new shapes of the urban environment that surrounded him in Charing Cross Road. A distinguishing feature of King's sculpture is his use of the cone: a non-organic, self-contained shape with almost no history in sculpture.[9] In the early sixties, King repeatedly used this shape to experiment with contour, volume, surface, colour and space. 'Earthbound' and yet encouraging an upward movement of the eye, his conical pieces explored the possibility of sculpture being able to start somewhere other than the floor. *Tra-La-La* (fig.76) comprises three shapes, but where their sequence begins is ambiguous. The central lozenge appears to extrude from the cone's spout-shaped apex, yet its upward swelling is inverted by the twisting, rope-like arm that, appearing out of nothing and suspended in mid-air, splays and stretches out in two directions, almost defying gravity. The verticality of this sculpture has been interpreted as a sign of life.[10] Indeed the suggested sense of movement, further animated by the succession of reflective and matt surfaces, points to King's concerns with natural processes: universal order, rhythm and growth.[11] Colour is also crucial and plays an important role in denying weight in the sculpture. King describes his use of pink as 'no longer subservient to the material but something on its own, to do with surface and skin'.[12] In addition, the playfulness of the 'sugar-coated' colours provokes more light-hearted, emotional associations. For King, such colour is the 'life-line into this invisible world where feeling takes over from thinking'.[13]

With increasing need for specialised equipment for the new materials and larger working areas, students and teachers began to work more regularly away from St Martin's at satellite spaces such as the Stockwell depot. Indeed, during the later stages of study 'a great degree of independence' was encouraged. At the same time, the department aimed to operate as 'an analogue of a sculptor's studio, in which discussion, criticism and experiment are actively pursued'.[14] Weekly re-grouping at St Martin's around finished work was insisted upon and extensive questioning

and debate ensued. The Sculpture Forum, as Martin recalls, 'developed into a regular Friday thing where we invited sculptors from all over London and members of staff from other schools, and critics, and gallery owners would come to these seminars on a Friday and have a fight, you know, around the subject'.[15] After the success of the *New Generation* exhibition, the reputation of the sculpture department grew and interest from leading American figures such as Clement Greenberg and Michael Fried, both strong supporters of Caro's work, furthered its international renown.

Closer to home, however, and during the very moment of the New Generation's success, disenchantment increased among a group of younger St Martin's sculptors (including Barry Flanagan, Richard Long and Bruce McLean), who were critical of the way in which sculpture was presented without regard for the gallery context. Even more open-minded about how and from what sculpture could be made, these younger artists adopted a more analytical and philosophical approach to explore the issue of 'what sculpture could be to you in your life'.[16] Consideration of physical surroundings and social and psychological conditions fostered a more direct engagement with the world again.

In 1960 Barry Flanagan attended Caro's sculpture class at St Martin's for three months. Before enrolling as a full-time student he wrote to Caro:

> The Friday evening classes at St. Martin's were good meat for my imagination. These classes prompted the writing of poetry, a play, film scripts, songs, the purchase of cine equipment, and work on a means to translate movement and atmosphere into music. I might claim to be a sculptor and do everything else but sculpture. This is my dilemma.[17]

Rejecting the modernist conception of sculpture – autonomous, hermetic and radically abstract[18] – in favour of a greatly expanded definition, Flanagan turned from metal to more ephemeral, 'un-sculptural' materials which, chosen for their shape-making qualities, were allowed to find their own forms. By filling pre-stitched cloth 'skins' with amorphous matter such as sand or wet plaster, Flanagan produced highly idiosyncratic standing objects such as those of *aaing j gni aa* (1965). Although it is difficult not to anthropomorphise the huddle of bulging solids, which bear some resemblance to Joan Miró's sculptural personages,[19] each of the final shapes were determined by factors such as gravity and drying time and were ultimately outside the artist's control: 'I wasn't looking for any particular shapes or looking for a way of projecting my head into the world of objects. I liked more the idea that these shapes virtually made themselves.'[20] While not entirely free of New Generation traits – in particular Phillip King's quirky, floor-based cones – the emphasis on process and organic form highlighted Flanagan's concern with discovering the potential of new materials rather than trying to master them: 'My work isn't centred in experience. The making of it is itself the experience.'[21] Moreover, the palindrome used to title *aaing j gni aa* cancels out any imposed meaning and instead points to Flanagan's interest in the experiential life of the sculpture itself.

Flanagan was interested in and influenced by a wide range of disciplines, but especially concrete poetry. He first exhibited *aaing j gni aa* at Better Books, a local bookshop in Charing Cross Road and host venue for happenings and events run by concrete poet Bob Cobbing. In the latter half of the sixties, investigation at St Martin's was responsive to such 'event structures', as advocated by tutor John Latham whose own work involved unexpected transformations of materials, such as his Skoob Tower Ceremonies, which involved burning stacks of books. Similarly, the analysis of wide-ranging creative processes as opposed to finished form, encouraged by Peter Atkins, contributed to a return to everyday reality in sculpture. A walk in the landscape, for instance, was accepted as sculpture and artists such as Richard Long successfully incorporated time into his work as in *A Line Made by Walking* (1967). Likewise, Gilbert and George used their bodies directly to become 'living sculptures' when they presented themselves in 1969 as *The Singing Sculpture*. Questioning the nature of sculpture now encompassed wider issues of representation, materials, concept and context and stimulated a successive new wave of exploration.

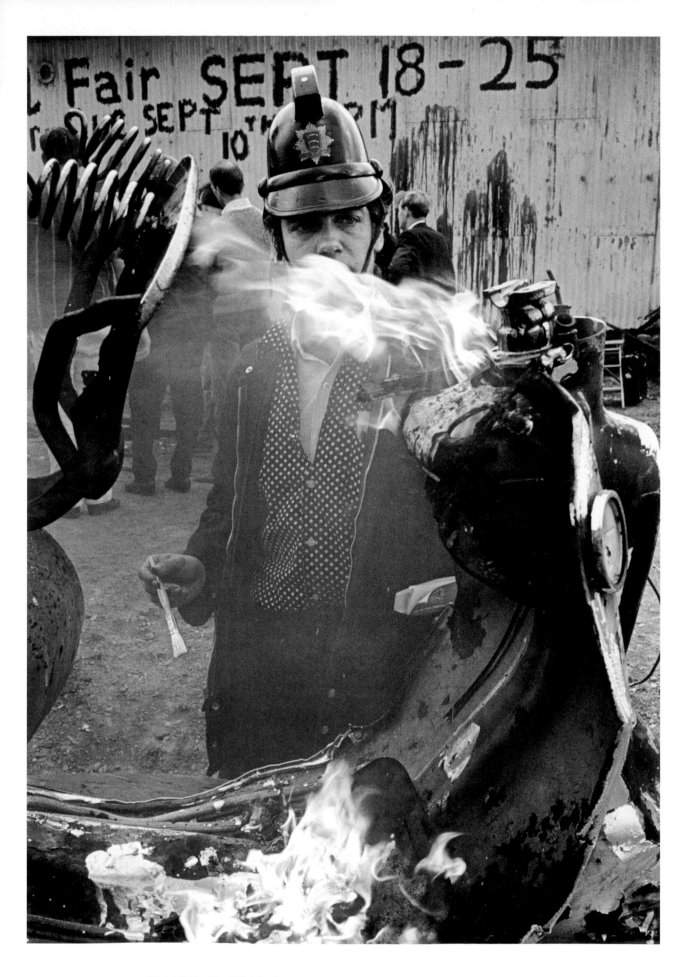

A POETICS OF DISSENT: NOTES ON A DEVELOPING COUNTERCULTURE IN LONDON IN THE EARLY SIXTIES

Andrew Wilson

More than six thousand were in the hall; many were turned away. They came, to our knowledge, from Manchester, from Birmingham, from Liverpool, from Leeds, from Gloucestershire – and from where else? They came expecting something new, immense, compelling – what?[1]

London is in flames. The spirit of William Blake walks on the water of the Thames. Sigma has exploded into a giant rose. Come and drink the dew.[2]

On 11 June 1965 at least 7,000 people filled the Royal Albert Hall for a four-hour International Poetry Incarnation. Fifteen months later, some fifty artists from ten countries gathered together at the Destruction In Art Symposium (DIAS) at the Africa Centre and for accompanying events at various locations around London. Although very different, both events define the emerging counterculture of the mid sixties formed by the dissolution of barriers between disciplines and the attempt to forge a new grammar and language alongside new ways of living life.

Eyewitness accounts of the International Poetry Incarnation are almost all in agreement as to its significance as a beacon identifying an emergent underground, even though as a poetry reading it left a lot to be desired.[3] To a core of internationally known poets – Gregory Corso, Lawrence Ferlinghetti and Andrei Voznesensky[4] – Allen Ginsberg, whose stay in London had sparked off the idea of the event in the first place, suggested adding the British writers Harry Fainlight (just returned from New York where he had collaborated with Ed Sanders's *Fuck You*,

Fig.77
Event with Motor-cycle
**A performance given
by Al Hansen as part
of the Destruction in
Art Symposium, 1966
Photo by Tom Picton
Collection of photo-
grapher's family**

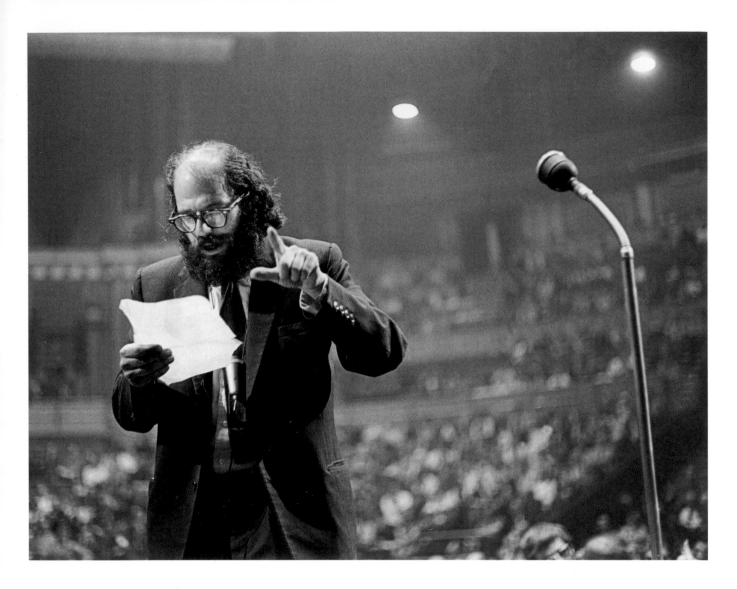

Fig.78
Allen Ginsberg at the
Royal Albert Hall
Poetry reading, 1965
Photo by Tom Picton
Collection of photo-
grapher's family

a magazine of the arts) and Alexander Trocchi (whom Ginsberg had met in New York in 1959 when Trocchi was living there). A Poets Co-operative – loosely organised by Trocchi's Project Sigma and Michael Horovitz's Live New Departures – then took over the organ-ising of the event so that within ten days the list of performers rose to nineteen, not including the recorded voice of William Burroughs, the robots of Bruce Lacey and a happening to be staged by Jeff Nuttall and John Latham. On the day, Ginsberg, Ferlinghetti and Corso were joined by fellow Americans Paolo Lionni and Dan Richter, the Austrian sound poet Ernst Jandl, the Dutch writer-activist (and Project Sigma's representative in Amsterdam) Simon Vinkenoog, the Finnish poet Anselm Hollo, and the New Zealand poet John Esam who, like Hollo, had been living in London for a number of years. This international group was matched by the two British poets chosen by Ginsberg who were joined by Pete Brown and Horovitz, Trocchi's friend and colleague from fifties Paris Christopher

Logue, Spike Hawkins, George Macbeth and Adrian Mitchell.

The International Poetry Incarnation rendered all too visible a hunger for poetry as part of a wider countercultural movement that had already been laying siege to the establishment since the late fifties. For a programme note for the event, ten of the poets had met at Trocchi's flat and penned an invocation that articulated the breadth of this community that was summoned up in its thousands. Under the watchful eye of William Blake, a direct inspiration for both Ginsberg and Horovitz and whose *Jerusalem* provided the invocation's epigram, the Co-operative – mainly Trocchi, Horovitz and Ginsberg – charted the new land:

> World declaration hot peace shower! Earth's grass is free! Cosmic poetry Visitation accidentally happening carnally! Spontaneous planet-chant Carnival! Mental Cosmonaut poet epiphany, immaculate supranational Poesy insemination!
> Skullbody love-congress Annunciation,

duende concordium, effendi tovarisch
Illumination, Now! Sigmatic New Departures
Residu of Better Books & Moving Times in
obscenely New Directions! Soul revolution City
Lights Olympian lamb-blast! Castalia centrum
new consciousness hungry generation Movement
roundhouse 42 beat apocalypse energy-triumph!
 You are not alone! Miraculous assumption!
O Sacred Heart invisible insurrection! Albion!
awake! awake! awake! O shameless bandwagon!
Self evident for real naked come the Words! Global
synthesis habitual for this Eternity! Nobody's
Crazy Immortals Forever![5]

Virtually every word here signals a magazine, a group, an event or a remembered statement which, taken together, maps a new emergent countercultural community: Trocchi's admission at the 1962 Writers' Conference at the Edinburgh Festival that he was a 'Cosmonaut of inner space',[6] or the naming of Project Sigma and its founding manifesto the 'Invisible Insurrection of a Million Minds'; Timothy Leary's Castalia Foundation at Millbrook; Better Books and Arnold Wesker's Centre 42; magazines such as Horovitz's *New Departures*, Richter's *Residu* and William Burroughs's insert *Moving Times* for Nuttall's *My Own Mag* (a title also appropriated by Trocchi for a one-off poster issue of his *Sigma Portfolio*); and also publisher/magazines such as New York's *New Directions*, San Francisco's *City Lights* and Paris's *Olympia*. As can be seen from just this sampling, the International Poetry Incarnation dismissed poetry that had become locked into the printed page in favour of a poetry of event, a carnivalesque poetry, which could embrace psychedelic drugs or an examination of definitions of madness, in its assault on dominant culture. This can be recognised as much in Fainlight's tortured rendition of his LSD-induced poem *Spider*, as in the presence in the audience of patients from the Philadelphia Foundation's anti-psychiatric residency at Kingsley Hall.[7] Trocchi and Fainlight's journeying through inner space towards the formation of a new society was a corollary of the position of the mad in institutional culture — the drug addict and the mad having both been banished to its margins. Furthermore, the study of madness — and specifically the schizophrenic — and the pursuit of anti-psychiatry (for which the distinction between analyst and analysand was dissolved) conforms to the defining image for a cultural revolution in which there were only participants and no spectators.

The Poetry Incarnation, however, did not only give visibility to a developing counter-culture. It tellingly revealed how the character of the counterculture had changed over the previous five years. Looking back on this period in 1971, Peter Stansill and David Mairowitz had observed how 'the gloomy earnestness of the "protest" mentality is displaced by a new "tough" frivolity and creative lunacy ... the debate is no longer between Right wing/ Left wing, but rather between the oppressions of the external world and the desire for internal liberation, between activist commitment to the continuing social struggle and dropping out of a cultural milieu that won't allow it.'[8] In the late fifties, this protest mentality focused around the Campaign for Nuclear Disarmament and its Easter Aldermaston marches which had taken place since 1958 and gave a tangible expression to protest as did, in a very different way, the Poetry Festival seven years later. Despite the impact of Adrian Mitchell's tour de force performance of his anti-Vietnam poem *To Whom It May Concern*, the move was already being made towards a politics of internal liberation.

For an older generation of artists and writers, such as Gustav Metzger and Jeff Nuttall, the possibility of nuclear annihilation defined their activity within what Nuttall chose to call Bomb Culture. Jazz bands, skiffle groups, poetry readings and the attendant dress codes of black jerseys, jeans and duffle coats hardly got in the way of the grim earnestness pictured in Roger Mayne's bleak and cold pictures of protesters marching in the belief that vaporisation was round the next corner. The foundation of the Committee of 100 in 1960 further pushed the boundaries of the level of political engagement within CND with its programme of mass civil disobedience which saw many of its leading figures jailed in 1961 for refusing to be bound over to keep the peace. Coffee bars provided a backdrop for much of this activity (as they also did for pop music at the same time) — younger members of CND met at the Peace Cafe in Fulham Road, the Committee of 100 was formed after meetings at the more monkish Partisan Cafe in Soho (under the offices of the *New Left Review*). Metzger also frequented The Farm, in Soho, where his first public presentation of auto-destructive art was made in 1959.

Live New Departures also naturally made such places their milieu. This grouping around Horovitz and Brown took beat-inspired poetry on the road and was emphatically multi-disciplined. It grew out of Horovitz's magazine *New Departures* and had been 'conceived in the name of experiment — an act, or course of action, of which the outcome is unknown. Experimental drama and music exist in notation, but only live in performance. Experimental poetry is based not on literary fashion or authority, but experience, which calls out to be articulated in a certain way. Ergo, "Live New Departures".'[9] As well as coffee bars, it took its brand of experimentation to galleries,

schools, prisons, civic and university halls, bookshops, clubs and pubs, radio, TV and private studios, as well as parks, squares and streets. For a season in 1963 Horovitz and Brown even mounted a series of jazz-poetry readings at the Marquee, performing and improvising within a constantly changing environment of coloured lights, slides and back-projections 'to stimulate the jazz musicians into playing free music by giving them abstract coloured patterns to contend with'[10] – a precursor of the light shows organised by Mark Boyle and Joan Hills for the Soft Machine at the UFO club three years later. Travelling all over the country Horovitz put on over 300 shows between June 1959 and June 1964. They not only established a British beat, or jazz, poetry which typified much that was performed at the Albert Hall, but also 're-established the oral/musical traditions for poetry' in which poetry and jazz were intertwined, and presented in the context of activity which included theatre (Beckett, Artaud and Ionesco), performance by The Alberts, music by the Live New Departures Quintet, Cornelius Cardew, John Cage, Morton Feldman, Arnold Schoenberg, as well as the more event-based compositions of George Brecht, Dick Higgins and La Monte Young. Poetry moved from the page to be given identity and reality as an event. Furthermore, politics, as the driving force behind protest, was gradually being replaced by culture in its widest sense.

Since they first met at the Beaulieu Jazz Festival in 1960, Horovitz and Brown also succeeded together in creating a voice and audience for an improvisatory jazz poetry in Britain. But they also proved that cultural activity did not only take place in London. The audience for the International Poetry Incarnation was primarily made up of people from the regions – the places Live New Departures had visited over the previous six years. The voice of The New British Poetry was resolutely not a London-based one. As Horovitz observed, 'towns with a thriving underworld of clubs and musicians and art students, multiracial late night populations and voluntary unemployment, tend to breed more intelligent fresh and sensitive audiences'.[11] Most of the major little magazines grew up alongside locally-inspired vibrant scenes: *Poetmeat* in Blackburn; *Dust* in Leeds; *Tlaloc* first in Blackburn and then Leeds; *Phoenix* and *Underdog* in Liverpool; *King Ida's Watch Chain* in Newcastle, a collaboration between Basil Bunting, Richard Hamilton and Tom Pickard (whose Modern Tower Book Room was a centre for poetry and multimedia activity in Newcastle after 1964; *Migrant* in Worcester; and *Move* in Preston. As if to ram this point home, shortly after having arrived in May 1965 Ginsberg had left

London and toured through the country, visiting and giving readings in Worcester, Bristol, Cambridge, Newcastle and staying with Pete Brown for a week in Liverpool.

Captivated, Ginsberg declared that 'Liverpool is at the present time the center of the consciousness of the human universe.'[12] Of all regional cities, Liverpool had already had the spotlight thrown on it as the home of the Beatles, but the poetry scene – typified by the regular readings organised by Adrian Henri and Johnny Byrne at Streate's Coffee Bar and Brian Patten's magazine *Underdog* – developed alongside, not as a result of, the pop scene. As with Horovitz, the events organised by Henri, Byrne, Roger McGough and Patten exploded the boundaries of what might be considered poetry. Henri had studied art in Newcastle and Durham, and had found in the work of Allan Kaprow confirmation for his own practice, which was already mixing poetry and music with assemblage. Mixed-media events such as *City*, 1962, and *Nightblues*, 1963, staged by Henri for the Merseyside Arts Festivals in those years, were characteristically described by him as 'a popular form of entertainment: a mixture of poetry, rock 'n' roll and assemblage'.[13] As if to underline this point, his more political collaborations with Patten, *Bomb*, 1964, and *The Black and White Show*, 1965, were both performed at the Cavern Club, home of the Beatles.[14]

Although to Henri his embrace of popular accessible forms was a positive step, to others it rendered their work, and the other British beat poets, lightweight. Horovitz had put down the Liverpool poets except for Patten who was in his eyes 'the man most responsible for building the *actual* Liverpool scene … Adrian Henri and Roger McGough are now becoming outspokenly pop artistes – & very good ones: but the hard core of working "public" poets worthy the name still have less in common with either pop painters or pop musicians than they do with the unbroken Young Christian Monk Getz Dizzy line of rhythm & blues & roots & bop.'[15] In a sense Henri was right and Horovitz wrong: Jazz had more to do with the grim determination of Aldermaston protesters; Pop was about frivolity, about changing the world and having a good time doing it – it was also becoming more of a mass-cultural force than the rather niche world of the jazz enthusiast and as such had the capacity to frame a burgeoning counterculture in ways that jazz just could not.

The status of all the British Beat poets as a credible avant-garde voice was, however, in question. Groups like Live New Departures or Henri's poetry-satire group The Scaffold had introduced a performance element to poetry that broke down barriers with other

birhopal takistruct

eyear poem for Takis Vassilakis

```
        A   TASIKATI
        KI  KASISAT
        SAT  IKASIK
        IKAT  ATIKA
        ISASI  TISA
        KATISA  KIS
        TIKATIK  AT
        ASITASIK  I
```

```
PROGRAM -
TaKiS - consonants permuted  ordered alphabetically
        & reversed:  KST KTS SKT STK TKS TSK
                     TSK TKS STK SKT KTS KST

then infold vowels - row 1  a-i-a-i-a-i- &c
                      row 2  -a-i-a-i-a-i &c

order resulting 36 letters in each row rhopalically
                      row 1  1 - 8
                      row 2  8 - 1

accent penultimate if A   otherwise antepenultimate

dsh 281164
```

disciplines whilst also adopting a culturally oppositional and questioning stance. However, from around 1962 or early 1963, and in parallel to the British beat poets' romanticised adherence to the authenticity of improvisation, a more structured, abstract poetry was being developed — primarily, and in very different ways, by Ian Hamilton Finlay in Edinburgh, Dom Sylvester Houédard in Gloucestershire and Bob Cobbing in London. They also moved through different disciplines, and a little over five months after the International Poetry Incarnation the breadth of the concrete poetry movement was made plain by the exhibition 'Between Poetry and Painting' at the Institute of Contemporary Arts. Organised by Jasia Reichardt, the exhibition took a positively inclusive view that conflated concrete poetry with both visual and sound poetry. The 1958 'Pilot plan for concrete poetry' of theBrazilian Noigandres group — one of the major pioneering statements for the development of concrete poetry in the fifties — certainly discussed concrete poetry in relation to both art and music but also stated categorically that the 'concrete poem communicates its own structure: structure-content. concrete poem is an object in and by itself, not an interpreter of exterior objects and/or more or less subjective feelings. its material: word (sound, visual form, semantical charge). its problem: a problem of functions-relations of this material ... with the concrete poem occurs the phenomenon of metacommunication.'[16] Although these words were paraphrased by Dom Sylvester Houédard in his 1963 essay on concrete poetry and the work of Ian Hamilton Finlay — the first definition of concrete poetry to be published in Britain — Houédard's range of reference was much wider than the Brazilians, and also created a space in which concrete poetry, beat poetry and the exploits of Live New Departures could all exist on the same stage.[17]

Concrete poetry did, however, come under attack for its inability to incorporate individual experiences and emotions within its objective formal structures. Finlay refused to compromise in his work, evolving his own poetic language out of the work of the Noigandres group and the more playful work of Eugen Gomringer. In contrast, Houédard and Cobbing elaborated forms of concrete and sound poetry that acknowledged the possibility of such experiences within their poems' communicative forms. Houédard had been aware of Ginsberg's poetry and that of other beat poets since the early fifties and had been initially attracted to the 'inner sacred source of its vision', though by 1962 he was becoming increasingly dissatisfied with the truthfulness of such work.[18] Even though a concrete poem should be non-

Fig.79
Dom Sylvester Houédard
birhopal takistruct
eyear poem for Takis Vassilakis 1964

descriptive, make no reference outside itself and should have no key, Houédard realised that 'in the mss-typography-typewriter-letraset tradition this is basically impossible', and given his earlier interest in beat poetry it is hardly surprising that he could not ally himself with such a purity of objectivity. His solution was to look to movement and space within the concrete poem that allied itself to kinetic art, to create 'a poetry not of alphabets commas mathsymbols & meta-post-hyper-super-letters &c but of movement & relation-ship between elements'.[19] His poems, termed by Edwin Morgan as 'typestracts' (all created using an Olivetti Lettera 22 typewriter), rely on a level of movement within the reader's eye that is significantly 'just as kinetic as movement of poem'.[20] His typestracts are about movement and time in their reading; they signal possible events, each word being both an object and an act. One aspect of his 'kinkon' (kinetic/konkrete) poems is their creation as prototypes for large machine poems in which 'the communicant signs are partly the grids that move & partly the move-ment observed but even more they are the relationship between grid & pattern'.[21] In this respect repetition, flicker and serialism are motivating aspects of his work, each coming together in a permutational poem like the 1964 *birhopal takistruct eyear poem for Takis Vassilakis* (fig.79) in which the individual letters of the kinetic artist's name fold in on each other according to a given programme and gridded structure.[22]

For Houédard, Bob Cobbing was the major sound poet in Britain and yet his poetry ranged from work made for the eye and that made for the ear or, as Houédard classified it, from 'ear' to 'eye-ear' (phonic poetry 'with an eye equivalent') to eyear ('poetry tending to balance appeal between eye-ear');[23] or as Cobbing less abtrusely explained, 'a sound poem is a sound poem is a pattern of sound, though a visual equivalent may be made. A typestract is visual, though it may be read.'[24] The range of his work as well as its often emphatically physical appearance – his main materials were a typewriter and duplicating machine – exceed the boundaries of concrete poetry, embracing many different disciplines, but the centrality of Cobbing's position in London in the early sixties was formed not just as a result of his poetry but through his role as a catalyst and publisher for other writers and artists. By the early sixties he had, for more than ten years, run an art club in Hendon, which as Group H was now no longer local, its exhibitions including work by Latham, Nuttall, Lacey and Barry Flanagan. In tandem Cobbing had set up the publishing press Writers Forum and set about publishing both his own work as well as, by 1965, work by Hollo, Ginsberg, Jandl,

Lee Harwood and Houédard, amongst others (of these Hollo, Ginsberg and Jandl read from their Writers Forum publications at the International Poetry Incarnation).[25]

The following year he took over from Miles as manager of Better Books. From November 1964 Cobbing and Nuttall used the shop's basement for exhibitions and events as an extension of Group H. Their first event had been a happening by Charles Marowitz and Ken Dewey, and this was followed in February 1965 by one of the shop's more notorious events – the *sTigma* environment – a colla-boration, directed by Nuttall, with Criton Tomazos and other Group H members, Lacey, John Latham, Nick Watkins, Keith and Heather Musgrave and Dave Trace. Nuttall had by this time come under the direct influence of William Burroughs and Trocchi. On 1 February 1964 he staged his cut-up publication *Mr Watkins got drunk and had to be carried home, a 'party-piece cut-up from an Idea by William Burroughs'*,[26] and soon after started publishing Burroughs's cut-up communications from Tangier, 'The Moving Times', in his own cut-up (sometimes physically lacerated) duplicated magazine, *My Own Mag*. Nuttall's intention was to 'make a paper exhibition in words, pages, spaces, holes, edges, and images which drew people in and forced a violent involvement with the unalterable facts. The message was: if you want to exist you must accept the flesh and the moment. Here they are. The magazine ... used nausea and flagrant scatology as a violent means of presentation. I wanted to make the fundamental condition of living unavoidable by nausea. You can't pretend it's not there if you're throwing up as a result.'[27] Nuttall's evocation of nausea in *My Own Mag* was the foundation of the oppressive labyrinth that was the *sTigma* environment. In a cramped and uncomfortable set of spaces – a hellish home – Nuttall's collaborators went on to create a violent iconography of war atrocities, pornography, bodily abjection and mechanised totemic sexualised depravity, which he termed as an 'experience' rather than an exhibition and which was 'designed to make people feel more'.[28]

Both the tenor of the *sTigma* environment and its title reflected Nuttall's recent allegiance to Trocchi's Project Sigma. A little over two years earlier Trocchi had declared that 'Modern art begins with the destruction of the object. All vital creation is at the other side of nihilism. It begins after Nietzsche and after Dada.'[29] With this statement he raised a liberating if nightmarish standard for a generation of artists and writers who enacted a retreat from the word as much as from the object and the past to create new time and new space through speed, violence,

engagement and the negation of any categorisation. For Trocchi, as for Burroughs, this entailed a new approach to language described as 'meta-categorical': 'To free themselves from the conventional object and thus pass freely beyond non-categories, the twentieth century artist finally destroyed the object.'[30] This position was explained as an event without defining objects, in which intersections could be mapped and new horizons sought; in which an alienated space of being could be deconstructed and so provide a platform for the subversion of social and cultural norms. For Burroughs, as recognised by Nuttall, this notion of an event was realised in the cut-up[31] through its potential for laying out a fragmented time of experience on the space of the printed page where narrative was dissolved, words were deployed to chart primary experience and where the authorial voice could be decisively questioned.

For Trocchi, portraying himself as alienated from the norms of society as a 'member of a new underground', this particular ideal of the event provided the basis for his elaboration of Project Sigma in providing the means and motivation for a 'meta-categorical revolution', the 'invisible insurrection of a million minds' and 'a coup de monde' which owed much to his friendship with Guy Debord and his close involvement in Paris since 1954 with the Lettrists and their successors the Situationists.[32] Project Sigma's main legacy is its series of duplicated publications under the title of the *Sigma Portfolio*, but if these give an indication of its elusive aims and its fluid identity, the cultural revolution Trocchi was calling for is even harder to pin down. As he explained to Burroughs, 'it would be misleading ... to differentiate between [Project Sigma's] communicative and research aspects, since there was no question of there being some (static) informations to be communicated, but rather a way of life (a creative posture) to be adopted and lived infectiously.'[33] Project Sigma may indeed have seemed 'imperfect, fragmentary and inarticulate',[34] but this was because Trocchi realised that 'What is to be seized is ourselves'.[35] This was Sigma's barely expressed yet most positive aspect – the creation of a revolution as a 'spontaneous university', and it accounts for his central involvement in the International Poetry Incarnation, just as it does the botched contributions of Lacey, Latham and Nuttall.[36]

Trocchi's call for revolution was also heeded by Miles who, a few months after the International Poetry Incarnation, published *Long Hair: 1 North Atlantic turn-on*, the major part of which was taken up with publishing Ginsberg's poem 'Ankor-Wat'. Miles's editorial declared its association with the 'huge scale of interest and participation' witnessed at the Albert Hall, its wholehearted allegiance with Project Sigma, and listed different countercultural figures and groups with which the magazine identified in a manner similar to the poetry festival's invocation, before stating categorically that 'LONG HAIR is for the POETRY revolution, the PROSE revolution, the CLOTHES revolution, the JAZZ revolution, the POP revolution, the SEXUAL revolution, the revolution of the mind, free thought and action and LOVE.'[37]

Despite Miles's seemingly light-hearted declaration, he was not alone in his call for a cultural revolution – a counterculture – that would change every aspect of life. Nevertheless, the alienated and much darker views of Nuttall and Trocchi reflected more accurately a growing group of artists who situated their activity within this milieu. Chief among them was Gustav Metzger, whose elaboration of an 'aesthetic of revulsion'[38] echoed Nuttall's poetics of nausea and Trocchi's embrace of Artaud's void, just as it also bore witness to his past as a child refugee from Nazi Germany in 1939 and the destruction of much of his family in the holocaust. Through the fifties he sought a fusion of his artistic practice with a committed political position that saw him take part in the activities of the Direct Action Committee Against Nuclear War and its actions against rocket bases in East Anglia, before moving to London the following year.[39] In London he definitively moved away from a concern with the painted object (he had earlier been a pupil of David Bomberg) and elaborated the theory and practice of auto-destructive art, whilst at the same time becoming one of the founding members of the Committee of 100, a more militant splinter group of CND. Following its demonstrations in 1961 he was arrested and imprisoned. Metzger's political activism at this time was embodied within the very fabric of his work, not as an illustration of ruins or a metaphor for social sickness, but as the very presentation of a clear, unfettered and progressively destructive force. That destructive force was itself a part of that which it was commenting on and, in the process, it effectively eliminated the ego of the artist. In 1962 for the Festival of Misfits – a Fluxus exhibition in London that also included Robert Filliou, Adi Koepke, Robin Page, Benjamin Patterson, Daniel Spoerri, Ben Vautier and Emmett Williams – Metzger proposed to show two different editions of the *Daily Express* for 24 October 1962, the headlines in which graphically described the deepening Cuban crisis. Spoerri and Filliou objected and Metzger withdrew from the exhibition. However, the direct and politically-determined nature of his work was at odds with the more playful bohemianisms of

the other artists involved in the exhibition.[40] Metzger's was a public art in which the resources and technology that would destroy the planet were harnessed to deliver a 'pharonic vision' of monuments 'to the power of man to destroy life'.[41]

To these ends Metzger painted with acid on nylon sheets that would finally disintegrate, or projected light through liquid crystals that at certain temperatures would change their colours and structure. Harold Liversidge's 1963 film of Metzger painting with acid on a nylon screen on the South Bank of the Thames facing St Paul's portrays Metzger dressed in the clothes of war, culled from army surplus stores – combat jacket, pilot's goggles, oxygen mask and gauntlets – both to protect him from the acid and underline his position as a revolutionary (fig.80).[42] The film reveals the dichotomies at the heart of auto-destructive art: that at the other side is an idea of auto-creative art, just as the aesthetic of revulsion walks hand in hand with beauty. As he later explained, 'Auto-destructive art is deeply concerned with beauty, with a terrible beauty. Adorno questioned beauty: what do we do after these calamities behind us and also facing us now? How do we respond? I responded with auto-destructive art. It is tinged with horror, threat and beauty ... A sheet of nylon can itself be very beautiful and then you take

material that will destroy it within seconds – tearing it to tatters which fall onto the floor. Well it's rather revolting isn't it? ... And you cannot touch the pieces of nylon that have fallen to the floor – they are acid, you would burn yourself. You shrink from the smell of acid.'[43] The film shows built-in obsolescence and the willed destruction of the demolition site and the stock car race – 'the chaotic, obscene present'.[44] Acid is applied both by a brush on a pole, creating tears in the cloth momentarily close in form to those in Fontana's series of 'Concetto Spaziale, Attese' paintings, and by a diffuse spray. In time the nylon sheet disintegrates and falls away to reveal a view of St Paul's cathedral framed by tatters of nylon falling to the ground.

It was in his pursuit of a socially-engaged public art that Metzger initiated the Destruction In Art Symposium (DIAS) throughout September 1966 – a month of events by a wide range of artists with a three-day symposium at its focus. Some fifty artists from ten countries were encouraged to take part, among whom were the Viennese Institute of Direct Art (Günter Brus, Otto Mühl, Hermann Nitsch, Peter Weibel and Kurt Kren), who were performing outside of Austria for the first time and whose invitation had been arranged by Ernst Jandl.

Fig.80
Gustav Metzger
Demonstration of auto-
destructive art on the
South Bank, London,
1961

Fig.81
The panel of the
Destruction in Art
Symposium. From
left to right: Gustav
Metzger, Wolf
Vostell, Al Hansen,
Juan Hidalgo.
Photo by Tom Picton
Collection of the
photographer's family

Fig.82
The Destruction
in Art Symposium,
Africa Centre, 1966
Photo by Tom Picton
Collection of the
photographer's family

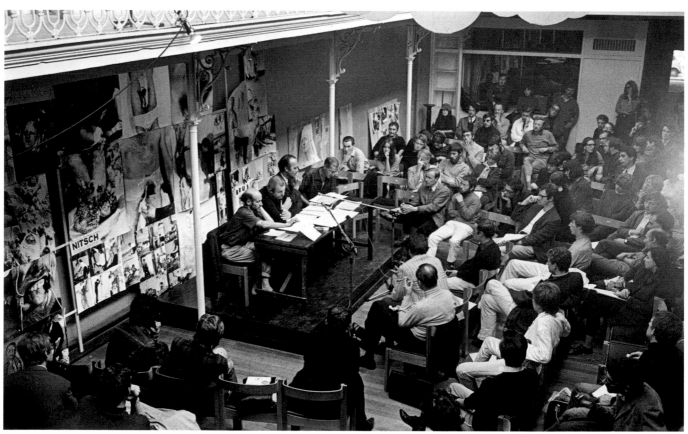

DIAS's aim, given its invitation to scientists, philosophers and psychoanalysts as well as artists, was not wholly artistic. It was an attempt to link theoretical issues of destruction with actual destruction taking place in society, in science as well as art. As a result it necessarily threw its net wide, taking in 'atmospheric pollution, creative vandalism, destruction in protest, planned obsolescence, popular media, urban sprawl/overcrowding, war... biology, economics, medicine, physics, psychology, sociology, space research.'[45] Even so, despite this ambition, the contributors to DIAS were in the main artists and the event's continuing significance can be recognised in the extent to which it provides a marker, in much the same way as the International Poetry Incarnation did the previous year, for an art that could engage with contemporary realities – an art that rejected the objectified image in favour of the dynamics of the event.

The contribution of the Viennese artists pointed towards the catharsis that DIAS hoped the use of destruction could deliver, whilst also underscoring the move from painted expressionism to bodily event. If Nitsch's *21st Action*, stopped by the police, was emphatically ritualised (fig.83),[46] Brus and Mühl's *Ten Rounds for Cassius Clay* (fig.84), in which a woman was covered in all sorts of foodstuffs and domestic products before Mühl leaps down to embrace her, threw a spotlight on individual as well as more socialised repressions. The Viennese presented an extreme investigation of freedom that admitted sadism, obscenity, aggression and perversity, proclaiming the 'aesthetics of the dungheap' as the 'moral means against conformism, materialism and stupidity'. Mühl, like Brus and Nitsch, was 'against laws and social rules no longer founded in reality'.[47]

As with the Albert Hall event, the organisers of DIAS provide a vivid picture both of the evolving countercultural community and its subversive aspirations. The organising committee included Mario Amaya, the editor of *Art & Artists*, whose August issue was devoted to destruction in art; Ivor Davies, an art historian, painter and creator of explosive happenings; the German happenings artist Wolf Vostell; Jim Haynes, who ran the Traverse Theatre at the Jeanetta Cochrane Theatre (one of the venues for DIAS events), who was on the editorial board of London's recently established underground newspaper *International Times* (IT) and was later to create the multimedia Arts Lab in Drury Lane; and Miles, who now ran the bookshop of the avant-garde Indica Gallery and was also on the editorial board of IT.[48] Taking a less active role were Roy Ascott, cybernetic artist and organiser of the Ealing Ground Course;

This page
Fig.83
Hermann Nitsch,
21st Action
Performance given as
part of the Destruction
in Art Symposium, 1966
Photo by Tom Picton
Collection of the
photographer's family

Opposite
Fig.84
Günter Brus and Otto
Mühl, Ten Rounds For
Cassius Clay
Performance given as
part of the Destruction
in Art Symposium, 1966
Photo by Tom Picton
Collection of the
photographer's family

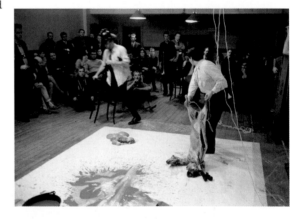

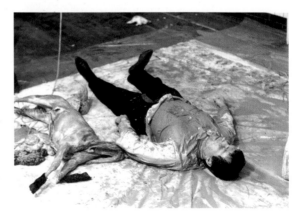

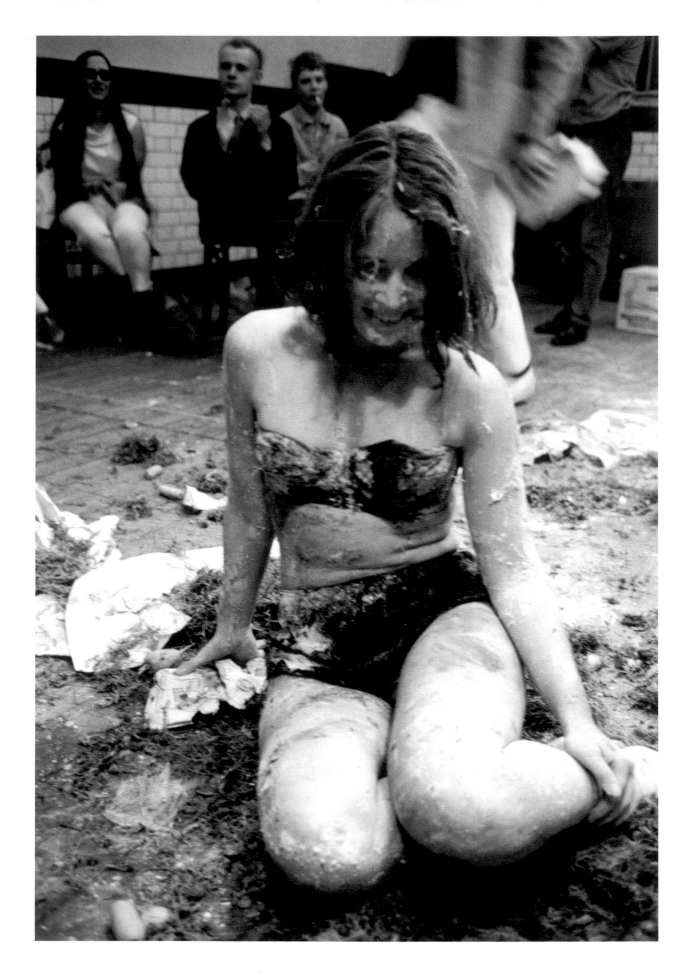

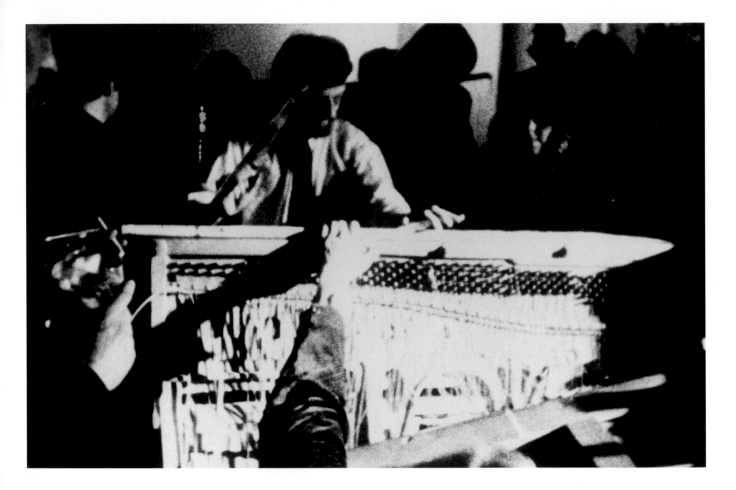

Fig.85
Mark Boyle and Joan
Hills, piano being
smashed and remade
during the event Oh
What a Lovely Whore,
1965
The Boyle Family

Enrico Baj, member of the Gruppo Nucleare in Milan; and the critic of kinetic art, Frank Popper.

Significantly, there were also three concrete poets on the committee: Bob Cobbing, who gave over the basement of Better Books for some of the events, Dom Sylvester Houédard and John Sharkey (who had also been gallery manager of the ICA for a year). Houédard found many points of contact between his own work and the concerns of DIAS, not least DIAS's prioritising of event-structure over object, reflecting Houédard's interest in the optical and kinetic structures underpinning his work. He, like Cobbing, was in sympathy with the manner in which Metzger and his colleagues were investigating a new set of languages, processes and means to effect a more fully engaged representation of the world. More specifically, Houédard made a direct link between Metzger's declaration that in his acid-nylon technique 'it certainly isn't the strips of nylon left that are important, it is the non-nylon', and the white space in the concrete poem being more important than the black printed areas it surrounds, energises and gives meaning to. He also emphasised auto-destructive art's 'ultimate interiorisation of the object ... semi creation of nothingness', and that it and concrete

poetry rested on the 'eliminated ego' of both artist and writer.[49] Houédard's concern with the 'destruction & invisibility in (the structuring of nothing into) poetry', the elimination of ego and his emphasis, like Metzger, on the creative aspect of auto-destructive art can be recognised in the work of John Latham, the light shows and earth pieces of Mark Boyle and Joan Hills, who were all participants in DIAS, and in the bio-kinetic works of David Medalla, whose work relied on the operation of chance through the continuous transformation of material. However, none of these artists engaged as directly with the issue of destruction as Metzger did, nor was there such a great politically directed element to their work either.

Boyle and Hills's work in the early sixties could be seen as analogous to the events organised by Henri in Liverpool, Live New Departures or those by Nuttall and Lacey. Indeed, they had on occasion collaborated both with Michael Horovitz and Cornelius Cardew, and in 1964 with the Alberts in *Exit Music*. Boyle and Hills's first event was *In Memory of Big Ed*, 1963, mounted as part of the Theatre Conference at that year's Edinburgh Festival. It connected with the theatre of the absurd as much as with the very different absurdist satire that the

Alberts delivered in their 'An Evening of British Rubbish' performances, or the constructions and robots exhibited by Lacey in 1963 at London's Gallery One, made from dexion units and government surplus objects that he had been recycling in his performances as the Preservation Man.[50] During this period Boyle and Hills had been making assemblages from what they discovered among the urban wastelands of inner city London, still pockmarked by twenty-year-old bomb sites and the demolition sites that had accompanied the city's reconstruction. The new realism they sought was not a Pop celebration of the everyday but used what had been discarded and thrown away as markers for the unseen textures of life. Their events, such as *Street*, 1964, and *Exit Music* relied to a degree on chance, whereby the detail of everyday life that usually goes unobserved became the substance of the

in destruction as it was projected through DIAS and the antics of artists like Ortiz. Boyle's statement, accompanying their contribution to DIAS, makes it clear that he was more involved in expressing a totality of existence in which creation and destruction coexisted, rather than just isolating destruction: 'I don't think I'm especially interested in "destruction in art". I'm interested in destruction as an aspect of everything ... Things are created and survive only by the destruction of other things.'[53]

If Houédard was concerned with 'invisibility' and 'nothing', by 1966 Boyle and Hills had elaborated a practice that focused on visibility and everything. And yet, like the concrete poets, their art — complex reconstructions of randomly chosen areas of ground and multimedia light show events that revealed the layering of life — was similarly ego-less.

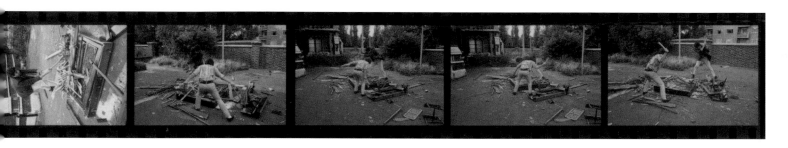

work, the audience being placed in a direct confrontation with the city, virtually unmediated by the artists save for the framing structure they imposed on each event.

This was certainly the case for their event at the ICA in 1965, *Oh What a Lovely Whore*, in which the audience was invited to take over and perform the event themselves and use the available props in whichever way they saw fit (fig.85). The audience went 'berserk' according to one account: 'They worked projectors and tape recorders, performed on numerous plastic instruments, painted by numbers, smashed a piano, took scripts from actors, acted with them or directed the performance, danced with ballet dancers, edited films and projected them onto walls, ceiling and people, directed a film of the proceedings, controlled the lighting, jumped on trampolines, prepared a press communiqué. They decided to build a new type of piano out of the pieces of the old. It began to be the centre of the event. It was smashed and re-smashed.'[51] The following year Ralph Ortiz also destroyed a piano as part of his contribution to DIAS (fig.86), and yet where Ortiz saw the 'object as the enemy' and called 'for more breakage, less timidity',[52] Boyle and Hills disagreed with Metzger's interest

The subjects for their reliefs were chosen through a random system and, although scored, the passage of each event took on its own momentum. Their event for the launch of DIAS, *Son et Lumière for Insects, Reptiles and Water Creatures* (fig.87), was the second in a trilogy that aimed to show the elements of the world, the creatures that live in the air, earth and water, and the workings of the human body and its functions as yet another form of potentially endless landscape study, 'aware that whether we watch or not the process of destruction/creation continues everywhere in our universe and in ourselves'.[54] Boyle and Hills adopted as their subject 'everything' in the world as a means of providing the possibility that the world could be seen and understood afresh — that 'the most complete change an individual can effect in his environment, short of destroying it, is to change his attitude to it'.[55]

Destruction was only one aspect of John Latham's practice and he did not subscribe to the revolutionary political ideas that underpinned not only Metzger's auto-destructive art but also Trocchi's Project Sigma.[56] For DIAS he presented the burning down by incendiary devices of a number of 'Skoob towers', Babel-like towers, constructed from books attached to a metal armature. He also

Fig.86
Ralph Ortiz, Piano Destruction Performance given as part of the Destruction in Art Symposium, 1966
Photo by Tom Picton
Collection of the photographer's family

Fig.87
Mark Boyle
and Joan Hills
Still from <u>Son et
Lumière for Insects,
Reptiles & Water
Creatures</u> 1966
The Boyle Family

Fig.88
David Medalla
Cloud Canyons no.1
1964
Artist's collection

presented *Film*,[57] in which two body-painted
participants with printed pages and books
applied to their bodies moved in a prescribed
way. Both events questioned the grammar
of knowledge and known reality, showing
reality to be made up of a dislocated and
artificial set of untruths. This questioning
was also followed by Cobbing who, in his
characteristic contribution to the final event
of DIAS, ran the stencil of the symposium's
press release through the duplicating machine
until it broke up, the final state of which
produced visual poems close in character to
a fetid open wound, the validity of the printed
word having been chaotically dismantled
(fig.90). Latham's use of the term 'skoob'
to describe his book installations as a 'form
of literature, to be read as what happens/ed,
to be looked at whole',[58] destabilises orthodox
notions of language. Allied to this is his obses-
sion with the determining metaphysics of
time. He was less preoccupied with the notion
of destruction than with the invalidation
or dematerialisation of objects in favour
of processes of cognition that were carried
out in time rather than locked into a delimited
space. Latham questioned and deconstructed
the viewers' orthodox understanding of
knowledge and its status, for which books
stand as metaphorical and actual containers,
in the realisation that the languages by which
we live our lives evolve and function through
time, even though this might often be denied
in a book's form and appearance as a collec-
tion of words and images. In his first major
book relief, *Burial of Count Orgaz*, 1958
(fig.89), he took El Greco's painting bearing
the same title as a model for the beginnings
of a theory that could conceive of reality as
a single unified system resulting from the
collision of knowledge, language and time,
as an event structure. The use of fire in his
'Skoob Towers' had a similar effect to the use
of black spray paint in his reliefs as an actual
(rather than representational) sign of the
action of time.

In this respect Latham is close to that other
half of Metzger's theories of auto-destructive
art, which entailed an auto-creative art, codi-
fied by Metzger in both his third manifesto
'Auto-Destructive Art Machine Art Auto-
Creative Art' of June 1961, and his final
manifesto, 'On Random Activity In Material/
Transforming Works of Art' of July 1964.
This latter manifesto, concerned with the
transformations felt through random activity
in art, as in society, was published in *Signals*,
the news bulletin of the Signals Gallery,
directed by Paul Keller and the artist David
Medalla.[59] The transformations that Medalla's
bio-kinetic work underwent stood beside
other transformations taking place in society
and life in general. It is this aspect that
was at the root of much kinetic art, such

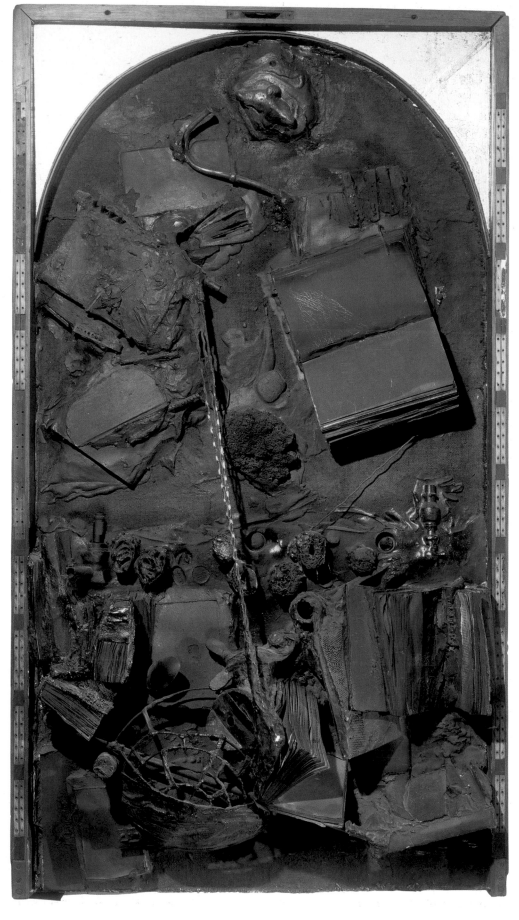

Fig.89
John Latham
Burial of Count
Orgaz 1958
Tate

Fig.90
Bob Cobbing
Stencil of the invitation
to and programme of
the Destruction in Art
Symposium, 1966,
gradually destroyed
on a duplicator
and printed at
each stage
Collection of the
artist's estate

was being extended to social structures and people. To these ends, Stephen Bann observed that the significance of Metzger's acid-on-nylon technique in relation to kinetic art rests in the way the movement and expansion triggered by the action of the acid cannot be regarded 'as neutral demonstrations of movement'.[60]

The main division within kinetic art in the first half of the sixties was between those artists whose work involved the movement of formal structures and those artists who, as Guy Brett has succinctly described, 'were searching for a new structure of material transformation, and a new space. What was at stake was to make visible the equivalence of matter and energy ... The new structure would achieve greater freedom and depth by being transparently simple, being both ordinary and cosmic at the same time.'[61] To these ends Medalla's work harnessed water, rice, gold and silver dust, sand, powdered coal, granulated coffee beans, dried seeds, rubber, gum, ice, salt, oil and steam. His best known works of this sort were a form of bubble machine, collectively titled *Cloud Canyons* (fig.88), in which the foam that is produced followed 'its aleatory paths, emerging and forming according to its own energies inter-acting with gravity, earth currents, atmos-pheric pressure and the shape of the contain-ers. Never the same two days in a row.'[62] Metzger, who had contributed to the founding of Signals gallery in 1964 with Medalla, wrote of these works in a similar vein, emphasising the role of random activity in their presentation: 'A quarter million forms continuously changing, reflecting, growing, disintegrating. Random activity is at present among the most crucial questions in art ... Medalla has shown conclusively that random activity in material/transforming art is capable of achieving not only the most complex forms and motions but also an aesthetic content of the highest order.'[63]

Metzger's observations apply not just to Medalla's work but also to many artists not normally associated with kinetic art — Metzger himself, but also the light shows of Boyle and Hills in which the projected actions of chemicals or microscopic creatures reveal a movement that is uncontrolled by the artist save for the fact that the event process has been set in train. This is also true for the work of Liliane Lijn whose series of *Liquid Reflections* (fig.92) were shown at the Indica gallery in 1967. Rotating discs of condensing liquid served as a moving platform for two small acrylic balls that moved in a seemingly random manner, the whole illuminated by a single spotlight. The droplets of liquid trapped in the disc, together with the two balls, created a myriad of different lenses

as the work of Liliane Lijn, Takis, Marcello Salvadori, Jesus Rafael Soto and the Groupe de Recherche d'Art Visuel, who all showed either at the Signals or Indica galleries, or the more cybernetic inspired work of Roy Ascott or Stephen Willats. And it is revealing that when Medalla moved towards a more performance-based practice with the estab-lishment of his Exploding Galaxy it was with the understanding that bio-kineticism

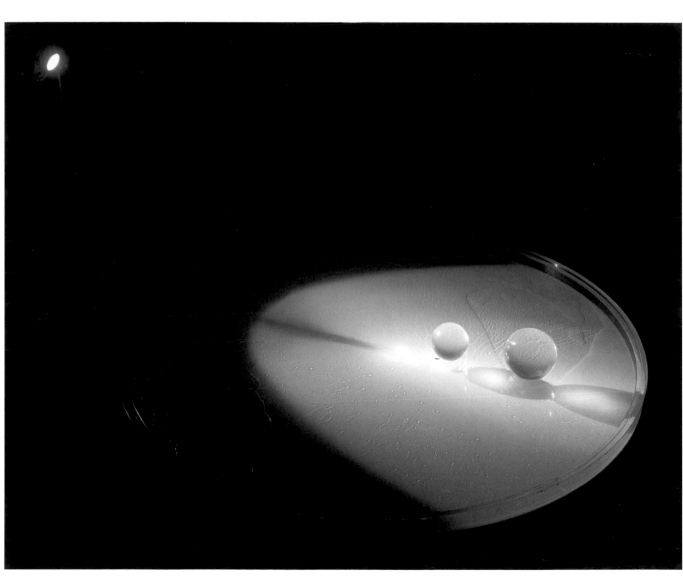

Fig.91
Stephen Willats
<u>Visual Field Automatic</u>
No.1 1964
Tate

Fig.92
Liliane Lijn
<u>Liquid Reflections</u> 1968
Tate

that captured, reflected and refracted the light. The random movement of the balls and the appearance of the liquid droplets contrasted with the constant movement of the revolving disc to create a space for reflection on cosmic forces as much as a space for a more inward meditation — another port of entry into inner space.

Lijn's harnessing of random forces was of a different order to Stephen Willats's own interest in random variables. Where for Lijn random activity could be used as a signifier for larger and more cosmic forces at play in society and on the physical make-up of the world at large, for Willats it served as an aspect of a cybernetic ordering of that society. His *Visual Field Automatic No. 1*, 1964 (fig.91), is a construction with five lights encased behind coloured gels. When in operation in a completely darkened space the five lights (four coloured and one central white light) are switched on and off in a wholly random sequence by separate homeostats, and the viewer is as a result pushed into a perceptual crisis which can only be alleviated by their projection of a possible order onto the random flashing. Their projection of order is, of course, subject to a continual breakdown and re-construction.

Such a 'game of prediction'[64] was informed by Willats's developing interest in cybernetics and behaviourism, disciplines he had first encountered as a student at Ealing College of Art, where he had been taught by Roy Ascott and William Green. Writing in the first issue of his magazine *Control*, Willats described the application of cybernetics in a more general way:

> Man lives in a constantly unstable relationship with his environment his propositions are altered and improved upon ... The observer is given restrictions inside these restrictions are variables, with which he determines his own relationship. Like a chess game, where inside the area of the board there are certain rules, from which the player determines his own move and his own relationship with the continuation of the game, if the player moves the game outside the environment of the board, he then moves into a new set of relationships, which can give him limitless possibilities of action, he then has to make a new set of restrictions. So the possibilities of action by the observer are limitless if he continues the philosophy or experience into outside reality.[65]

Willats's concern with behaviourism and its contextual workings indicated a direct engagement with the understanding and engineering of social structures. But it was coupled with an increasing conceptualisation, both in and of art practice, which was to be one of the major legacies of experimental art in the mid sixties. It is symptomatic of this direction that Lucy Lippard should use a quotation from Ascott's major early text 'The Construction of Change', 1964, as the epigraph for her 1973 anthology of conceptual art, *Six Years: the dematerialization of the art object from 1966 to 1972*.

This move away from the object in art did not happen in isolation but across culture. The written and printed word was transformed through event and action. Whether it is Michael Horovitz's event-based jazz poetry, Trocchi's meta-categorical revolution, the use of anti-psychiatry by R.D. Laing and the Philadelphia Foundation, or the concrete poets' pursuit of objective expression in which words could be put into movement, an attempt was being made to evolve new means of expression that might also reflect a possible re-ordering of dominant culture. Metzger's auto-destructive art, Latham's investigation of eventstructure, Medalla's bio-kineticism, or Boyle's pursuit of 'everything' significantly take their place within society at large. This engagement with society and social processes was partially signalled in the use of the London Free School playground in Notting Hill[66] as a site for many of the DIAS events such as Al Hansen's *Event with Motor-Cycle*[67] or Yoko Ono's evocative *Shadow Piece* (figs.77, 93). The same aspirations were graphically embodied in the Antiuniversity. Under the banner of 'music art poetry black power madness revolution',[68] it aimed to 'unify disparate perspectives ... We must do away with artificial splits and divisions between disciplines and art forms and between theory and action,'[69] and was directly founded on principles emanating from Trocchi's Project Sigma. The list of figures associated with it, and the courses they gave, included Berke on 'Anti-institutions', Cardew on 'Experimental Music', Cobbing on 'composing with sound', Barry Flanagan on 'Space', Laing on 'Psychology and Religion', Latham on 'Antiknow', Metzger on 'Auto-destructive art', Miles on 'Underground Communication Theory', Nuttall on 'Day Long Group Mind Merger', and Ono on 'The Connection'. The Antiuniversity created a 'meeting ground for discussion, discovery, rediscovery and revelation ... an on-going experiment in the development of consciousness',[70] where personal and external forces of liberation could be harnessed as an event in which material objectification was rejected. The enthusiastic reaction three years earlier to the International Poetry Incarnation had borne fruit not in any fixed community of ideas but in an ever-shifting challenge to the dominant culture and the structures that held it together.

BRUCE LACEY, THE WOMANISER 1966

Adrian Glew

> The objects I make are hate objects, fear objects and love objects. They are my totems and fetishes ... It's what I feel about life, about people. Life is not a pretty thing; these are not pretty things.[1]

In his most famous work, *The Womaniser*, Bruce Lacey comments on the profundity of sex and sexuality as a metaphor for the wider world. Executed at a critical moment in the sixties when anti-war, civil rights and sexual liberation movements were coalescing, Lacey's assemblage operates on a multitude of levels.

The figure is shown to be a licentious and lustful beast able to caress several pairs of breasts while at the same time kicking its manly legs and raising and lowering a pipe-like appendage. That the figure is both male and female emphasises Lacey's fascination with the anima and animus (psychic images of woman held by a man and man held by a woman), terms associated with the psychoanalyst C.G. Jung. Jung became fascinated by the symbols of alchemy following his break with Sigmund Freud. Jung looked at alchemy not from a scientific standpoint but from a symbolic one, as one of the precursors of the modern study of the unconscious and the transformation of personality. Using one of these symbols, Jung was drawn to the hermaphrodite as a means of discovering a process in the unconscious. Many of the original alchemists discovered personal rebirth, seeing connections to the inner and outer self whilst dealing with the phenomenon of transformation. All transformation, whether psychic or alchemical, encompasses experiences of mystery and transcendence involving symbolic death and rebirth. Lacey purposefully emphasises the transformative properties of this work by making a hermaphroditic object. Rather than being emascul-ated and displaying a sacrifice of power, *The Womaniser* can be viewed as a transformer, representing the fullness of human potentialities. It is as if Lacey wishes to pull himself and the viewer back from the male—female polarity from whence we all came.

By using male and female attributes Lacey in *The Womaniser* also taps into the cultural zeitgeist of the mid sixties as seen in films such as *The Girl from U.N.C.L.E.* and in books like *The Circle Game* by Margaret Attwood, *The Double Image* by Helen McInnes, and *The Master and Margarita* by Mikhail Bulgakov.

To counterpoise the male elements of the figure — head, 'brains' (consisting of girlie magazines) and penis — the female elements include the torso, Marigold gloves and multiple breasts. The breasts recall the statues of Artemis Polimastros found near the great temple dedicated to her at Ephesus in Turkey. Artemis has many attributes, from lady of the forest and all the wild things to presiding over childbirth and protecting the young. In poetry, Artemis became associated with the Goddess of the Dark of the Moon,

connected with deeds of darkness, evil magic and an awful divinity known as Hecate. Artemis, with Selene in the sky and Hecate both in the lower world and the darkness above, became 'the goddess with three forms'. Through its reference to Artemis, *The Womaniser* vividly illustrates a further polarity: the uncertainty between good and evil. Just as the male elements, with their emphasis on pornography, represent the darker side of *The Womaniser*, so the female elements hark back to Artemis's fierce and vengeful character. Lacey was aware of the burgeoning women's liberation movement, which was beginning to challenge male-dominated power structures. In the United States, women had been meeting from as early as 1964 when Stokey Carmichael made his infamous remark that 'the only position for women in the Student Nonviolent Coordinating Committee is prone.' By 1966, Betty Friedan had founded the National Organization for Women, while a more radical form of feminism took hold following the first national American women's conference in 1968, echoed in this country by a similar gathering held in Oxford in 1970.

As 1965 saw President Johnson authorising the first bombing raids in Vietnam and a dramatic increase in troop levels, good and evil were present in the public's consciousness. In this context, one can see parallels between Lacey's assemblage — through his use of ex-military items such as the inflated vinyl cylinder and bandages — and that other bitingly satirical work about the futility of the First World War, *The Merry-Go-Round* by Mark Gertler (1916). Both works depict the male and female, both concern themselves with a mindless circularity and both emphasise a certain mechanised inhumanity. Even the metallic legs remind the viewer of conflict in the form of the British fighter pilot, Douglas Bader, who lost both limbs when shot down during the Second World War. One also needs to remember that whilst Lacey was working on *The Womaniser*, newspapers were reporting a whole sequence of violent events in civilian life, from the first major race riots in the Watts district of Los Angeles in 1965 to mass killings of female student nurses in Chicago and passers-by on the campus of the University of Texas by single male snipers in 1966. Lacey's comments, made a year after *The Womaniser* was constructed, reflect this turmoil and help to provide a neat summation of the work:

> Art shouldn't just be stimulating man intellectually, or emotionally ... it should instead be awakening his conscience and his awareness of life as it is and what it is going to be, as we move forward to a frightening future where man's very individuality and personality may be lost.[2]

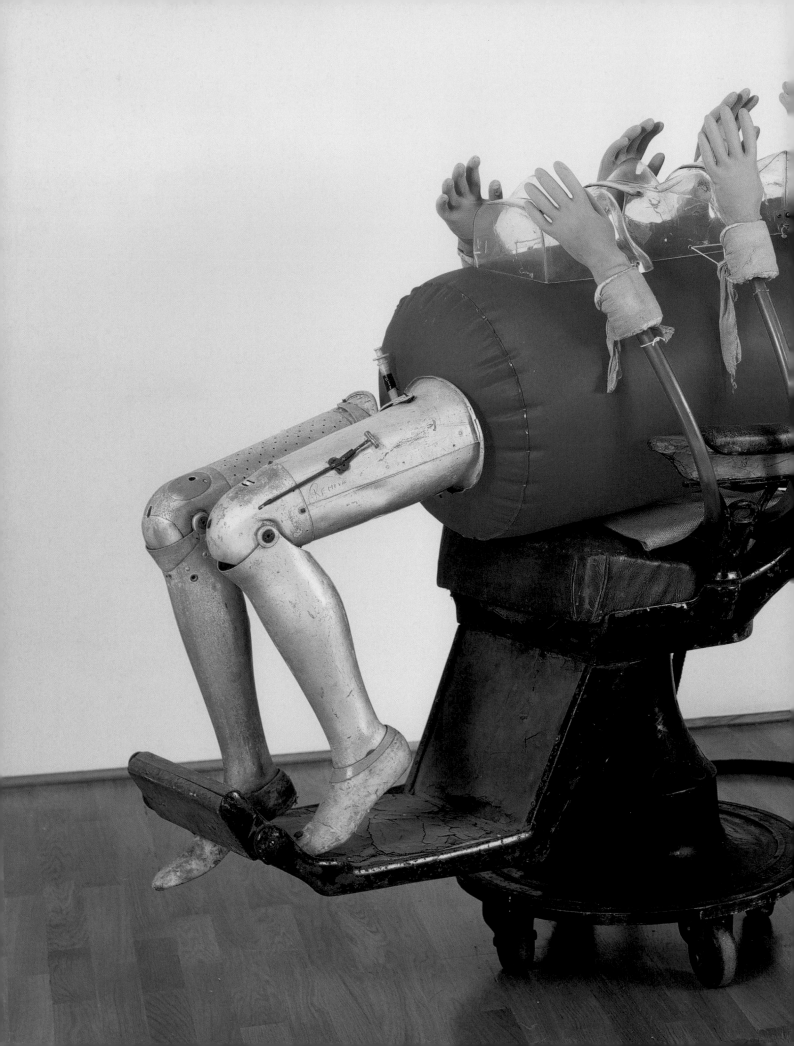

Fig.94
Bruce Lacey
The Womaniser 1966
Tate

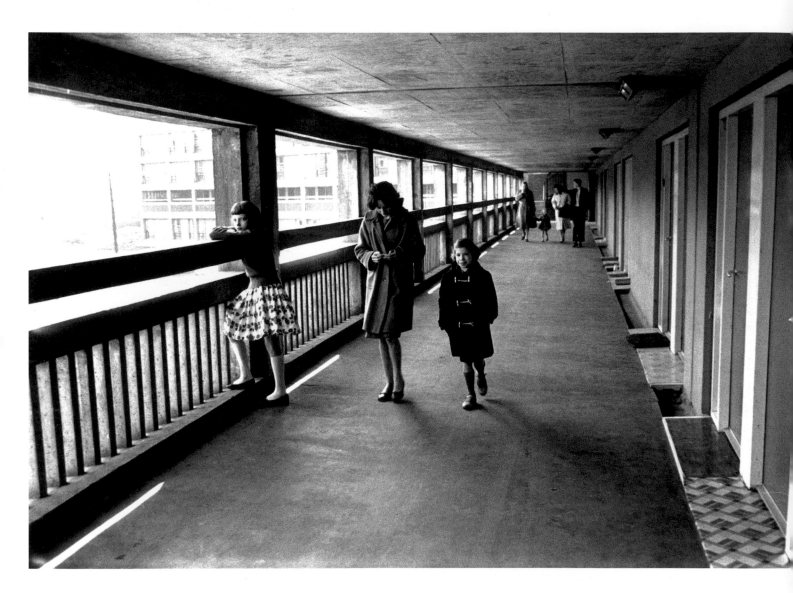

Fig.95
Jack Lynn, Ivor Smith
and J. Lewis Womersley
(architects)
Park Hill housing
scheme, Sheffield
Photograph: Roger
Mayne

BRITISH ARCHITECTURE IN THE SIXTIES

Simon Sadler

In the 1930s, the philosopher Walter Benjamin noted the melancholia of Paris's glassy nineteenth-century arcades, faded heralds of a modernity that fell out of fashion.[1] A similar aura quickly befell the designs of sixties Britain, mementoes of an affair with 'progress' warily pardoned some three decades later when, for example, the resurgent Labour Party adopted Millbank Tower in London (Ronald Ward, 1960–3) as headquarters.

During the fifties architects, builders, architectural publishers, ministries, developers and local authorities reached a near-consensus that modernism was the one true path for British architecture, setting the agenda for the succeeding decade.[2] 'Traditional' and 'classical' designs, dominant in British civil architecture and fine house-building until the thirties, were to become styles on their way to extinction in the sixties, while modernism marched beyond single buildings and named architects to govern the arrangement of space at large through the anonymity of architectural planning. By the end of the sixties, however, the consensus that modernism would accompany Britain to the hereafter was collapsing, and the de facto agreement amongst different factions was that post-war modernisation had been too much, too fast.

Eddies had always been detectable at the edges of the British modernist tide; almost as quickly as modernism became mainstream, its avant-garde reacted by encouraging architectures of irregularity and idiosyncracy. Sixties architecture presented Britishness in various compelling guises (a selection of which provide approaches taken in this essay):

as the unsentimental compassion of the Welfare State; as the boom of economic and technological resurgence; as an avenger, restoring fibre to homogeneous space.

Surveying sixties British architecture comprehensively, from the heights of Glasgow tower blocks to the depths of London night-clubs, remains a challenge. Many of the structures that defined the British environmental experience were too generic, too distant from trendsetting arenas, to capture attention from the Anglocentric architectural journals of London. This leaves it incumbent upon history to observe masterpiece buildings within their wider context of elevated road-ways and shopping centres, and to acknowledge that inequalities between social groups and regions were not cancelled, as modernisation implied, but were at best amended.

WELFARE

A striking aspect of the sixties British-built environment, virtually a caricature in retrospective impressions of the period, was the imprint of the Welfare State. This culminated a process stretching back to the end of the Second World War, which returned a generation of architects to civilian life convinced that systematic, rational teamwork, undertaken from public offices, should sweep away slum housing and a crumbling Victorian infrastructure. The completeness of the vision was ensured by accompanying legislation governing land use, health and social security.[3]

British school-building and social housing exemplified the team-designed, 'Socialist Fordian' architecture of the Welfare State.[4] In the fifties, standardised school-building

finish, which in housing varied over time and between regions: frames sheathed in plaster or brick were elsewhere left visible and infilled; increasingly in the sixties they were clad in standardised panels for a more overtly prefabricated appearance. Some monument-ality was achieved too, through chunky, sculptural concrete components, often left in an 'unfinished' state with aggregate and imprints from moulds creating tactility. The visual rhetoric was of objectivity, tending toward an aesthetic of repetition, a techno-logical sublime in the largest buildings, termi-nated apparently arbitrarily at a given storey or given number of terraced units, and as a rule topped with a flat (rather than pitched) roof. Yet Welfare modernism of the fifties and sixties was not necessarily inhumane. The lobby of the severest tower block might be tiled in 'Contemporary'-style patterns and, partly inspired by Scandinavian colleag-ues, Britain's New Humanist architects decorated surfaces with bricks and tile-hangings. Ultimately it was assumed that the plant-pots, curtains and rituals of everyday life would ornament the schemes naturally and democratically.

Point blocks, or tower blocks, introduced to Britain in the fifties, provided British public housing with its most powerful image. In fact they peaked at little more than twenty per cent of public housing output in the UK,[9] yet their physical presence and urban concen-tration made them staggering emblems of municipal decisiveness, especially in northern England and Scotland. Between 1961 and 1968 Glasgow set the record for tower block production and height, at seventy-five per cent of housing output topping-out with twenty-six to thirty-one storeys at the Red Road development of 1962–8.[10] The dénouement of the tower block came in London in 1968. In west London, Ernö Goldfinger's Trellick Tower boasted a triumphant Constructivist-Futurist composition with a separate lift tower and projecting, 'control-tower' boiler room (fig.97). But in south-east London, Ronan Point partially collapsed following a small gas explosion as a resident was making a cup of tea.

Ronan Point had been built just two years earlier by British contractors using a commercial prefabricated building system imported from Denmark. Mass-produced housing had been a dream of the international modern movement since the 1920s, but to be structurally sound, factory-made building systems required degrees of accuracy during assembly that were not easily attainable on site. Moreover the National Building Agency warned that commercial building systems might result in inhuman scale and monoto-ny.[11] Emulating the spirit of CLASP, the local

systems were developed by public offices in Hertfordshire and the Nottinghamshire-led Consortium of Local Authorities' Special Programme (CLASP), earning international acclaim by the sixties.[5] It was, however, public housing that became the hothouse of British modern architecture, producing at its peak in the sixties over half of all new housing — a share barely rivalled in the Eastern bloc.[6] Municipal housing had been provided in large quantities in Britain since 1919,[7] but a walloping half-million homes each year were required by the Labour Government of 1964–70 to meet the demand of the post-war population boom.[8]

Generic, anonymous architecture portrayed the public sector's commitment to function-alism and service, although the form and detail of buildings *were* undoubtedly of aesthetic concern. The fundamental 'language' found in the typical hospital, school or hous-ing block of the fifties and sixties was provid-ed by the building's structural frame, its 'vocabulary' by the standardisation and arrangement of component measurements (windows, panels, cross-walls and so on). The language was accented by the building's

Fig.97
Ernö Goldfinger
(architect)
Trellick Tower,
Paddington
RIBA Library
Photographs
Collection

authorities of Leeds, Sheffield and Hull (the Yorkshire Development Group of 1962—8) did take account of these issues within the prefabricated system they devised for the public sector, yet the economies of scale offered by competing, commercially contracted systems were an overwhelming temptation for many other local authorities.

There was a broad divergence in housing philosophy between the capital city and the 'provinces' in the sixties. Aside from the catastrophe at Ronan Point, London boroughs and the London County Council (LCC) tended to be sceptical of systems and favoured 'bespoke' design solutions. Resistant to targets set by aldermen and driven by enquiry, London's housing architects acquired a sort of 'avant-garde' profile. Advanced architectural planning focused upon socio-psychological need rather than the statistical monster of housing waiting lists composed of 'average' families with 'average' needs. With the threat of tuberculosis retreating, and the 1955 Clean Air Act passed into law,[12] housing estates in London increasingly preferred low-rise density to high-rise separation, 'clustering' residencies to create 'communities', 'nodes' and 'places'.

Sociological investigation, street photography and 'kitchen sink' painting and drama of the period gave architects a new image of the housing client as disenfranchised but socially adept and bound by extensive kinship. Certain characteristics of Victorian terraced housing, formerly scorned by modernism, were now sought again. Between 1955 and 1959 Denys Lasdun erected two upright Cluster Blocks in Bethnal Green, London, pinwheeling out from shared stairs, lifts and rubbish chutes designed to serve the social functions once found at communal wells (fig.98). The blocks upended the East End street, their sills, windows and balconies ostensibly keyed in to the proportions of existing nineteenth-century terraces nearby. Eventually the horizontal orientation of the terrace was consciously recovered too, as at Darbourne and Darke's Lillington Gardens of 1964—9. Inspirations as exotic as Arab casbahs were recruited at Lillington Gardens to provide form for a high-density settlement that avoided an institutional appearance, the blocks' profiles staggered and finished in dark red brick to better reference the existing grain of its Westminster neighbours.

Housing design became factional. The change in direction taken at vanguard housing projects, represented in a style known as New Brutalism, was steered by some of Le Corbusier's fiercest young admirers, who had seen the master's revised vision of mass housing at the Unité d'Habitation, near

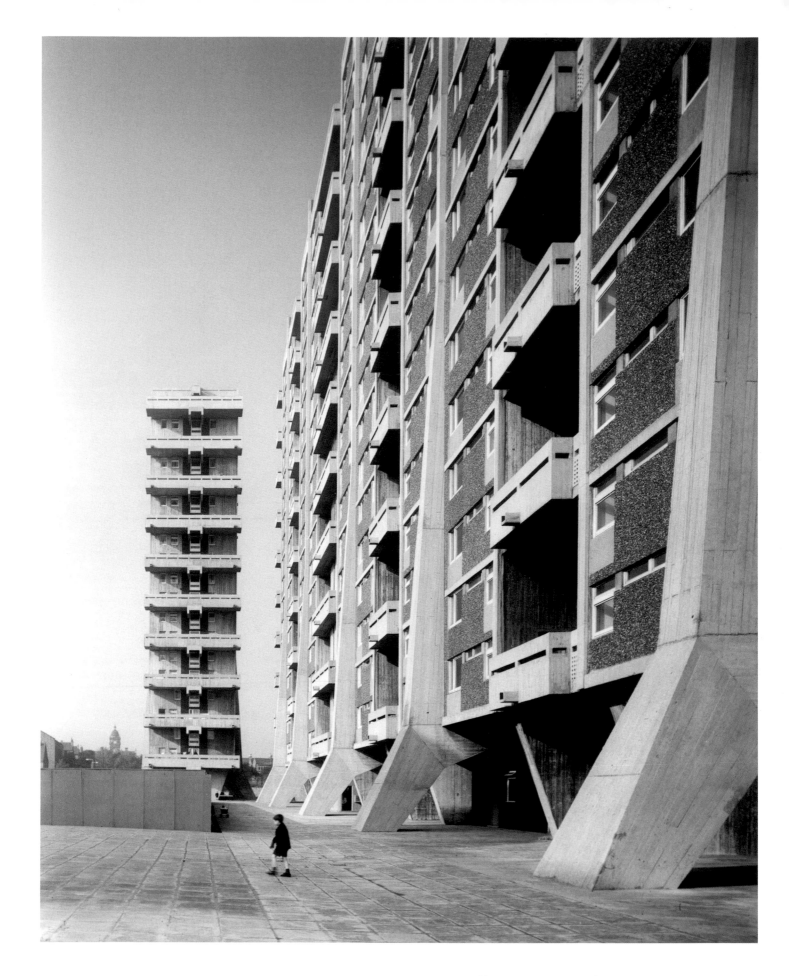

Marseilles, France, in 1947–53. The Unité
lay on its side to make a slab block, oriented
around the communal life of internal streets,
rooted in the sculptural massiveness of
'unfinished' concrete. Young Brutalists
working for the LCC famously designed
a flotilla of 'unités' to sail through the grass
of the Alton West estate (1955–8). The
intellectual leaders of the New Brutalism,
Alison and Peter Smithson, further proposed
– in their famous but unsuccessful 1952–3
submission to the City of London's Golden
Lane competition – to tie 'unités' together
with wide decks, elevating the communal
space of the street into the sky.[13] It would
be some fifteen years before the Smithsons
started to realise their vision, committing
an East End population to the tough-love
arms of paired super-blocks at Robin Hood
Gardens in London's Tower Hamlets. By
this time, however, another still more forceful
version of their concept was long-completed.
In Sheffield, under the city architect, J. Lewis
Womersley, Jack Lynn and Ivor Smith creat-
ed the Park Hill housing scheme between
1957 and 1961. Park Hill's 'streets in the sky'
were wide enough for a milk float to rise from
the city streets below to deliver the daily pint
to each doorstep, an event captured in three
BBC documentaries.[14]

Park Hill's astonishing plan was like organic
matter,[15] spiralling and colonising the hillside.
Welfare architecture typically sought out such
powerful images of cohesion. References to
serial production, ships, Italianate hill-towns
and biological chains were evoked. A late
addition to the visual language of modernist
housing cohesion was the 'Georgian', notably
found in the super-terraces of Camden
Council's Alexandra Road Housing (1968–79,
chief architect Neave Brown) in north London
(fig.100). These heroic monuments of big
British public housing were completed as the
first post-war government unsympathetic to
the aims of the Welfare State came into office.

Architectural magazines initially selected
photographs of public housing that portrayed
the successful attainment of utopia, Henk
Snoek's photographs capturing the pristine
geometric aerial perspective of Basil Spence's
Hutchesontown-Gorbals unités in Glasgow,
two figures moving from darkness to light
(fig.99), Roger Mayne's photography populat-
ing Park Hill with chatter and play (fig.95).[16]
But when the critical onslaught against
modernist housing was launched by such
salvos as Nicholas Taylor's in the *Architectural
Review* in 1967, 'The Failure of Housing'
was attributed precisely to the fact that
'visual images of community' were merely
a 'substitute for reality'.[17] Representations
of 'provincial' estates began to disappear
in the architectural press in the mid-sixties,

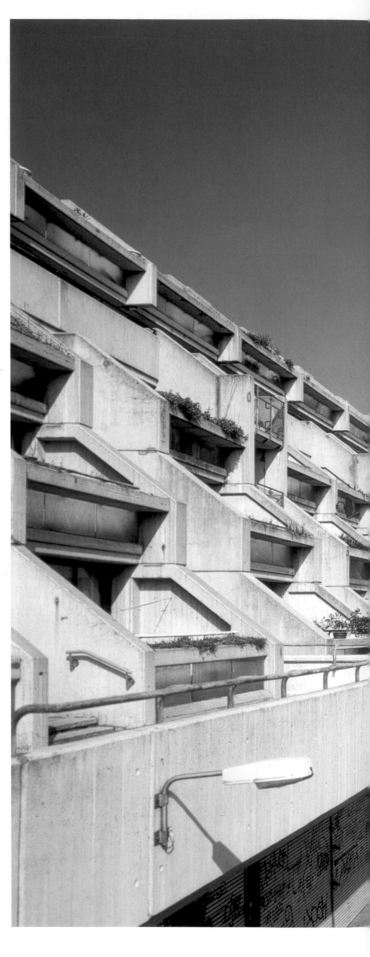

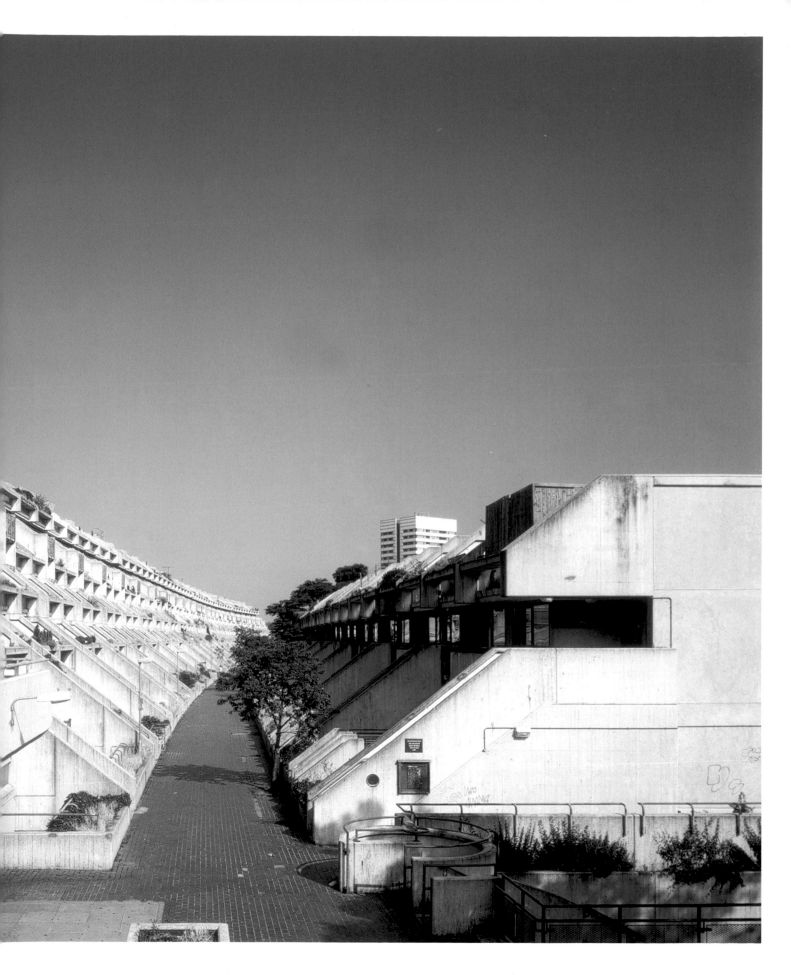

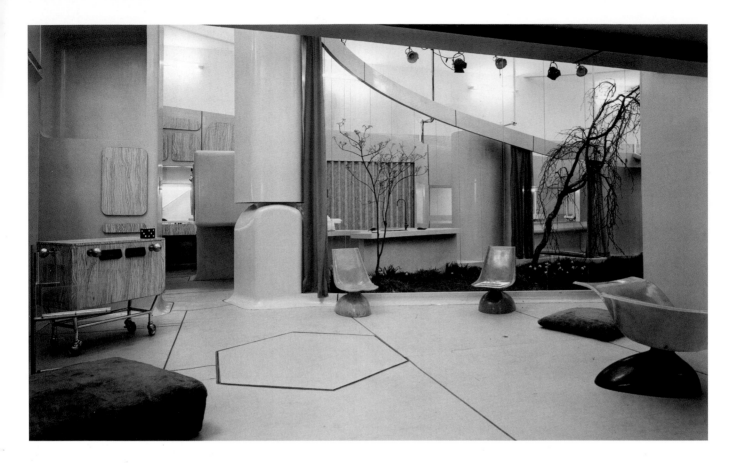

Fig.101
Alison and Peter
Smithson (architects)
House of the Future
Ideal Home Exhibition,
1956
RIBA Library
Photographs
Collection

only to re-appear in the early seventies as dystopias where the spatial and political boundaries between public and private had been blunted by bureaucratic paternalism. The vast burden of housing administration had been met increasingly by planners, geographers, sociologists and surveyors rather than architects, and in 1968 architectural planning was overhauled to make it less regulated.[18] Another reaction to the Welfare State's 'civil-servicing' of space, and to the persistence of homelessness, was a dynamic self-help and squatting movement that was organised at the end of the decade through such bodies as the London Squatters Campaign (1968).[19]

BOOM
In 1956 the Smithsons produced two imaginary domestic spaces. The first, 'Patio and Pavilion', created with photographer Nigel Henderson and artist Eduardo Paolozzi for the sensational Whitechapel Gallery exhibition *This is Tomorrow*, had about it the aesthetic of the pigeon-loft and allotment shed. Yet by contrast, the Smithsons' 'House of the Future', at the Ideal Home Exhibition, was the gadget-filled dream of the middle-income household (fig.101). The apparent paradox in the Smithsons' outlook was that Britain yearned for tradition and modernisation concurrently. Whatever the misgivings of new tenants with modernist flats, the

appliances available within were a welcome appetiser for boom Britain. During the sixties few British social segments and institutions would resist this rapture of modernisation.

Following the post-war decade of austerity and cultural prudence, the later fifties and early sixties saw an economic upturn and rapid social and technological change. There is a celebrated sequence in the 1963 film *Billy Liar* where Julie Christie, playing the character of Liz, traverses central Manchester's dramatic retail and commercial renovation, including Covell and Matthews's Constructivist-Futurist Piccadilly Plaza (under construction and completed two years later, fig.102): Liz, it appears, is energised in her very dislocation by the forces of 'progress'.[20] The ambition, volume and appearance of comprehensive redevelopment was overwhelming in many locales, and even to the architectural profession itself, where the perception arose that the scale of projects primarily necessitated managerial (not design) skills, encompassed in the label 'architectural planning'.[21]

The sixties had about them an almost Victorian ambition that turned against many Victorian cities, particularly in the English Midlands and North. Descriptions of urban redevelopment were usually profligate. Liverpool compared its pedestrianised

shopping area to Venice,[22] and the Newcastle *Evening Chronicle* found the magnitude of the redevelopment plans of that city in 1961 simply appropriate to the 'space age'.[23] Drawing comparisons with the nineteenth century, the government's Buchanan Report on *Traffic in Towns* of 1963 claimed 'it is possible that a vigorous programme of modernising our cities, conceived as a whole and carried on in the public eye, would touch a chord of pride in the British people and help to give them that economic and spiritual lift of which they stand in need.'[24] A wartime spirit was distantly detectable as well; just as the Second World War had been won through comprehensive strategy, so strategy would prevent the defeat of British cities and institutions by competitors overseas. Yet sixties redevelopment was not quite the orderly, familial, one-nation, post-colonial renewal that had been envisaged in 1951 by that initial foray into themes of urban renewal, the Festival of Britain. It transpired instead to be a slightly frenzied, uncoordinated boom.

Politically, two government reports of 1961 alone, the Census and the Parker Morris Report, cautioned that the 'baby-boomer' generation had not inherited their parents' limited social and economic expectations and was unlikely to share their taste in homes and towns. Economically, a second wave of property speculation roared through British city centres after a previous crescendo in the mid-fifties.[25] Neither public nor private capital could single-handedly pay for 'comprehensive redevelopment': redevelopment saw a convergence of public- and private-sector interests. Although post-war reconstruction policy endowed the major legislative tools of replanning (the Town and Country Planning Acts), by the sixties urban redevelopment had moved beyond the hallowed field of public endeavour to take on partnerships with builders, investors and architects in the private sector, fuelling the so-called 'property boom'. The expert pilots of the boom, the property developers (the Clore wing of Tate Britain is named in honour of an exceptional practitioner), mediated between city corporations, site owners, financial backers, contractors, designers and tenants. Local authorities would plan the land they owned and sell leases with planning gains, like relief roads, riding on them. But property development was, as Lord Esher later observed, an unequal partnership, in which the entrepreneurial skills of developers were always a step ahead of those of public-servant architect-planners.[26]

Complexes of roads, underpasses, multi-storey car-parks, shopping malls and office slabs arrived en masse in sixties town centres, to the degree that a civic centre like Croydon's

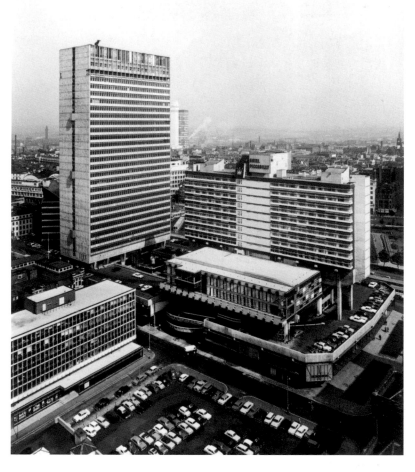

Fig.102
Covell & Matthews
(architects)
Piccadilly Plaza,
Manchester
RIBA Library
Photographs
Collection

could appear as if ex nihilo. The redevelopment packages, like that of Birmingham (announced 1959), were of a scale that belied the distinction between corporate and capitalist. For example, Birmingham's Smallbrook Queensway, defining a processional entry to the city centre and terminated by the new landmark of the Rotunda circular office block, resulted from collaboration between the laissez-faire Corporation, builder John Laing, developer Jo Godfrey and architect James A. Roberts.[27] As with countless development schemes, Smallbrook Queensway's ribbon-block was occupied by offices, its ground floors by retail. In its immediate vicinity was the flow of cars. All urban activity, planners accepted, could be, had to be, separated and spatially zoned, channelling the city core away from 'dirty' manufacturing and housing and towards 'clean' retailing, white collar work, leisure activities and commuting. This was to accompany the growing free time, employment and purchasing power of its citizens (the Queensway's plate-glass ground storey gave office workers a spot- and neon-lit retail experience).

More than simply functional, the traffic system to which the Ringway connected correlated in the minds of architectural planners with social and economic mobility. Birmingham's re-planning encouraged consumption of a prime local product, the car, while nationally the exponential increase in private automobile traffic was routed and striated through overpasses and under-passes to create multi-level cities, recalling the dreams of early twentieth-century modernists who had prophesied future cities of skybridges. With pedestrians shepherded away from road traffic by networks of decks and subways, urban design prioritised misguided concerns for 'safety' and point-to-point pace over psychological contiguity or accessibility for wheelchairs and prams. 'Urban motorways' cleaved victorious politi-co-economic pathways through city centres such as Newcastle upon Tyne, until they were impeded by local protest groups, notably at London's Westway at the end of the decade.[28] Cities were in turn networked one to the other, dragged from the age of steam by the 1955 Modernisation Plan and 1963 Beeching Report, by Intercity diesel and electric trains,

and by the opening of the M1 motorway and its later progenies in 1959, agrarian Britain hanging on the threads of elegant camber-arched reinforced concrete bridges. Adopting the overpasses and concourses of airports (such as Frederick Gibberd's Heathrow), motorway service areas and rail and bus stations presented the sixties travelling public with the sort of hyper-contemporary space that cinema lobbies had offered in the thirties. The whirl of these schemes was tempered by the rationality of new signage systems, founded upon the universal standards and sans-serif type for British roads, railways and airports devised by Jock Kinneir and Margaret Calvert.

North American visions of the city fed the British urban 'renaissance'. If during the fifties the apogee of advanced shopping in Britain was the precinct, with its redolence of the traditional city market square, the focus of the sixties was the American-style indoor shopping centre, such as Greenwood and Hirst's Bull Ring Centre in Birmingham (1964, fig.103) and Rodney Gordon's 'casbah'-centred Tricorn Centre in Plymouth, for the

Fig.103
Sydney Greenwood
with T.J. Hirst
(architects)
Bull Ring Centre,
Birmingham
RIBA Library
Photographs
Collection

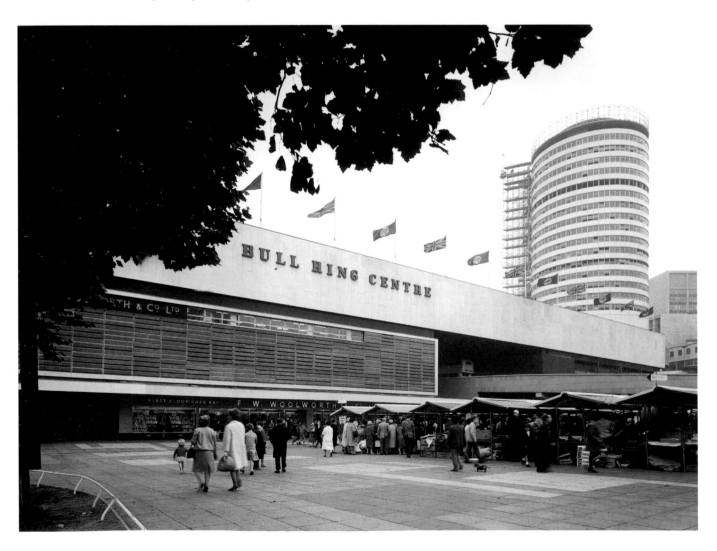

Owen Luder Partnership (1966). Immune to the inclement weather but met with greater ambivalence in Britain than in America, the shopping-centre was the central element in the 'Mark 2' New Towns, supplanting the precinct and clocktower of 'Mark 1' New Towns like Stevenage (built 1957–8), which planners felt had been too sedate. Central Cumbernauld, designed under chief architect Hugh Wilson and project architect Geoffrey Copcutt, gathered and zoned its urban functions of shopping, offices, leisure and civic life within a single, multi-level, Brutalist-style megastructure. Half a mile long, it was designed to be extendable and responded frankly to the car, whereas Mark 1 New Towns had assumed that the modest circumstances of their austerity-Britain populations would largely confine them to walking, cycling and public transport. Plans for Milton Keynes, drawn up in 1967 by Llewellyn Davies, Weeks, Forestier-Walker and Bor, most fully implemented the infrastructure for motorised consumers.

Los Angeles sociologist Melvin Webber counselled the Milton Keynes team to spread out their new town thin and flat from its shopping-centre heart, though in pre-existing British city centres tall buildings were deployed to provide a thrusting, Manhattan-esque element to the skyline. Castrol House in London (1960–1, by Gollins Melvin and Ward) launched a glass-clad generation of variants upon New York's Lever House office skyscraper. Two restaurants opened to the public in 1966 to offer space-age views of London (the Post Office Tower by Eric Bedford) and Liverpool (the Beacon Restaurant by James A. Roberts, atop the four-hundred-foot heating flue of a shopping centre).[29] Wearing 'precast concrete knit-ware',[30] London's thirty-three-storey Centre Point of 1961–6 (fig.105) was Britain's best-known skyscraper, replete with good detailing, landscaping and an intended panoramic restaurant.

But without embarrassment the priorities of its architect, Richard Seifert, lay in delivering developer-friendly buildings on time, and the financial oddities of the project gained notoriety. The prevalence of such expediency over idealism has made the architectural quality of much sixties commercial work difficult to judge. Newcastle upon Tyne employed a roll-call of highly regarded architects in its city-centre redevelopment before descending into Britain's best-known property scandal. Prior to work in Newcastle, for instance, Robert Matthew, Johnson-Marshall and Partners created the choice diplomatic elegance of London's New Zealand House (1959–63). There were many other outstanding sixties office developments

amidst the mediocrity of the genre: near New Zealand House the Smithsons produced their most praised work with a commercial development for the Economist group (1960–4), its double towers addressing an innovative urban plaza. Hillingdon was graced by a design from none less than the creator of Lever House, Gordon Bunshaft (of American firm Skidmore, Owings and Merrill), when the Heinz company commissioned a new headquarters (1962–5), fashioned like Centre Point with a shell of concrete stanchions.

Sixties bureaucratic chic further bestowed the cachet of modernisation to Britain's tradition-bound collegiate organisations. Denys Lasdun memorably planned the spaces of the Royal College of Physicians' new London headquarters (1960–4), floating beside Regent's Park, around the college's time-honoured ceremonial processions. The relatively free rein afforded by fine sites and inquiring patrons made university architecture the plum commission of the sixties; not surprisingly, perhaps, the style of new university campuses of the period, like Basil Spence's Sussex, Kenneth Capon's

Essex and Denys Lasdun's East Anglia, conveyed the universities' desire to revolutionise access to higher education. Lasdun's ziggurat blocks at East Anglia (fig.106) huddled undergraduates together a little like the working-class residents of his East End blocks. Cost-consciousness was never far from the surface at the new universities, dictating CLASP construction at York, though budget alone did not disguise a certain revelling in system building at Essex and York, which threw down the ideological gauntlet to the 'creative' architecture of

Fig.104
Hugh Wilson and
Geoffrey Copcutt
(architects)
Cumbernauld Town
Centre
RIBA Library
Photographs
Collection

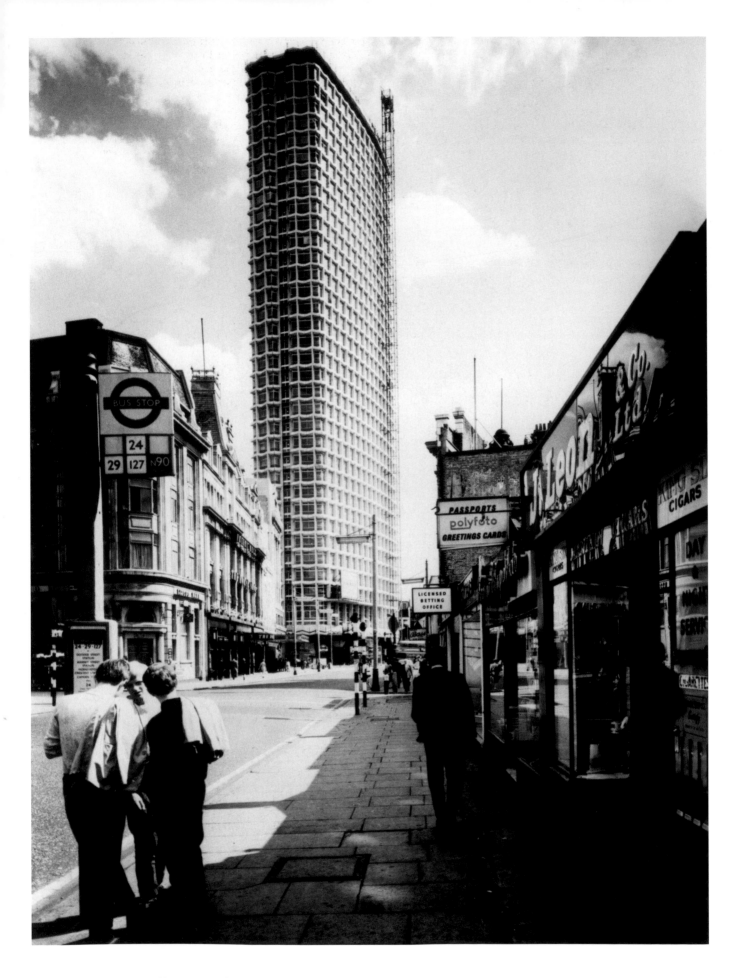

Sussex and East Anglia. [31] Common to all, nevertheless, was a love of the English Picturesque, of modern piles offset with grand pasture and great trees.

York's central courts hinted at cloistered grandeur, and timber was found to line its common rooms. In short, modernism could adapt to the revered principles of academic community, and made deep ingress into the ancient universities where cost considerations were usually less urgent. James Stirling brought mechanistic processes to the Andrew Melville Hall at the University of St Andrews (1964–8). In 1964 Oxford University took delivery of Arne Jacobsen's supremely 'cool' St Catherine's College, one of a new generation of Oxbridge foundations. Cambridge University had declined Walter Gropius's proposal for Christ's College in 1937, but much as Gropius took greater pleasures in form after World War Two, Cambridge too began to indulge in quirky modernist buildings such as the Byzantine-domed New Hall by Chamberlin, Powell and Bon (1962–6). The competition to build Churchill College in 1958 provided a snapshot of twenty-one leading practices (including the Smithsons, who received the Economist commission following their participation). Richard Sheppard, Robson and Partners' winning solution was a continuous flow of courts

that satisfied both the rational and romantic sides of the Cambridge mind. Something of a modernist vernacular emerged amongst the architects teaching at Cambridge, at once Brutalist and systematic, apparent in Gonville and Caius College's Harvey Court (1960–2) by Leslie Martin (doyen of the modernist establishment) with Colin St John Wilson and Patrick Hodgkinson (associates of the young Brutalists). At one end of the project the architects paid minute attention to the quality of brick bonds, while at the other they abstracted the residential totality into mathematically calibrated terraces, gathered round a piazza to form a self-contained urban module (a solution carried through to Hodgkinson's Brunswick Centre, London, 1962–73).

Some buildings nonetheless tested Oxbridge's tolerance of modernism to the limit, especially James Stirling and Michael Wilford's History Faculty Library at Cambridge (1964–7), and their Florey Building at Queen's College Oxford (1966–71), though these red-brick and patent-glazed compositions had not exceeded the impact of Stirling's first university building, the 1959–63 Engineering Building for Leicester University (fig.107), designed in partnership with James Gowan. Stirling and Gowan used Constructivist methods from the 1920s to ensure that the

Opposite
Fig.105
Richard Seifert
(architect)
Centre Point,
London
RIBA Library
Photographs
Collection

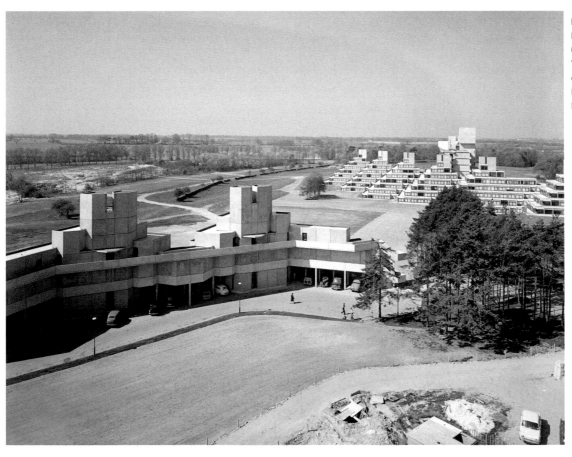

Fig.106
Denys Lasdun
(architect)
The University
of East Anglia
Photograph: Richard
Einzig/Arcaid

Fig.107
Stirling & Gowan
(architects)
Engineering Faculty,
Leicester University
Photograph: Richard
Einzig/Arcaid

internal functions of their building generated dazzling interplays of shape, geometry, mass, transparency, material and colour. Modern architecture, in the process, was being handled as a plastic language rather than a social-moral mission, suggesting a significant new motivation for British architecture. Raised upon splayed legs, Leicester's Engineering Building reached into the source code of modern architecture and the red brick origins of Britain's nineteenth-century industrial modernisation. A muted past was talking through the ear-splitting boom of the sixties.

AVENGERS

Many pundits, indeed, discerned that blanket programmatic 'modernisation' on the one hand (like central Birmingham) and perfected types (like Harvey Court) on the other could inhibit the rejuvenation of sixties architecture. Harvey Court, the architect Cedric Price complained, was really 'just the middle ages with 13-amp power points'.[32] Price and other

avant-gardists were dismayed that the best and brightest in British architecture only updated the mindset of the past, missing the opportunity to weave indeterminate, technologically enabled possibilities into architecture.[33] Other dissidents approached the problem from the opposite direction, arguing that Britain's living history should be spliced into the monologue of modernisation.

Price was Britain's most radical architectural thinker. His opposition to monumental architecture was signalled in 1962–4 by the spiky net of his Aviary at London Zoo (with Lord Snowdon and Frank Newby) (fig.108). His unbuilt Potteries Thinkbelt project of 1964–6 was the counter-proposal to the wistfulness of the new university campuses. Thinkbelt would inhabit the wastelands of a forgotten casualty of the Industrial Revolution, the Staffordshire Potteries, its teaching and research faculties linked by rail to serve the instantaneous demands of 'the White Heat of technological revolution'.[34] A socialist with high-level connections across the political and cultural spectrum, Price believed it was the duty of a democratic architect to hand over the controls of architecture as fully as possible to the end-users. His 1961 Fun Palace project, with theatre impresario Joan Littlewood, became one of the most revered unbuilt schemes of the decade, a large 'learning shed' for a run-down East End site (most likely the Lea Valley).[35]

As a structure, the potential of the Fun Palace concept to adapt to change was noted by the 'High-Tech' generation, which emerged in 1967. Team 4 (Norman and Wendy Foster, Richard and Su Rogers) designed the Reliance Controls factory in Swindon with the potential to receive further 'slices' of building. The content of the Fun Palace was no less predictive. Its visitors were intended to devise their own 'free-form' entertainments – the contrast with the largely passive spectatorship of the Festival of Britain a decade earlier was pronounced – anticipating 'happening' sixties event-spaces like London's Ad Lib discothèque (1964–6), psychedelic light shows (circa 1967) and, in the most experimental, often student-led, projects, the pursuit of inflatable environments and immaterial, poetic 'situations' of light, sound and encounter. The body itself, at ease on the floor of a 'rumpus room' or dancing in communal space, became a prime medium of alternative architecture.

Creative designers were resisting a pincer movement closing in from the left (with housing targets and stringent economy) and right (with property-boom architecture).[36] Even Brutalism was waning as a radical, experimental current by the mid-sixties. The South Bank Centre (1960–7), devised

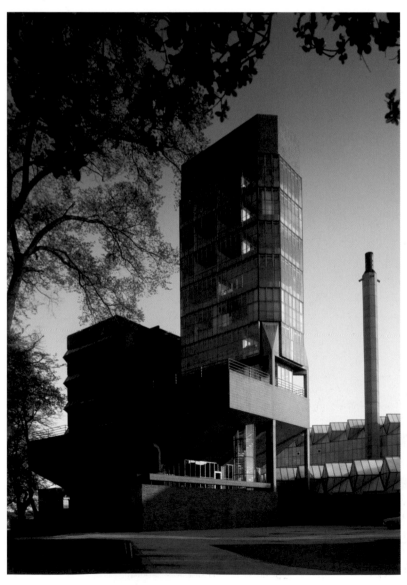

within the LCC by an avant-garde cell, proposed the next stage of Brutalism: layered, craggy, mysterious and comic-book, virtually a protest against the good manners of recent architecture by the Smithsons and St John Wilson and a riposte to the rationality of its neighbour, Leslie Martin and Robert Matthew's Royal Festival Hall (a survivor of the 1951 Festival of Britain that was renovated concurrently).[37] Three of the South Bank Centre's designers would form half of the experimental Archigram group, acquaintances of Cedric Price who shared his driving conviction that architecture should retire from monumental form to purvey the equipment of enhanced living.

Archigram tried to show that 'automobile-styled' houses were not an experimental proposition for twenty-five years hence (as the Smithsons had been at pains to explain in regard to their 1956 House of the Future)[38] but for the here-and-now. In doing so they drew attention to the Pop impetus behind Brutalism that had been overshadowed by the rough concrete austerity of actual Brutalist buildings. Like the charismatic historian Reyner Banham, *Archigram* magazine believed that the age demanded the dissolution of architecture into information technology terminals, soft plastics and air-conditioning. While Brutalists sought establishment credibility, Archigram made the avant-garde wild again and gave architecture a walk-on part in the British pop culture insurgency of the sixties. Archigram discovered the casual, expendable style of a leisured consumer society in which close-knit social structures and the buildings that accompanied them were largely irrelevant.

But architects were rarely found at the forefront of cultural revolution. As historian Elain Harwood points out,[39] however radical the social and economic transformations supervised by the 1957–63 Macmillan

Fig.108
Cedric Price, Lord
Snowdon and Frank
Newby (architects)
Aviary for London Zoo
RIBA Library
Photographs Collection

administration may have been, it also presided over the most church-building for a century. Many new churches were in a boldly modernist idiom, like those by Andy MacMillan and Isi Metzstein (of Gillespie Kidd and Coia) in Scotland. Britain's most prolific architects were as at ease with the infrastructure of faith as of White Heat: Basil Spence, the creator of Britain's celebrated modernist cathedral at Coventry (1951–62), also designed the Nuclear Power Station at Trawsfynydd in 1963. Frederick Gibberd's Metropolitan Church of Christ the King, Liverpool (1962–7) evoked not just the distant Cathedral at Brasilia (1959–70) but his own cooling towers at Didcot Power Station, and it came complete with an underground car park. Too many of Britain's elderly institutions were surviving the sixties, the avant-garde grumbled; a counter avant-garde emerged, meanwhile, determined to retrench against those social, cultural, and architectural innovations – seen another way, destructions and impositions – that had taken place.

And yet in retrospect British architectural 'revolutionaries' and 'counter-revolutionaries' were surprisingly close in character. Since revolutionaries wanted to avenge the vulgarisation of modernist principles, and counter-revolutionaries wanted to avenge disloyalty to history, all shared an antipathy for hegemonic, homogeneous, Welfare- and property-boom modernism. Until the mid-sixties, many architectural counter-revolutionaries (such as Nicholas Taylor)[40] had been apologists for modernism; and from the mid-sixties,

architectural revolutionaries backed away sharply from modernist 'megastructures' and the like to favour more piecemeal approaches. While the alarm expressed by conservationists at the 'loss' of the skyline belied the fact that most British cities remained predominantly Victorian and Edwardian in infrastructure and building stock, the frequent insensitivity of new building projects was sufficient to galvanise a conservationist front whose membership was broader than knee-jerk conservatives. This much was apparent in the 1958 foundation of the Victorian Society, and in the grave concern common to figures as diverse as John Betjeman and the Smithsons, first for the fate of Philip Hardwick's 1838 Euston Arch in London (demolished in 1962 in favour of a bus stand for the new Euston station), later for the heritage of the city of Bath.

The common fondness for the Picturesque and embarrassment by such words as 'ideology' again suggested a proximity between conservationists and the avant-garde. Britain's main architectural journal and modernist sponsor, the *Architectural Review*, had long advocated a 'Townscaped' conciliation between modernism and heritage in editorials by Nikolaus Pevsner, Ian Nairn and Gordon Cullen. The vanguard and the conservatives shared a particular reverence for Victoriana and the intrepid achievements of the Industrial Revolution; Stirling and Wilford's berated Cambridge History Faculty was initially reckoned to have about it a Victorian valour.[41] The 1967 meeting of a nineteenth-century Paddington terrace with Terry Farrell and

Fig.109
Ron Herron for
Archigram
Walking City, New York
1964
Ron Herron Archive

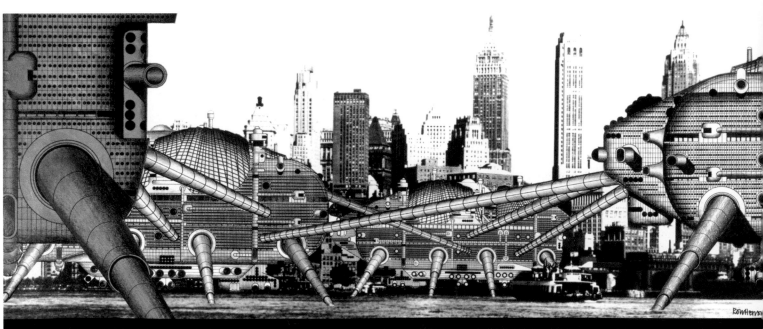

EACH WALKING UNIT HOUSES NOT ONLY A KEY ELEMENT OF THE CAPITAL, BUT ALSO A LARGE POPULATION OF WORLD TRAVELLER-WORKERS.

A WALKING CITY

Nicholas Grimshaw's plastic bathroom tower (built for a student hostel) suggested a British 'empiricist' outlook: a relish for difficult urban sites, a Pop idiom, and elaborate neo-Victorian engineering upon which British High-Tech style was founded.

Bohemians liked to refashion the material culture of the past rather than see it swept up by philistine renewal. London's artfully déclassé sixties intelligentsia gentrified a decayed Islington, no-go riverside warehouses and forgotten corners of Kensington and Chelsea.[42] Whenever stationed in London, the most radical avant-garde of the day, the Situationist International, used its wanderings to satisfy a taste for the Dickensian. The hot-spot of alternative arts in London, the Roundhouse (opened 1964), was a Victorian railway shed. Interior designers increasingly chose historicist alternatives to the sixties 'space-age' manner: Terence Conran's designs and selections revived an Arts and Crafts discourse of 'honesty' in British interiors, and the way-out boutiques of Swinging London experimented with the décors of Art Deco, Art Nouveau and Victoriana (notably the Biba stores in Kensington, and cult Carnaby Street shops such as I Was Lord Kitchener's Valet). Interior designer David Hicks suggested to possibly baffled readers of *The Sun* in 1965 that they juxtapose up-to-the-minute transparent appliances side-by-side with 'things like penny-farthing bicycles, and those old GPO red wicker delivery barrows'.[43]

Whatever the homage paid to the past by these more eclectic approaches, they were nonetheless acutely of the sixties: coordinated, ephemeral, witty, often quasi-surrealist and 'trippy', sometimes camp assemblies further investigated by the designers of television thrillers like *The Avengers* (1961–9) and *The Prisoner* (1967, set in Portmeirion), and by the ever-changing Kings Road shop-front of Granny Takes a Trip (1967, fig.110). Much of the 'underground' design of the sixties delighted in its appliqué nature, distinguishing it from the earnestness of Welfare architecture, from institutions labouring to appear 'modern', and from the moral despair of conservationism. Winds of postmodernism were to be felt in the frank, ironic acceptance that modernity was in part a matter of 'dressing up',[44] acknowledging the possibility that Britain's bright future already lay in the past.

Fig.110
Nigel Weymouth, decoration for Granny Takes a Trip, Kings Road, London 1965

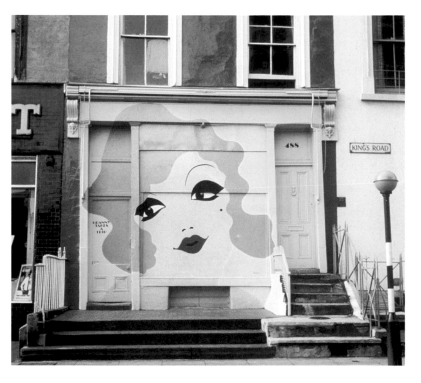

RICHARD HAMILTON, SWINGEING LONDON 67

Lizzie Carey-Thomas

London was very boring. Suddenly, around 1964, it was all happening. An eruption, you know. A social revolution.[1]

In February 1967, tipped off by the popular press, police raided a gathering at Redlands, the country home of Rolling Stones guitarist Keith Richards, in what was widely perceived to be a carefully orchestrated attack on the primary arbitrators of sixties permissiveness and the growing popularity of the 'catalyst' of youth rebellion, cannabis. Guests at Redlands included fellow band member Mick Jagger and maverick art dealer Robert Fraser, who together with Richards bore the brunt of the episode. Richards was charged with allowing his house to be used for smoking cannabis while Jagger and Fraser were found guilty of unlawful possession of drugs (in Fraser's case heroin) and, following court proceedings in June, both were sentenced to imprisonment. Jagger's sentence was later revoked, while Fraser served four months in Wormwood Scrubs prison, West London.

The prosecution provoked an avalanche of press coverage, with newspapers noting with varying accuracy and increasing relish every detail of the proceedings, from the clothing of the defendants to the food purportedly delivered to their cells, spiralling off into numerous banalities. Aside from predictable tabloid moralising there was surprisingly vociferous support for Jagger and Fraser from establishment figures, most notoriously *Times* editor William Rees-Mogg whose famous article 'Who Breaks a Butterfly on a Wheel' appeared in the paper on 1 July: 'It should be the particular quality of British justice to ensure that Mr Jagger is treated exactly the same as anyone else, no better and no worse. There must remain a suspicion in this case that Mr Jagger received a more severe sentence than would have been thought proper for any purely anonymous young man.'[2]

Richard Hamilton, who was represented by Fraser at the time, gained access to the huge number of press cuttings collected by the gallery and, motivated by his own sense of outrage at the situation, initially presented them as a collage to be published as an art poster. By addressing the subject via 'pure information'[3] he highlighted how the seemingly factual reports were in reality peppered with contradictions. Hamilton's subsequent series of paintings and prints, *Swingeing London 67* (1968–9), focused on a single press photograph by *Daily Mail* photographer John Twine.[4] It featured Jagger and Fraser handcuffed together, appearing to shield themselves from the glare of the camera flash through the window of a police van en route to the courthouse in Chichester. The image of the shackled pair highlighted the absurdity of the situation – these were hardly dangerous criminals – and elicited

a wave of sympathy from the public. *Swingeing London 67* was a wry comment on the dichotomy between the hedonistic freedom attributed to sixties London and the seemingly draconian sentences imposed on Jagger and Fraser, who were seen by many as deliberately high-profile scapegoats for the perceived drug problem. Hamilton commented: 'Among the pieces I used for the collage, there was a phrase that struck me very forcibly, a remark made by the judge in the case, who said, "There are times when a swingeing sentence should be administered" – something like that, anyway – and only a few months earlier Robert had been very well represented in the *Time* piece, which was called Swinging London. So it was a pun on swinging London and the swingeing sentence.'[5]

Hamilton's series functioned not just in the context of the Jagger-Fraser case; through its depiction of the merging of the art and rock worlds it succinctly captured the spirit of the period. The prosecution had taken place against a backdrop of media mythologising about the London scene and its key protagonists, culminating in a feature published in *Time* magazine in April 1966, whose cover presented the slogan 'London: The Swinging City'. The article featured a map of The Scene, pinpointing hip boutiques, galleries, nightclubs and restaurants dotted between Soho and Notting Hill, and comments from those considered to be key 'movers and shakers' at the time. Among those quoted included Fraser, owner of 'London's most pioneering art gallery': 'Right now, London has something that New York used to have: everybody wants to be there. There's no place else. Paris is calcified. There's an indefinable thing about London that makes people want to go there.'[6] Hamilton's series therefore neatly encapsulated the merging of the art and rock worlds that typified the period.

Fraser opened his gallery in Duke Street in 1962, at the age of 25, shortly after his return from America. It quickly gained a reputation as one of the most forward-looking contemporary art galleries in London and was seen as synonymous with the 'cultural revolution', attracting musicians, fashion designers, film-makers and actors to its openings. Fraser himself seemed to straddle both the old worlds and the new. Eton educated, he was the son of a successful banker, retaining the formality and attitude appropriate to his background, while leading a wildly promiscuous lifestyle embracing drug-taking and homosexuality and counting the Beatles and the Stones amongst his friends. He was also a hopeless businessman, with little interest in money, often in debt to his artists. Yet with complete assurance in his own idiosyncratic taste and a total disregard

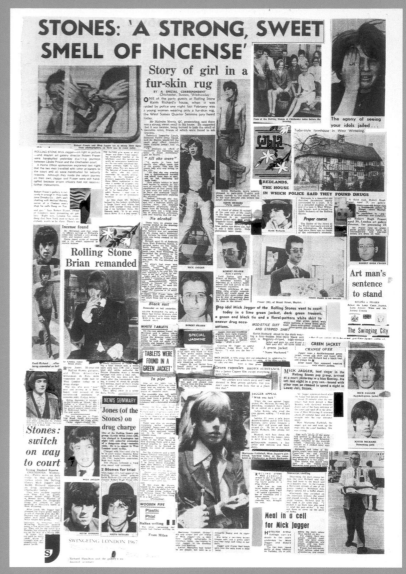

Fig.111
Richard Hamilton
Swingeing London 67
1967—8
Tate

for convention he was enormously respected by those close to him and presented consistently groundbreaking shows. Fraser was the first gallerist in the UK to promote American Pop artists such as Jim Dine, Andy Warhol and Claes Oldenburg and launched, among others, Eduardo Paolozzi, Peter Blake, Jann Haworth and Colin Self. He was also instrumental in initiating Peter Blake and Jann Haworth's involvement in the design of the Beatles' *Sgt Pepper* album cover, insisting that it should take the place of the psychedelic design originally favoured by Paul McCartney, and heralding many future collaborations between artists and musicians. Following his release from prison and owing to increasing financial disorganisation as well as a growing despondency with the London art scene, Fraser closed his gallery in 1969 and disappeared to India, commenting: 'I've closed because I didn't want to become a middle-aged art dealer and I felt I had had enough. I'm looking for something new in art.'[7] Fraser eventually reopened his gallery in new premises on Cork Street in 1983. However, he found his approach at odds with the conservative mood of 1980s London and this, combined with increasing debt, ensured that it never repeated the success it had achieved in earlier days.

With *Swingeing London 67* Hamilton captured and immortalised a moment of modernity, exploiting the iconic nature of the image to the full and ensuring it remained in the public consciousness. The depiction of a bound Jagger and Fraser, two men of differing histories caught in a shared compromise, appeared to encapsulate the social and cultural cross-fertilisation indicative of sixties London. At the same time, it underscored the disparity between the freedom they represented and the incarceration they were about to endure. With hindsight, the image has become an icon for a passing era, a watershed moment that signalled for many the demise of a fleeting period of radical liberalism and a return to a more rigid regime.

Fig.112
Richard Hamilton
Swingeing London 67
(f)
1968—9
Tate

SELECTED CHRONOLOGY: 1956—69

By Hymie Dunn and Katharine Stout

56

Martin Luther King leads black community in one-year boycott of bus service in Montgomery, Alabama, protesting against continuing racial segregation and discrimination in USA.

British and French troops invade Egypt on 31 October after President Nasser nationalises Suez Canal and seizes all revenue from the jointly owned Anglo/French company. Troops withdraw after UN declines to support invasion.

In October, resistance in Hungary to USSR occupation is dealt with by oppressive Soviet military force.

First British rock and roll singer Tommy Steele reaches no.1 with his first UK chart entry, 'Singing the Blues'.

Elvis Presley tops both the US and UK charts with his singles 'Heartbreak Hotel' and 'Blue Suede Shoes'.

Teddy Boys riot in south London in September following the release of American film *Rock Around the Clock*, starring Bill Haley and the Comets.

John Osborne's *Look Back in Anger* opens at Royal Court Theatre, London. Its concern with social criticism marks a turning-point in British theatre.

Modern Art in the United States, Tate Gallery, London, presents the work of Mark Rothko and Jackson Pollock amongst others. January

Exhibition of French action painter, *Georges Mathieu*, Institute of Contemporary Arts, London. July

This is Tomorrow, Whitechapel Art Gallery, London. August

In August, Jackson Pollock dies in a car accident, USA.

57

In January, Harold Macmillan becomes Prime Minister following Sir Anthony Eden's resignation. In July at Bradford football stadium he gives the following speech: 'Let's be frank about it; most of our people have never had it so good. Go round the country, go to the industrial towns, go to the farms, and you will see a state of prosperity such as we have never had in my lifetime — nor indeed ever in the history of the country.'

Chairman Mao Zedong attempts to modernise technology and agriculture in China in his Great Leap Forward campaign.

Israel rejects US and UN demands for withdrawal of troops from Gaza strip.

'Space Race' begins as USSR launches first space satellite, Sputnik.

Britain commits to decolonisation of sub-Saharan colonies: Ghana is the first to gain independence.

European Economic Community created by the Treaty of Rome.

In July, the Situationist International group is established at Cosmo, Italy. Ralph Rumney is the only British founding member.

Arne Jacobsen receives the Grand Prize at the Milan Triennale; exhibits include his Model 3107 chair.

Elvis Presley's 'All Shook Up' is best-selling single of the year in the UK.

On the Road by Jack Kerouac is first published in USA.

Metavisual-Tachiste-Abstract: Painting in England Today, Redfern Gallery, London. August

an Exhibit, ICA, London. Installation by Richard Hamilton and Victor Pasmore. August

The first *John Moores Liverpool Exhibition*, an annual showcase for contemporary British painting (founded by John Moores, owner of Littlewoods), opens at the Walker Art Gallery, Liverpool. November

Dimensions, curated by Lawrence Alloway, includes Richard Smith, William Green, Robyn Denny, William Turnbull and Eduardo Paolozzi. O'Hana Gallery, London. December

58

President Eisenhower commits the USA to 'contain Communism' worldwide.

Eisenhower establishes National Aeronautics and Space Administration (NASA) in the USA.

Syria and Egypt establish United Arab Republic in attempt to bring unity to Arab world.

CND (The Campaign for Nuclear Disarmament) is founded. At Easter, the first protest march to the Atomic Weapons Research Establishment at Aldermaston in Berkshire departs from London.

Race riots in Notting Hill, London, in late summer.

First transatlantic passenger service by jet between New York and London.

Thalidomide identified as drug causing limb defects in newborn babies.

In December, first motorway opens in Britain on the Preston bypass (later to become section of M6).

Urban environment action group, The Anti-Ugly Action emerges from RCA. Organises protest marches against certain London buildings.

Five Young Painters, ICA, London. Includes Peter Blake, William Green, Richard Smith, John Barnicoat, Peter Corviello. January

Avant-garde American art is actively promoted abroad by the US government.

Some Paintings from the E.J. Power Collection, ICA, London, includes Jackson Pollock, Willem de Kooning, Clyfford Still, Franz Kline and Mark Rothko. February

The US Embassy opens a new gallery space with *Seventeen American Painters*, Grosvenor Square, London. November

Jackson Pollock, Whitechapel Art Gallery, London. November

59

Fidel Castro takes power in Cuba, backed by Soviet military aid.

China suppresses uprising in Tibet, banning religious institutions. Dalai Lama flees Lhasa.

Soviets crash-land first (unmanned) spacecraft on moon.

Harold Macmillan's Conservative Government wins general election on 9 October.

IBM markets the first fully transistorised computer in the United States.

New Mini car unveiled, costing around £500.

Colin MacInnes's *Absolute Beginners* published.

Buddy Holly killed in plane crash.

François Truffaut's *Les Quatre Cents Coups* marks emergence of New Wave of intellectual European film-makers.

Cliff Richard's 'Living Doll' becomes his first UK no.1 hit.

American critic Clement Greenberg visits London.

New American Painting, organised by the Museum of Modern Art, New York, at the Tate Gallery. February

First *Biennale of Young Artists* opens in Paris; includes Yves Klein, Friedrich Hundertwasser, Robert Rauschenberg, Jasper Johns and Jean Tinguely.

Place, ICA, shows environmental installation work by Robyn Denny, Ralph Rumney and Richard Smith. September

In October, David Hockney, R.B. Kitaj, Peter Phillips, Derek Boshier and Allen Jones start at Royal College of Art, London.

Mateus Grabowski opens gallery in Sloane Avenue.

60

In Sharpeville, South Africa, 56 are killed in response to a peaceful protest in March organised by the African National Congress. A State of Emergency is declared.

CND rally on Easter Day in Trafalgar Square attracts up to 100,000 supporters. Hugh Gaitskell, Leader of Labour Party defies CND's bid to change Labour Party policy on possession of nuclear weapons.

In April, students in North Carolina, USA, lead civil rights sit-ins in public places. Non-violent Coordinating Committee formed to organise peaceful protests.

Wedding of Princess Margaret and Antony Armstrong-Jones who later becomes Lord Snowdon.

Penguin Books wins rights to publish *Lady Chatterley's Lover* by D.H. Lawrence (previously banned for 30 years under the Obscene Publications Bill) in Old Bailey test case in October.

John F. Kennedy elected US President on 9 November.

Fifteen African countries gain independence from Britain.

First report of National Advisory Council on Art Education produces the Coldstream Report which recommends creation of Diploma in Art and Design.

Brasilia, designed by Oscar Niemayer, inaugurated as new capital of Brazil.

Beyond the Fringe with Alan Bennett, Peter Cook, Jonathan Miller and Dudley Moore debuts at the Edinburgh Festival in August.

Granada's TV soap opera *Coronation Street* begins.

Popular Culture and Responsibility conference for the National Union of Teachers, Westminster; Richard Hamilton gives lecture.

Saturday Night and Sunday Morning, starring Albert Finney, receives Best British Film award.

La Dolce Vita, directed by Federico Fellini, is released.

Psycho, directed by Alfred Hitchcock, is released.

Situation RBA gallery. Key exhibition of abstract artists. September

In September, Peter Blake begins to teach at St Martin's School of Art, London, alongside Richard Smith and Joe Tilson.

The Mysterious Sign, ICA, London. Includes first painting to be exhibited by Jasper Johns in the UK. December

61

Contraceptive pill goes on sale in the UK.

Spy ring arrested in London, charged with passing on secrets from the Navy's Underwater Warfare Establishment, Portland, Dorset, to USSR.

On 12 April, Soviet cosmonaut Yuri Gagarin is the first man in space.

On 19 April, Cuban exiles and US Forces unsuccessfully try to invade Bay of Pigs, Cuba, in attempt to overthrow Castro.

South Africa becomes a Republic and leaves Commonwealth.

In August the Berlin Wall is erected, dividing East and West Berlin.

USSR detonates the largest H-Bomb of 57 megatons in Arctic.

The Committee of 100, a splinter group of CND, which includes philosopher and author Bertrand Russell and artist Gustav Metzger, demonstrate at the Ministry of Defence and are subsequently arrested.

US first sends in military aid to assist South Vietnam's struggle against attacks by the Communist North.

Ministry of Transport establishes Worboys committee to recommend new system of traffic signs. Design of new signage devised by Jock Kinneir and Margaret Calvert.

Launch of Amnesty International.

E-Type Jaguar launched at Geneva Motor Show.

First issue of *Private Eye*, satirical current affairs magazine. The Establishment Club opens in Greek Street, Soho, becoming a meeting place for those involved in the growing market for satirical media, political journalism and comedy TV and radio.

Opening of International Union of Architects Congress (IUAC), South Bank, London. Bernard Cohen, William Turnbull, John Plumb, Eduardo Paolozzi, Richard Hamilton exhibit in Theo Crosby's temporary building. Gustav Metzger gives 'unofficial' Auto Destructive performance to coincide with opening.

The Rebel, starring Tony Hancock, includes a pastiche of artist William Green cycling over splashed paint.

Billy Budd launches the career of Terence Stamp.

The Young Ones, film starring Cliff Richard is released.

Young Contemporaries, RBA Gallery, London, features upcoming exponents of the Pop art movement. February

In July, Lawrence Alloway leaves London to become curator at the Solomon R. Guggenheim Museum, New York.

New London Situation, Marlborough's New London Gallery. August

In summer, Richard Smith returns from New York and moves to London's East End, where he is one of the first artists to rent a studio in a large ex-industrial space.

R.B. Kitaj, Bernard Cohen, Anthony Benjamin and Brian Wall begin to teach the Ground Course set up by Roy Ascott at Ealing Art School, a prototype Pre Diploma course.

Mark Rothko: A Retrospective, Whitechapel Art Gallery, London. October

In December, Peter Blake's *Self Portrait with Badges* wins junior section of John Moores exhibition, Liverpool.

62

US communications satellite Telstar beams live TV broadcasts direct from USA to Britain and Continent.

Caribbean countries, Jamaica, Tobago and Trinidad as well as Uganda become independent of Britain.

On 5 August, Marilyn Monroe dies, aged 36.

In October, President Kennedy demands withdrawal of offensive missiles from Soviet nuclear bases in Cuba. After much international tension and the US agreeing to withdraw their missile bases from Turkey, Khrushchev complies.

Harold Macmillan announces biggest cabinet reshuffle since War in attempt to restore Conservative position.

Sunday Times is first newspaper to launch a colour magazine. First edition on 4 February includes article by John Russell on Peter Blake, 'Pioneer of Pop Art'.

In March, *Pop goes the Easel* by Ken Russell is screened on BBC, featuring Peter Blake, Derek Boshier, Pauline Boty and Peter Phillips.

Biba shop, selling affordable high fashion clothes, opens in West London.

In September, the first Ford Cortina comes off production line at Dagenham.

In November, BBC screen Saturday late-night satirical series *That Was The Week That Was*, directed by Ned Sherrin.

Traverse Theatre, Edinburgh, opens, becoming a focal point for the literary and arts avant-garde. Run by Jim Haynes, leading figure of the counterculture movement.

Lawrence of Arabia, directed by David Lean released to huge critical acclaim, winning 7 Academy awards.

A Clockwork Orange by Anthony Burgess published.

The Ipcress File, by ex-Royal College of Art student Len Deighton, published.

Dr No, starring Sean Connery as Agent 007 in first James Bond film, based on Ian Fleming's spy novel.

The Beatles' first single 'Love Me Do' enters UK charts.

The Rolling Stones play their first major gig, Marquee Club, London.

In April, Robert Fraser Gallery opens in Duke Street, designed by Cedric Price, with exhibition by Jim Dine.

Image in Progress, first anthology exhibition of Pop with Derek Boshier, Peter Phillips, Allen Jones, David Hockney, Norman Toynton, Grabowski Gallery, London. August

Derek Boshier, Frank Bowling, *Image in Revolt*, Grabowski Gallery. October

63

In February, Harold Wilson becomes new Leader of Opposition following death of Hugh Gaitskell, Labour party leader.

British double-agent Kim Philby defects to Russia.

Britain, USA and USSR sign Nuclear Test Ban Treaty, agreeing to end atmosphere testing of nuclear weapons.

Organisation of African Unit established by leaders of 30 African nations.

Kenya gains independence and enters Commonwealth as 18th sovereign member.

Unemployment figures of 900,000 are highest since World War II.

In June, John Profumo, Secretary of State for War, admits lying to House of Commons over his affair with Christine Keeler, a 20-year-old model who is also connected to a Soviet intelligence officer.

In August, Martin Luther King leads march in Washington to protest against continuing racial discrimination in USA: 'I have a dream that one day this nation will rise up and live out the true meaning of its creed: "We hold these truths to be self-evident, that all men are created equal."'

In October, Macmillan resigns. Sir Alec Douglas-Home becomes new Prime Minister.

On 22 November, President John F. Kennedy assassinated, USA.

Britain refused entry into EEC.

John Robinson, Bishop of Woolwich, publishes *Honest to God*, challenging Anglican traditional views of 'God up there'. The term 'the new morality' comes into general usage.

Great Train Robbery, Glasgow – London mail train robbery of £2.5 million.

Ready Steady Go, pop music show screened on ITV.

Andre Courreges's Autumn fashion collection causes sensation with his dramatic futuristic couture. The mini-skirt is introduced to British public by young fashion designer Mary Quant.

Vidal Sassoon introduces the ubiquitous 'bob', the haircut of the era, adopted by Mary Quant and other leading fashion exponents.

Billy Liar, starring Tom Courtenay and Julie Christie, is released.

Dr Strangelove, or How I Learned to Stop Worrying and Love the Bomb, by Stanley Kubrick and starring Peter Sellars, released. Awarded Best Film, Best British Film and Best Art Direction.

The Beatles become a nationwide household name as Beatlemania grips the nation. 'She Loves You' is released and becomes the best-selling single of the decade.

The Feminine Mystique by Betty Friedan is published in the USA.

In April, Kasmin Ltd. opens in London's Bond Street with *Kenneth Noland* exhibition. Graphics designed by Gordon House.

David Hockney, Kasmin, Allen Jones, Derek Boshier, Francis Morland, Peter Phillips at 3rd Biennale of Young Artists, Paris. April

British Painting in the Sixties, Whitechapel Art Gallery and Tate Gallery, London. June

Archigram's *Living City* exhibition, ICA, London. June

Mark Boyle, Caroll Baker and Joan Hills perform the first Happening in Britain, *In Memory of Big Ed*, at the Edinburgh Festival with Alan Kaprow in the audience. September

Anthony Caro, first major public exhibition. Whitechapel Art Gallery. September

The Popular Image, ICA, London, shows first London overview of American Pop Art. October

64

Under President Lyndon B. Johnson, Civil Rights Act forbids racial segregation in public places in USA.

The USA step up their involvement in the Vietnam conflict.

Rhodesia becomes Republic. White electors vote for white suprematist Rhodesia Front Party and UN Security Council calls for economic sanctions and oil embargo.

In May, riots at British coastal towns as Mods and Rockers fight.

In June, Nelson Mandela sentenced to life imprisonment for planning to overthrow the South African government.

Palestine Liberation Organisation is created in Jerusalem.

USSR leader Khrushchev deposed by a peaceful coup on 15 October and replaced by Leonid Brezhnev.

Labour Party, under Harold Wilson, wins General Election on 16 October by a small majority, after 13 years of Conservative rule.

Creation of Ministry of Technology.

Dangerous Drugs Act introduces new offences in respect of cannabis and Drugs (Prevention of Misuse) Act increase control of amphetamines. (Cocaine and heroine use increases tenfold in the first half of the decade.)

Mary Whitehouse introduces the 'Clean Up TV' campaign, in response to the perceived moral laxity in the increasingly liberal broadcasting standards.

Labour government report, *Policy for the Arts*, leads to a large rise in government subsidy for the arts.

Pete Townshend of *The Who* breaks his guitar during performance and refers it back to Gustav Metzger's lecture on Auto-destructivism at Ealing Art College.

Terence Conran opens first Habitat store in London.

Radio Caroline, pirate radio, starts transmitting pop music off the coast of south-east Britain.

Naked Lunch by William Burroughs is published in the UK.

Entertaining Mr. Sloane by Joe Orton's opens at New Arts Theatre, London.

The Beatles' first film, *A Hard Day's Night*, directed by Dick Lester premieres in Liverpool. The band gain a huge following in the USA.

Petula Clark's single *Downtown* becomes a big hit in Western Europe and launches her career in USA.

Bob Dylan's *The Times They Are A' Changing* is released in Britain.

Robert Rauschenberg, Whitechapel Art Gallery, London. February

New Generation, Whitechapel Art Gallery, London. Curated by Bryan Robertson, includes Derek Boshier, Patrick Caulfield, Antony Donaldson, David Hockney, John Hoyland, Paul Huxley, Allen Jones, Peter Phillips, Patrick Procktor, Bridget Riley, Michael Vaughan and Brett Whitely. March

54–64: Painting and Sculpture of a Decade, Tate Gallery, London. April

Joe Tilson is one of four artists representing Britain in Venice Biennale. June

Exhibition of kinetic art by Takis opens at Signals Gallery. First issue of *Signals*, bulletin of kinetic and alternative art published. November

Jasper Johns, Whitechapel Art Gallery, London. December

65

In January, Sir Winston Churchill dies at the age of 91.

USA increases its military involvement in Vietnam, backing the South Vietnam regime against the Viet Cong; anti-war protests start to spread across America.

In February, Black American Muslim leader Malcolm X is shot dead.

In summer, race riots erupt in Watts, Los Angeles, triggering further violence in northern US cities.

Edward Heath becomes new leader of Conservative party following resignation of Sir Alec Douglas-Home.

In October, Ian Brady and Myra Hindley are arrested for the murder of Edward Evans. It is subsequently discovered that they murdered four other children, and two of the bodies are found on the Yorkshire Moors.

Abolition of the Death Penalty in Britain.

Beatles awarded MBEs.

Opening of the Post Office Tower, Britain's tallest building, by Harold Wilson.

First issue of *Nova*, a fashion and style magazine for young women.

The Rolling Stones release their hit single '(I Can't Get No) Satisfaction' and The Who, 'My Generation'.

BBC Wednesday Play series presents hard hitting plays including *Up the Junction* by Nell Dunn and, later, *Cathy Come Home* by Jeremy Sandford.

The Albert Hall poetry reading brings together international Beat and experimental poets, including Allen Ginsberg, Alexander Trocchi and Michael Horowitz.

The Philadelphia Association opens in east London, an experimental psychiatric research centre where doctors and patients live together.

Jim Haynes moves from Edinburgh to London and opens London Traverse at the Jeanetta Cochrane Theatre, with a grant from the Arts Council.

A Box of Pin Ups by David Bailey is published featuring his selection of celebrities.

London, the New Scene mounted by the British Council opens at Walker Art Center, Minneapolis, and tours across North America. February

New Generation sculpture exhibition, Whitechapel Art Gallery. Includes David Annesley, Michael Bolus, Phillip King, Tim Scott, William Tucker, Isaac Witkin, Roland Piche, Christopher Sanderson and Derrick Woodham. March

sTigma environmental exhibition by Jeff Nuttal, Bruce Lacey and John Latham opens in the basement of Better Books on Charing Cross Road, a counterculture bookshop managed by Barry Miles.

Private View, the Lively World of British Art, by Bryan Robertson and John Russsell, with photographs by Lord Snowdon, is published.

Pop as Art, by Mario Amaya – first publication to focus on Pop art as a movement.

US Gemini missions launched in transitional step towards landing man on the moon.

USSR lands Luna 9, the first unmanned probe on moon.

Indira Ghandi takes over as first female Indian Prime Minister.

IRA bomb destroys Nelson's Column, Dublin.

Cultural Revolution declared by Mao in China.

17-year-old Twiggy launched as the face of 1966.

On 18 March, General Election and second victory for Harold Wilson's Labour party.

In July, Wilson admits his government has been 'blown off course' in worsening economic situation, marked by the seamen's strike and subsequent wage freezes.

LSD, Mescaline and Psilocybin made illegal. Release, an organisation to help drug users, is set up.

England wins the World Cup against West Germany. July

Centre Point, by Richard Seifert and Partners, opens in London.

In November, flood ruins numerous art treasures in Florence, Italy.

Ravi Shankar invites John Lennon to India for sitar lessons and tutoring on foundations of eastern music and culture.

First issue of *The International Times (IT)*.

The Playboy club opens in London.

UFO club opens on Tottenham Court Road, with Mark Boyle's light show, Soft Machine and David Medalla's Exploding Gallery. November

Alfie, starring Michael Caine, is released.

US opens at the Almeida Theatre, London. Peter Brooks' theatre production criticising Vietnam War.

Primary Structures, Jewish Museum, New York, includes some British sculptors and confirms new movement of Minimalism. April

Marcel Duchamp retrospective, Tate Gallery, organised by Richard Hamilton by invitation of the British Arts Council. June

Indica, bookshop and gallery, opens in St. James's, London. First exhibition is of GRAV (Groupe Recherche d'Art Visual) from France. June. John Lennon and Yoko Ono first meet here.

Anthony Caro, Bernard Cohen, Harold Cohen, Robyn Denny and Richard Smith represent Britain at Venice Biennale. June

Pauline Boty dies, July.

The Richard Demarco gallery opens in Edinburgh. August

The Destruction in Art Symposium (DIAS) opens with contributions by many significant international and British artists. September

Still and Chew, by John Latham; a library copy of Clement Greenberg's *Art and Culture* from St Martin's School of Art is chewed by participants in interactive event and subjected to a series of chemical processes. Latham returns the remains to the library and is then sacked from St Martin's.

Signals Gallery closes. December

67

In June, Arab forces attack Israel in 'Six Day War'. In retaliation, Israel takes Sinai, Gaza Strip, Golan Heights, West Bank and Jerusalem with US support. The PLO takes leadership of the Palestinian struggle against Israel.

National Health Service (Family Planning) Act enables local authorities to provide family planning service and the contraceptive pill.

Sexual Offences Act legalises homosexual acts between consenting adults over the age of 21.

Abortion Act passed, allowing women to terminate pregnancies on medical or psychological grounds.

On 9 October, Argentine-born Marxist revolutionary, guerrilla leader and aide to Castro, Che Guevara, is murdered in Bolivia.

In November, Sterling devalued by 14.3% in response to economic crisis.

World's first heart transplant operation carried out in South Africa.

Dialectics of Liberation conference at the Roundhouse, London, bringing together international figures from the revolutionary Left.

Oz Magazine is first published in UK.

The Arts Lab is set up on Dury Lane.

Robert Fraser, Mick Jagger and Keith Richards arrested in February and found guilty of drugs possession in June.

The Beatles's *Sgt Pepper's Lonely Hearts Club Band* released in Britain with album cover designed by Peter Blake, Jann Hayworth and Michael Cooper.

Radio 1 begins broadcasting with *The Tony Blackburn Show*, described in BBC minutes as a 'daily disc delivery'.

BBC 2 begins regular colour broadcasting.

Jimi Hendrix moves to the UK and enters the UK charts with *Hey Joe*.

Chelsea Girls, film by Andy Warhol, screened in UK.

Blow Up, directed by Michelangelo Antonioni, starring David Hemmings and Vanessa Redgrave. Works by John Cowan, Don McCullin, Ian Stephenson, Peter Sedgley, Brian Wall are featured.

Artists Placement Group (APG) founded by John Latham, with aim of placing artists in industrial manufacturing situations.

The student protests in Paris during May inspire students at Hornsey School of Art to turn a 'teach-in' on art education into an occupation of college buildings.

In August, USSR invades Czechoslovakia.

In October, Enoch Powell makes 'Rivers of Blood' speech in protest at the numbers of immigrants coming to Britain and is subsequently sacked from his government post for inciting racial prejudice.

Hayward Gallery, London, opens at South Bank Centre with exhibition by Matisse. July

Theatre Act ends censorship of plays.

2001: A Space Odyssey, film by Stanley Kubrick, based on novel by Arthur C. Clarke.

SPACE (Space Provision Artistic Cultural and Educational) established by London-based artists Peter Sedgley, Bridget Riley and Peter Townsend to provide affordable artists' studios.

Phillip King and Bridget Riley represent Britain at the Venice Biennale, which is closed after demonstrations. Riley wins International Painting Prize. June

On 3 June, Andy Warhol is shot in New York by Valerie Solanis.

The ICA relocates to The Mall.

East End gangsters Ronald and Reginald Kray jailed for life for murder.

Divorce Reform Bill passed, enabling couples to separate legally after two years apart.

Legal age for voting for women is reduced from 21 to 18.

Launch of *Monty Python's Flying Circus*.

When Attitudes become Form, survey exhibition of new Conceptual and Land art, opens at ICA, London. August

68

In March, Anti-Vietnam war protests in USA are followed by student uprisings in Europe. In London, a protest in Trafalgar Square moves on to the US Embassy in Grosvenor Square.

On 9 April, Martin Luther King assassinated, sparking race riots in USA.

In May, Ronan Point tower block, made of pre-fabricated slabs, collapses in East End of London.

69

First man on the Moon: US Apollo 11 lands astronauts Neil Armstrong and Edwin 'Buzz' Aldrin.

British troops initially deployed in Northern Ireland to take up internal security duties.

Concorde makes its maiden flight.

Human eggs first fertilised in test tubes, Cambridge University.

NOTES

THIS WAS TOMORROW
Chris Stephens and Katharine Stout

1 Piri Halasz, 'You Can Walk Across it on the Grass', *Time*, April 1966.

2 In a speech to cadets at West Point Military Academy, 5 Dec. 1962, quoted in Leslie Stone, 'Britain and the World', in David McKie and Chris Cook (eds.), *The Decade of Disillusion: British Politics in the Sixties*, London 1972, p.122.

3 The term originated from David Sylvester, 'The Kitchen Sink', *Encounter*, vol.3, Dec. 1954, pp.61–4.

4 Richard Hoggart, *The Uses of Literacy*, London 1957.

5 Letter to Peter and Alison Smithson, 16 Jan. 1967, published in Richard Hamilton, *Collected Words: 1953–1982*, London 1982, p.28.

6 Clement Greenberg, 'Avant Garde and Kitsch', first published in *Partisan Review*, vol.6, no.5, 1939, reissued in *Horizon*, vol.1, no.4, April 1940, pp.255–73.

7 Lawrence Alloway, 'Personal Statement', *Ark*, no.19, Spring 1957, pp.28–9.

8 *Opposing Forces*, Institute of Contemporary Arts, London 1953.

9 Denys Sutton, 'Preface', in *Metavisual Abstract Tachiste*, exh. cat., Redfern Gallery, London 1957.

10 Harold Rosenberg, 'The American Action Painters', *Artnews*, vol.51, Dec. 1952, reprinted in Harold Rosenberg, *The Tradition of the New*, New York 1959, London 1962.

11 After his first demonstration, Metzger used a spray gun to apply the acid.

12 Gustav Metzger, *Auto-Destructive Art*, 4 Nov. 1959.

13 Robert Kudielka, *Robyn Denny*, exh. cat., Tate Gallery, London 1973, p.13.

14 Lawrence Alloway, 'Illusion and Environment in Recent British Art', *Art International*, Feb. 1962, p.41. The first Situation exhibition was held at the Royal Society of British Artists Galleries in 1960, and included Gillian Ayres, Bernard and Harold Cohen, Peter Coviello, Robyn Denny, John Epstein, Peter Hobbs, Gordon House, John Hoyland, Gwyther Irwin, Bob Law, Henry Mundy, John Plumb, Richard Smith, Peter Stroud, Marc Vaux, Brian Young. It was followed by a second exhibition at Marlborough's New London Gallery in 1961 and an Arts Council tour, 1962–3. The title was taken from a quote by William Turnbull, 'the situation in London now'.

15 Lawrence Alloway, *Young Contemporaries*, Royal Society of British Artists, London 1961.

16 In *Modern Art in the United States*, 1956, and *The New American Painting*, 1959, both at the Tate Gallery.

17 Roger Coleman, 'Introduction', in *Situation*, exh. cat., Royal Society of British Artists, London 1960.

18 Richard Smith, 'Trailer: Notes Additional to a Film', *Living Arts*, no.1, 1963, p.29.

19 Quoted in Alex Seago, *Burning the Box of Beautiful Things: The Development of a Postmodern Sensibility*, Oxford 1995, p.107.

20 Artist's statement, in *New Generation*, exh. cat., Whitechapel Art Gallery, London 1964.

21 Richard Smith, 'New Readers Start Here ... Boshier's Paintings, *Ark*, no.32, Summer 1962, p.40.

22 Quoted in Nikos Stangos (ed.), *David Hockney by David Hockney*, London 1976, pp.63–4.

23 He studied at Central St Martin's School of Art and was taught by Richard Smith. His first solo exhibition in London was at the ICA in 1964.

24 *Gerald Laing*, exh. cat., Scottish National Gallery of Modern Art, Edinburgh 1971, p.12.

25 *Painting and Sculpture of a Decade, '54–'64* Tate Gallery, 1964 included 354 works by 169 artists from Europe, North America and Japan; *British Art Today*, San Francisco Museum of Art, 1962.

26 Fraser was fined for exhibiting 'obscene' drawings by Jim Dine in 1966.

27 Vance Packard, *The Hidden Persuaders*, New York and London 1957; on Boshier, see David E. Brauer, Jim Edwards, Christopher Finch, Walter Hopps, *Pop Art: US/UK Connections 1956–1966*, exh. cat., Menil Collection, Houston 2001, p.30; Jasia Reichardt, 'Towards the Definition of a New Image', *Image in Progress*, exh. cat., Grabowski Gallery, London 1962, unpaginated.

28 Christopher Finch, *Image as Language: Aspects of British Art 1950–1968*, Harmondsworth 1969.

29 *First Report of the National Advisory Council on Art Education* (The First Coldstream Report), London 1960, quoted in Clive Ashwin (ed.), *Art Education: Documents and Policies 1768–1975*, London 1975, p.93.

30 Nigel Gosling, 'The Shapes of the Sixties', *Observer*, 10 Feb. 1963 quoted in David Mellor, *The Sixties Art Scene in London*, exh. cat., Barbican Art Gallery, London 1993, p.112.

31 Harold Cohen in *Harold Cohen*, exh. cat., Robert Fraser Gallery, London 1963, p.1.

32 Richard Morphet, *Bernard Cohen: Paintings and Drawings 1959–71*, exh. cat., Hayward Gallery, London 1972, p.22.

33 Bryan Robertson, *New Generation*, exh. cat., Whitechapel Art Gallery, London 1968, p.1.

34 Ibid.

35 Ibid., p.2.

36 David Thompson, *New Generation*, exh. cat., Whitechapel Art Gallery, London 1964, p.1.

37 In *Pop as Art: A Survey of the New Realism* (1965), Mario Amaya suggested it might be better named as New Super Realism, rather than the term Pop Art credited to Lawrence Alloway in 1954 (Alloway denies naming the movement at this early date).

38 In the 1966 *New Generation* catalogue, Robertson acknowledges that Anthony Caro and Bernard Meadows of the Royal College of Art offered him advice during the selection.

39 Tim Scott in *New Generation*, exh. cat., Whitechapel Art Gallery, London 1965, pp.57–8.

40 *Dimensions: British Abstract Art 1948–57*, exh. cat., O'Hana Gallery, London 1957.

41 Andrew Forge, 'The Development of Ian Stephenson's Paintings', *Studio International*, 1968, reprinted in *Ian Stephenson*, exh. cat., Laing Art Gallery, Newcastle upon Tyne, 1970.

42 Michael Compton, *Optical and Kinetic Art*, London 1967.

43 Quoted in *Signals*, vol.1, no.1, Aug. 1964, [p.4].

WILLIAM GREEN
Toby Treves

1 Roger Coleman, 'Introduction', *Five Painters*, exh. cat., Institute of Contemporary Arts, London 1958.

2 See Alex Seago, *Burning the Box of Beautiful Things: The Development of a Postmodern Sensibility*, Oxford 1995, p.125.

3 Many of Mathieu's titles referred to events in French history, particularly the triumphs of the early French monarchy.

4 John Berger, 'The Art of Assassination', *New Statesman*, 18 Jan. 1958, p.70.

5 Lawrence Alloway, '"Pop Art" since 1949', *Listener*, 27 Dec. 1962, p.1086.

6 Ibid.

'A HIGHLY MOBILE AND PLASTIC ENVIRON'
Barry Curtis

1 Kristin Ross, *Fast Cars, Clean Bodies: Decolonization and the Reordering of French Culture*, Cambridge, Mass. 1995, pp.160–5.

2 Andreas Huyssen in *Popartretrospective: DocumentaXCantz*, Kassel 1997, p.399, quoted by Kevin Davey in *English Imaginaries: Six Studies in Anglo-British Modernity*, London 1999.

3 Arthur Marwick in A. Aldgate, J. Chapman and A. Marwick, *Windows on the 60s: Exploring Key Texts of Media and Culture*, London and New York 2000.

4 The year 1963 is seen by a number of historians as a particularly significant year. See John Lawton, *1963: Five Hundred Days: History as Melodrama*, London 1992.

5 See David Caute, *1968: The Year of the Barricades*, London 1998; Mark Kurlansky, *1968: The Year that Rocked the World*, London 2004.

6 Christopher Booker, *The Neophiliacs: A Study of the Revolution in English Life in the Fifties and Sixties*, London 1969, p.307.

7 Bernice Martin, *A Sociology of Contemporary Cutural Change*, Oxford 1981, p.235.

8 Regis Debray quoted in Bart Moore-Gilbert and John Seed (eds.), *Cultural Revolution*, London 1992, p.5.

9 Sohnya Sayres, Anders Stephanson, Stanley Aronowitza and Frederic Jameson (eds.), *The 60s Without Apology*, Minneapolis 1984, p.2.

10 Raymond Williams, *The Long Revolution*, London 1961.

11 Kenneth Allsop, *The Angry Decade: A Survey of the Cultural Revolt of the 1950s*, London 1958, p.207.

12 Ibid., p.208.

13 W.T. Lhamon, Jr, *Deliberate Speed: The Origins of a Cultural Style in the American 1950s*, Washington and London 1990, p.xi.

14 Ibid., p.xiv.

15 'The bulk of pictures are Americanised to an extent that makes them (the audience) regard the British film as a foreign film.' *Daily Express*, 1927, quoted by John A.Walker, *Cultural Offensive*, London 1998, p.8.

16 John Colville quoted by Richard Weight, *Patriots: National Identity in Britain 1940–2000*, London 1997, p.397.

17 Angela Carter in Sara Maitland (ed.), *Very Heaven: Looking Back at the 60s*, London 1988, p.215.

18 Shawn Levy, *Ready Steady Go: Swinging London and the Invention of Cool*, London 2002, p.66.

19 Lawrence Alloway, 'A Personal Statement', *Ark*, no.19, 1957, p.28.

20 John McHale, *The Plastic Parthenon*, first published in *Dotzero*, Spring 1967, reprinted in John Russell and Suzi Gablick, *Pop Art Redefined*, London 1969, pp.47–53.

21 Ibid.

22 David Mellor in David Robbins (ed.), *The Independent Group: Postwar Britain and the Aesthetics of Plenty*, Cambridge, Mass. 1990, p.229.

23 Anthony Sampson, *Anatomy of Britain*, London 1962, *Anatomy of Britain Today*, London 1965, *The New Anatomy of Britain*, London 1971.

24 Harold Wilson, *Speeches*, Harmondsworth 1964, p.10.

25 Thomas Frank, *The Conquest of Cool: Business Culture, and the Rise of Hip Consumerism*, Chicago and London 1998, p.6.

26 Michael Bracewell, *England Is Mine*, London 1998, p.13.

27 Richard Hoggart, *The Uses of Literacy*, London 1957, p.246.

28 Lawrence Alloway, 'The Long Front of Culture', *Cambridge Opinion*, no.17, 1959, p.33, reprinted in Brian Wallis (ed.), *This Is Tomorrow Today: The Independent Group and British Art*, New York 1987.

29 See in particular Jeff Nuttall, *Bomb Culture*, London 1968, and Richard Neville, *Playpower*, St Albans 1971.

30 'You had to go up to Compendium Books, when you asked for the literature you had to pass an eyeball test' (Jon Savage, *Englands Dreaming*, London 1991, p.30).

31 See Nigel Fountain, *Underground: The London Alternative Press 1966–74*, London 1992.

32 Reyner Banham, 'The Gutenberg Backlash', *New Society*, 10 July 1969, p.63.

33 Lawrence Alloway quoted in Lucy Lippard and John Russell (eds.), *Pop Art*, London 1966, pp.31–2.

34 Richard Hamilton quoted in Christopher Finch, *Image as Language: Aspects of British Art, 1950–1968*, Harmondsworth 1969, p.24.

35 Mary Quant quoted in Levy 2002, p.81.

36 *Ark*, 'Fine Artz' issue, cited in Alex Seago, *Burning the Box of Beautiful Things: The Development of a Postmodern Sensibility*, Oxford 1995, p.19.

37 Richard Hamilton quoted by Dick Hebdige in Chris Jencks (ed.), *Visual Culture*, London 1995, p.97.

38 Greg Taylor, *Artists in the Audience*, New Jersey 1999, p.148.

39 Reyner Banham, *Art and Design in the First Machine Age*, Cambridge, Mass. 1960.

40 Robert Freeman, originally published in *Living Arts*, no.2, 1963, quoted in Martin Harrison, *Young Meteors*, London 1988, p.47.

41 See Richard Hamilton, *Collected Words: 1953–1982*, London 1982.

42 Quoted in Harriet Vyner, *Groovy Bob: The Life and Times of Robert Fraser*, London 1999, p.67.

43 The *Sunday Times* colour supplement was first published in 1962, the *Telegraph* in 1964 and the *Observer* in 1965.

44 Andrew Ross, *No Respect: Intellectuals and Popular Culture*, New York and London 1989.

45 Peter and Allison Smithson, 'But Today we Collect Ads', *Ark*, no.18, 1955, reprinted in Wallis 1987, p.53.

46 Thomas Crow, *The Rise of the Sixties: American and European Art in the Era of Dissent 1955–69*, London 1996, p.9.

47 Statistics from Magnus Pyke in C.W.E. Bigsby (ed.), *Superculture*, London 1975.

48 The lyrics of 'I Can't Get no Satisfaction' are indicative of a resistance to more and more interpellative advertisements, no longer the voice of authority but the voices of seduction.

49 Cited in Francis Frascina (ed.), *Pollock and After: The Critical Debate*, London 1985, p.118.

50 Bryan Robertson, John Russell, Lord Snowdon, *Private View*, London 1965.

51 Pearl Binder, *The Peacock's Tail*, London 1958, p.382.

52 See Peter Burton in Paolo Hewitt (ed.), *The Sharper Word: A Mod Anthology*, London 1999.

53 Jonathan Rose, *The Intellectual Life of the British Working Classes*, New Haven, p.439.

54 Davey 1999, p.83.

55 Levy 2002, p.11.

56 Crow 1996.

57 Seago 1995, p.178.

58 Robert Hughes quoted in Ian Barker et al., *English Art Today 1960–76*, Milan 1976, p.183.

59 Anthony Caro quoted Crow 1996, p.107.

60 Hoggart 1957.

61 Allan Kaprow quoted in Crow 1996, p.33. Note the similarities with Henri Lefebvre's injunction (*Critique of Everyday Life*, vol.1, 1991, p.132), 'All we need to do is simply open our eyes, to leave the dark world of metaphysics and the false depths of the "inner life" behind and we will discover the immense human wealth that the humblest facts of everyday life contain'.

62 Alex Seago quotes a revealing letter from Robyn Denny to John Minton: 'we believe in the dynamism of the times where painting, being inseperable from the whole is an exciting problem now linked mother than ever with the whole world problem of communication', in Seago 1995, p.123.

63 Marshall McLuhan in C.W.E. Bigsby, *Superculture*, London 1975, p.55.

64 Robertson 1965, p.252.

65 Cited in Reinhold Martin, *The Organisational Complex*, Cambridge, Mass. 2003, p.22.

66 Harold Rosenberg quoted by Max Kozloff in Frascina 1985, p.113.

67 Reyner Banham cited in Martin 2003, p.25.

68 Norbert Weiner cited in Martin 2003, p.213.

69 Booker 1969, pp.293–4.

COLIN SELF AND THE BOMB
Ben Tufnell

1 It is estimated that by the mid-sixties over 40,000 nuclear warheads had been stockpiled globally (www.banthebomb.org).

2 Nuclear imagery is obliquely referenced in work by Paolozzi and the Cuban Missile Crisis is referred to by Boshier, Kitaj and others. In contrast, nuclear imagery is central in a number of key works by American artists including Warhol (*Atomic Bomb* 1965, Daros Collection, Switzerland) and Rosenquist (*F1-11*, 1965, The Museum of Modern Art, New York).

3 In fact Britain had achieved nuclear capability in 1952 and had, by the beginning of the sixties, developed a considerable nuclear arsenal.

4 The Committee of 100 was set up in 1960 to organise Non-Violent Direct Actions, including demonstrations, sit-ins and blockades. Alongside politicians, clergymen, pilosophers and writers it included the artists John Hoyland, Metzger and Augustus John, and the critics John Berger and Sir Herbert Read.

5 Gustav Metzger, *Auto-Destructive Art, Machine Art, Auto-Creative Art*, 23 June 1961.

6 David Alan Mellor, *The Sixties Art Scene In London*, London 1993, p.33.

7 All quotes by Colin Self from a conversation with the author, 1 Dec. 2003.

REALISM, SATIRE, BLOW-UPS: PHOTOGRAPHY AND THE CULTURE OF SOCIAL MODERNISTATION
David Alan Mellor

1 For example, in the localist dramas of Salford and the Greater Manchester area in Tony Richardson's film *A Taste of Honey* (1962).

2 As in the extraordinary sequence in *We Are the Lambeth Boys*, in which the group, sitting in the back of a lorry, drive through Whitehall, insurgent in the territory.

3 *Vogue*, Oct. 1959, p.190.

4 Mayne photographed the seminal event for the nascent New Left, the March to Aldermaston, organised by the Campaign for Nuclear Disarmament (CND) in 1958, 1959, 1960 and 1961.

5 'The most important filmmakers to me are Kurosawa and Keaton' (Roger Mayne, cited by Mark Haworth-Booth in *The Street Photographs of Roger Mayne*, exh. cat., Hayward Gallery, London 1987, p.66. Haworth-Booth's narrative of Mayne remains the best historical account of the photographer. Mayne's photographs were fed back into a filmic world, functioning as stills advertising the CND documentary shot by Lindsay Anderson, *March to Aldermaston* (1959).

6 Commissioned for the journal *Architectural Design* and published in the September 1961 issue.

7 Negative catalogued by Mayne as SZ 29, Roger Mayne Archive.

8 Negative catalogued by Mayne as YAN 8a, Roger Mayne Archive.

9 See Don McCullin, *Unreasonable Behaviour*, New York 1991, p.20.

10 W. Lewis, *The Fifties*, London 1978, p.118.

11 On the structure of 'moral panics' see Stanley Cohen, *Folk Devils and Moral Panics*, London 1972, p.72.

12 Andrew Loog Oldham, *2Stoned*, London 2003, p.311. In addition to drilling Mankowitz (and Bailey) as they worked as still publicists of the Rolling Stones, Loog Oldham also usurped the directorial roles of TV directors such as Michael Lindsey Hoog (of *Ready, Steady, Go!*), attempting to manage camera movements and cutting: c.f. Tony King, cited in Loog Oldham 2003, pp.304–5.

13 See Dick Hebdidge, *Sub-Cultures: The Meaning of Style*, London 1996, p.35.

14 McCullin regarded Brandt, with his sombre and strange documentaries which had been regular features of mainstream magazines such as *Lilliput* and *Picture Post*, as an inspirational and influential photographer – as did David Bailey, who photographed hommages to him in the couple of years after the publication of Brandt's *A Perspective of Nudes*, in 1961.

15 'Notes on the Photographs and the Photographers', *The British Journal of Photography Album*, London 1964, p.177.

16 McCullin documented the violent street provocations of the National Front in the East End and at Trafalgar Square in 1962.

17 Harold Hobson cited in Martin Esslin, *Harold Pinter the Playwright*, London 1982, p.23.

18 Esslin 1982, pp.55–6.

19 The text for 'The Teenage Thing', *Vogue*, December 1959, is uncredited, but may be by the individual credited as 'consultant', Alexander Jacobs.

20 David Bailey in conversation with the author, April 1983, London.

21 Jean Shrimpton, *Jean Shrimpton: An Autobiography*, London 1991, p.86.

22 Haslam lived in a large apartment near Astor Place, close to the Bowery where dereliction was an inescapable social fact.

23 'F Is for Fairground', *Tatler*, 19 Aug. 1959, pp.25–8.

24 Illustrated on p.114, Humphrey Carpenter, *That Was Satire That Was*, London 2000.

25 Mikhail Bakhtin, *Rabelais and his World*, Cambridge, Mass. 1968, p.109.

26 Unpublished correspondence, cited in Gwyneth King, 'Pauline Boty', MA Dissertation, University of Sussex, 1978.

27 In fact it had only been since 1958 that an anglicised sexual cabaret was established in Soho, the Raymond Revue Bar.

28 Like the 'contemporary' chair which Keeler straddled, the muscleman was a foundational image at the beginnings of British Pop in the work of Eduardo Paolozzi's *Bunk* or Richard Hamilton's *Just what is it that makes today's homes so different, so appealing?*

29 See *Private Eye* covers by Morley for no.73, 2 October 1964 and no.208, 5 December 1969.

30 Sir Hugh Carleton-Green reported in *Private Eye*, cited in Carpenter 2000, p.278.

31 See Carpenter 2000, p.265–6.

32 Colin McCabe, *The Eloquence of the Vulgar*, London 1999, p.100.

33 For a comparative account of the cultural impact of processes of 'modernisation as an event' in France during this period, see Kristen Ross, *Fast Cars, Clean Bodies*, Cambridge, Mass. 1996, p.4.

34 From BFI *Monthly Film Bulletin*, cited in Robert Murphy, *Sixties British Cinema*, London 1992, p.22.

35 Murphy 1992, p.23.

36 See David Alan Mellor in *David Bailey: Black and White Memories*, exh. cat., Victoria and Albert Museum, London 1983, p.7.

37 A commonality of the 'hard edge' pictorial and sculptural language of the New Generation artists of 1964 had already been summed up by a layout in *Vogue* early in 1965, when Bailey's photograph of a Vidal Sassoon helmet hairstyle was juxtaposed with an installation shot of Phillip King's sculpture, *Genghis Khan* (*Vogue*, Jan. 1965, p.20).

38 Freeman was also guided by a fellow Cambridge student who would shortly be founder of the Establishment Club, Peter Cook, towards an important Pop-journalistic precedent for insubordinate, acidic satire as a cultural model, the scandalous American magazine, *Confidential* – the epitome of low, vulgar sensationalism in photos and text.

39 Mayne's photograph is captioned 'How far can freedom of expression go without giving licence to sedition, libel and obscenity? Traditional safeguards of freedom of expression are endangered when those protected by them loose all sense of responsibility' (*Schoolmaster and Women Teacher's Chronicle*, 28 Oct. 1960).

40 Robert Freeman in conversation with the author, 24 July 1992.

41 Robert Freeman in correspondence with the author, 12 Jan. 2004.

42 Ibid.

43 'The pictures were edited with one line for each Beatle, on the same principle as the poly-photo system, where a person is photographed with different expressions from a fixed camera position. The grid format worked equally well for the film poster and the album cover.' Robert Freeman, ibid.

44 Ibid.

45 For an account of Bailey's lighting techniques at this time see Martin Harrison in Victoria and Albert Museum 1983, p.16.

46 Alexander Walker, *Hollywood, England*, London 1974, p.240.

47 Frances Wyndham, 'Notes' for *David Bailey's Box of Pin-Ups*, 1965.

48 Susan Sontag, *Against Interpretation*, New York 1966, pp.16–17.

49 Ibid., p.304.

50 See the anecdote of Oldham's physical assault of mocking 'chinless wonders' in a London restaurant, which is retailed in Frances Wyndham's notes to the *Box...*.

51 Sir Winston Churchill's death in January 1965 could be said to inaugurate the symbolic post-Imperial moment.

52 Sontag 1966, p.298.

53 This was the ignition point for Mrs Mary Whitehouse's campaign against blasphemy and obscenity in the media, precipitated, in her case, by the realist narratives of BBC TV dramas.

54 Hilde Spiel, 'Beckett, Bacon und "Skiffle"', *Die Weltwoche* (Zurich) 12 April 1957.

55 Ibid.

56 Robert Pitman, 'Strange Company this Team of Topical Pin-Ups', *Sunday Express*, 19 December 1965. Like Mary Whitehouse, the journalist Robert Pitman recognised blasphemy when he saw it and he perceived it in Bailey's portrait of P.J. Proby, which the photographer claimed to have modelled on Pollaiuolo's *Martyrdom of St Sebastian* in the National Gallery: 'Well, he looks like the painting of St Sebastian in the National Gallery, anyway' (David Bailey cited in Matin Harrison, *David Bailey, Black and White*

Memories: Photographs 1948-1969 (London 1983, p.55.) The portrait was predicated on a camp visual conceit – part epicene travesty, part sado-masochist muscularity – similar to that behind the Morley portrait of Joe Orton.

57 Published in *Queen*, June 1966.
58 C.f. Nell Dunn, *Up The Junction*, London 1964.
59 See Robert Murphy, *Sixties British Cinema*, London 1992, pp.241–2.
60 The aerialism of Cowan's 'Flying High', had been preceded, the previous year, by Bailey's 'Cape Courreges' feature, with leaping models, in *Vogue*, March 1965, pp.106–9.
61 Colin MacInnes *Absolute Beginners* (1959), Harmondsworth, 1964, pp.9–10.
62 McCullin 1991, p.87.
63 Ibid., p.88.
64 Ibid., p.17.
65 Ibid., p.112.
66 Ibid., p.113.
67 Susan Sontag, *Regarding the Pain of Others*, London 2003, p.71.
68 McCullin 1991, p.125.
69 Reproduced in his first collection, *The Destruction Business*, London 1971, p.35.
70 McCullin 1991, p.125.

SCULPTURE AT ST MARTIN'S
Rachel Tant

1 William Tucker quoted in *The Alistair McAlpine Gift*, exh. cat., Tate Gallery, London 1971, p.91.
2 Bryan Robertson, in *New Generation*, exh. cat., Whitechapel Art Gallery, London 1965, p.8.
3 Course descriptions 1962–5, printed in Sculpture Department prospectus, Central St Martin's School of Art and Design Archive, London.
4 Anthony Caro quoted in Andrew Dempsey (ed.), *Sculptors Talking: Anthony Caro, Eduardo Chillida*, London 2000, p.46.
5 Frank Martin interviewed by Cathy Courtney for the National Life Story Collection of the National Sound Archive, 11–13 Aug. 1995.
6 Ibid.
7 Anthony Caro quoted in Dempsey 2000, p.46.
8 Phillip King quoted in Giovanni Carandente, *Phillip King*, exh. cat., Forti di Belvedere, Florence 1997, p.20.
9 Charles Harrison, 'Phillip King: Sculpture, 1960–68', in *Artforum International*, Dec. 1968, p.34.
10 R. Oxenaar in *Phillip King*, exh. cat., Rijkmuseum Kröller-Müller, Otterlo 1974, p.11.
11 Ibid., p.14.
12 Phillip King, 'British Artists at Venice 2. Phillip King talks about his sculpture', *Studio International*, June 1968, p.301
13 Phillip King quoted in *Phillip King* 1974, p.37.
14 Taken from course descriptions 1962–5, printed in Sculpture Department prospectus, Central St Martin's School of Art and Design archive.
15 Frank Martin interviewed by Cathy Courtney for the National Life Story Collection of the National Sound Archive, 11–13 Aug. 1995.
16 Anthony Caro quoted in Diane Waldman, *Anthony Caro*, Oxford 1972, p.34.
17 Letter of 7 June 1963 printed in *Silans* (no.6 Jan.

1965), quoted in Terry Neff (ed.), *A Quiet Revolution: British Sculpture since 1965*, exh. cat., Museum of Contemporary Art, Chicago and touring 1987, p.27.
18 Lynne Cooke, in Neff 1987, p.39.
19 Lewis Biggs, *Barry Flanagan: A Visual Invitation, Sculpture 1967–1987*, exh. cat., Tyne and Wear Museum Service 1987.
20 Barry Flanagan in discussion with Gene Baro in 'Sculpture Made Visible', *Studio International*, Oct. 1969, p.124.
21 Ibid., p.122.

A POETICS OF DISSENT
Andrew Wilson

1 Leader Comment, 'Stirring Times', *Times Literary Supplement*, 17 June 1965, p.519.
2 Letter from Jeff Nuttall to Klaus Lea, June 1965, quoted in Jeff Nuttall, *Bomb Culture*, London 1970, p.183.
3 See Jonathon Green, *Days in the Life: Voices from the English Underground 1961–1971*, London 1988, pp.64–74 and Barry Miles, *In the Sixties: A Memoir*, London 2003, pp.57–63.
 Peter Whitehead's film of the Albert Hall event, *Wholly Communion*, captures only thirty-five minutes of the four-hour event and hardly any poem is filmed in its entirety. Nevertheless, it captures well the spirit of the occasion and the sense of a new community recognising itself. For discussion of the film see Jack Sargeant's interview with Whitehead in Jack Sargeant, *Naked Lens Beat Cinema*, London 1997, pp.126–45.
4 In the event neither Voznesensky, Pablo Neruda nor Pablo Fernandez read – although Voznesensky was in the audience and one of his poems that had been written in New York was read by Ginsberg.
5 'International Poetry Invocation', *International Poetry Incarnation*, printed programme note, Royal Albert Hall, London, 11 June 1965, folded card.
6 Trocchi's phrase was delivered at a press conference, 22 August 1962, during the Writers' Conference organised by John Calder for the 1962 Edinburgh Festival. The audiotapes of this conference are held at the National Sound Archive, London.
7 The term 'anti-psychiatry' was not to be coined by David Cooper until 1967 (Cooper worked in collaboration with R.D. Laing, Aaron Esterson and Joe Berke). It offered a challenge to the core values of contemporary psychiatry and claimed that psychiatric patients were not necessarily ill, but individuals that are misfits within society.
8 Peter Stansill and David Zane Mairowitz (eds.), *BAMN (By any means necessary): Outlaw Manifestos and Ephemera, 1965–70*, Harmondsworth 1971, p.13.
9 Michael Horovitz, 'A Circle for the Square World', *Times Literary Supplement*, 6 August 1964, p.710.
10 Pete Brown cited in Peter Fryer, 'A Map of the Underground: The Flower Power Structure & London Scene', *Encounter*, vol.24, no.4, Oct. 1967, p.15.
11 Michael Horovitz (ed.), *Children of Albion: Poetry of the 'Underground' in Britain*, Harmondsworth 1969, pp.325–6.
12 Barry Miles, *Allen Ginsberg: A Biography*, London 2000, p.366.

13 Adrian Henri, *Environments and Happenings*, London 1974, p.117.

14 Patten, writing about these events in *Poetmeat*, no.11, Summer 1966, pp.79–80, declared that 'Events are a form of entertainment peculiar to Liverpool. They are a semi-improvised art form based on the American Happenings, the happenings which were pioneered in the early 1960s by a group of young painters of the third US post war generation (Claes Oldenberg, Jim Dine, Allan Kaprow and others). A new form of instant theatre; a 3-D collage using sound, music, poetry and people – with sort of visual jazz variations on a pre-arranged theme. This is as valuable as readings to many people. More valuable if you are attempting to reach people outside poetry. It's not as you say "theatrical props and comic trappings to sustain audience interest" but a new form derived from straight poetry readings. There is a place for both. It's not true that "if straight poetic communication fails to interest an audience, it is either bad poetry or a bad audience". And poetic communication does not have to be poetic communication. Words are only one side of the story.'

15 Horovitz 1969, p.328.

16 Decio Pignatari, Haroldo de Campos, Augusto de Campos, 'Pilot Plan for Concrete Poetry' (1958), cited in Stephen Bann (ed.), *Concrete Poetry: An International Anthology*, London 1967, p.15. Bann's introduction is a useful and partial view of concrete poetry's developments since the fifties pioneers in Brazil and the work of poets around Eugen Gomringer in Ulm, to British practitioners.

17 Dom Sylvester Houédard, 'Concrete & Ian Hamilton Finlay', *Typographica*, no.8, 1963. In 1962 E.M. de Melo e Castro had written a letter published in the *TLS* (25 May 1962, p.373) in which he describes the origins of a 'poesia concreta' as an 'experiment in ideogrammatic or diagrammatic writing and poetic creation' and which alerts Finlay, Houédard, Anselm Hollo and Edwin Morgan to the existence of concrete poetry. The following year Houédard translated Pierre Garnier's 'Spatial Poetries Position 1' (signed by Houédard, Finlay, John Furnival, Hollo, Morgan and Herbert Read), which was published by Cavan McCarthy and distributed in Leeds shortly before the founding of Tlaloc.

18 This can be charted through his 1960 essay 'heathen holiness' in the *Aylesford Review*, vol.3, no.3, Autumn 1960, his 1962 essay 'beat/afterbeat' in the *Aylesford Review*, vol.5, no.2, Summer 1963, and his essay 'the third bridge' in *Tzarad*, no.1, August 1965. In this latter text he tries to show that 'new' poetry (i.e. that spawned by the Black Mountain College), beat poetry and 'nouvelle' poetry (concrete poetry, or what he terms 'semi kinkon') might have common ground, while at the same time criticising British beat poetry: 'the 3rd isnt just the balance between beat/blckmtn – between romantic/ classical – it is observing the flicker machine at work ie observing observation – this (maybe only to me) zen flickereffect between knower and known (JE & MOI) seems the operative relationship between the original beats & the noigandres after WW2 – here in gb we never got our ginsberg-orlovsky kerouac corso since we never produced a burroughs – our west coast didn't face the orient – our beats are 1/5 of a century after the dharma bums – we never had a prophet – not a real holy wiggy one – we had bloomsbury buddhism instead of the subterraneans – france had dada.'

19 Dom Sylvester Houédard, 'ica expo bpp selective notes on 3 aspects', unpublished typescript, c.1965/66, University College London Library, Special Collections, Cavan McCarthy Archive, Box 2.

20 Ibid.

21 Ibid.

22 This poem was first published, incorrectly, in *Tlaloc*, no.4, Feb. 1965. In the letter to McCarthy in which he offers the poem for publication Houédard explains that the 'interest in this poem is: its totality: its balance: its rhythm: its dual eye/ ear validity: its rigid convention: its pleasing appearance & sound: its minimal but adequate reference to something outside itself ie TAKIS: the harmony of its form with the magnetic sculptural forms of takis: its neatness & brevity – all sorts of other things you cld say abt it too'. Letter from Dom Sylvester Houédard to Cavan McCarthy, 7 December 1964, University College London Library, Special Collections, Cavan McCarthy Archive, Box 2.

23 See Dom Sylvester Houédard, 'Bob Cobbing: Troubadour & Poet', *Extra Verse*, no.17, 1966, pp.3–11.

24 Bob Cobbing, note in *Between Poetry and Painting*, Institute of Contemporary Arts, London 1965, unpaginated.

25 Group H and Writers Forum were part of a larger organisation run by Cobbing called Arts Together, which also included Music Unlimited, Moment (which mounted theatre and happenings, and was a forerunner of Nuttall's People Show) and Cinema 61, which in 1966 became part of the London Filmmakers Co-operative which had itself been founded by Cobbing.

26 Nuttall explains this event/publication as follows: 'GUESTS … wrote their own forecasts of what would happen PLUS accounts in advance from pupils of Ravenscroft School A TAPE RECORDER recorded or did not record the proceedings. The creative CUTUPRY was done by Jeff Nuttall 50 or so copies of the result were prepared and presented to guests friends and potential publishers … it is an HISTORIC DOCUMENT dating from the heyday of the groups making up ARTS TOGETHER: WRITERS FORUM which continues in publishing GROUP H painters and sculptors MUSIC UNLIMITED, MOMENT theatre happenings a forerunner of the People Show CINEMA 61 which by a natural progression eventually merged in the London Film-Makers Co-operative and various others.' See preface to Jeff Nuttall, *Mr Watkins got drunk and had to be carried home*, 'a party-piece cut-up by Jeff Nuttall from an Idea by William Burroughs', London 1968. Nuttall also decribes the event/publication in his *Bomb Culture*, London 1970, pp.148–150, in which he admits, 'I put Mr Watkins together wrongly,

created the idea like a wild way of making a word object. That was okay but Burroughs meant the project as the dissolution of time' (p.148).

27 Nuttall 1970, p.141.

28 Jeff Nuttall, untitled commentary in *My Own Mag*, no.12, May 1965, unpaginated, which also includes two photographs and subsidiary statements. Nuttall's later detailed, but more retrospectively apologetic, description of *sTigma* is in Nuttall 1970, pp. 224–7.

29 Alexander Trocchi, 'The Destruction of the Object' [1962], one-page MS note, Trocchi estate.

30 Alexander Trocchi, from a press conference, 22 August 1962, during the Writers' Conference organised by John Calder for the 1962 Edinburgh Festival.

31 The cutting up of a text at random and re-arranging it to create a new text was a technique which had been discovered by chance by the artist and writer Brion Gysin. While cutting mounts his knife had also cut through some pages of newspaper which, when rearranged, emerged as strangely coherent and meaningful. For Burroughs, introduced to the technique by Gysin, it offered exciting and new opportunities. At the 1962 Writers' Conference in Edinburgh, Burroughs had claimed that through the cut-up 'I am acting as a map maker, an explorer of psychic areas ... and I see no point in exploring areas that have already been thoroughly surveyed.' He believed that these random juxtapositions of words pointed to another consciousness for which the technique became the medium for prophecy. Instead of telling stories, these recombined words now charted what Burroughs described as 'tomorrow's news today' – the intersection points of future time.

32 Trocchi's background in Paris and New York is dealt with in my 'Sigma: London Counter-culture: Moving Times – New Words – Dead Clocks' in David Alan Mellor and Laurent Gervereau (eds.), *The Sixties, Britain and France 1962–73: The Utopian Years*, London 1997, p.256; for which see also Allan Campbell and Tim Niel, *A Life in Pieces: Reflections on Alexander Trocchi*, Edinburgh 1997. Although this ignores his involvement with the Situationists, it is good on his more purely literary life in Paris.

33 Copy of a letter from Trocchi to Burroughs, 12 October 1963, p.2, Trocchi Estate.

34 Alexander Trocchi, 'Sigma: A Tactical Blueprint', *Sigma Portfolio*, no.3, p.1.

35 Alexander Trocchi, 'Invisible Insurrection of a Million Minds', *Sigma Portfolio*, no.2, p.1.

36 Latham and Nuttall had planned to stage an event in which they were painted in body paint and wore what Nuttall described as 'huge Aztec costumes of books'. While they waited to go on, Latham passed out and they both had to wash their paint off. The event never happened. Lacey's robots malfunctioned and also did not appear. See Nuttall 1970, p.229.

37 Barry Miles (ed.), *Long Hair: 1 North Atlantic Turn-on*, London 1965, unpaginated.

38 Gustav Metzger, *Auto-Destructive Art: Metzger at AA*, London 1965, p.16.

39 For a more detailed discussion of this see Andrew Wilson, 'papa what did you do when the nazis built the concentration camps? My dear, they never told us anything', in Gustav Metzger *damaged nature, auto-destructive art*, London 1996, pp.64–73.

40 A useful discussion of the Festival of Misfits and Metzger's role in it can be found in Adrian Glew, 'Happening and Fluxus Artist Lost and Found', in Ian Cole (ed.), *Gustav Metzger: Retrospectives*, Oxford 1999, pp.19–21.

41 Gustav Metzger, untitled statement in *Art and Artists*, August 1966, p.22.

42 He had stated quite categorically that 'auto-destructive art is a comprehensive theory for action in the field of the plastic arts in the post war world period. The action is not limited to theory of art and the production of art works. It includes social action. Auto-destructive art is committed to a left wing revolutionary position in politics, and to a struggle against future wars', Metzger 1965, p.1.

43 Gustav Metzger interviewed by Andrew Wilson, 'A Terrible Beauty', *Art Monthly*, no.222, Dec. 1998–Jan. 1999, pp.7–8.

44 Gustav Metzger, 'Machine, Auto-Creative, & Auto-Destructive Art', *Ark*, Summer 1962, p.8.

45 Gustav Metzger, 'Excerpts from Selected Papers Presented at the 1966 "Destruction In Art Symposium"', *Studio International*, Dec. 1966, p.282.

46 When Nitsch's *21st Action* was performed at the St Bride Institute, the police were called and, faced by the ritual crucifixion and evisceration of a lamb and the projection of a film of the manipulation of a cow's brains against a young man's penis, they halted the event shortly before it finished. As a result Metzger and John Sharkey were charged with 'unlawfully causing to be shown and presented an indecent exhibition contrary to common law' and found guilty, Metzger being fined £100.

47 Otto Mühl cited in Hubert Klocker (ed.), *Viennese Actionism 1960–1971: The Shattered Mirror*, Klagenfurt 1989, p.18.

48 Between 1966 and 1967, Indica gallery (a partnership between Miles, John Dunbar and Peter Asher), was one of London's main points of convergence between art and the counterculture at large as well as with a pop music subculture. This was largely a result of Miles's involvement with the Beat poetry scene as manager of Better Books, he was also friendly with William Burroughs who lived nearby. Asher's sister was Paul McCartney's girlfriend and as a result McCartney became friendly with Miles and supported his ventures at the Indica bookshop in Southampton Row from 1966 and the almost simultaneous founding of *International Times*. During this period Dunbar, who ran the gallery, became friendly with John Lennon and, because the gallery was close to the Scottish nightclub, with a subculture of film and pop stars who frequented it. *International Times* also fed into the founding of the UFO Club, for which Boyle and Hills (who had shown at Indica) provided light projections. For more on this network see Miles

2003, and also Andrew Wilson, 'Towards an Index for Everything: The Events of Mark Boyle and Joan Hills 1963–71', in *Boyle Family*, exh. cat., Scottish National Gallery of Modern Art, Edinburgh 2003, pp.49, 54.

49 Dom Sylvester Houédard, 'The Aesthetics of the Death Wish', *Art & Artists*, Aug. 1966, pp.48–9. Throughout this account of the Ravensbourne College of Art's one-day symposium in May 1966 on 'Change and Creative Destruction' he makes a direct link between auto-destructive art and concrete poetry as well as Fluxus and other intermedia arts. He enlarged on this theme in his 'intro to arlington-une catalog: poetisches untersuchun-gen in glostershire 070766', reprinted in *Ceolfrith 15: dom sylvester houédard*, Ceolfrith 1972, pp.56–8.

50 For more on Bruce Lacey and the Alberts, see David Mellor, *The Sixties Art Scene in London*, London 1993, pp. 141–2.

51 Cited in Mark Boyle, *Journey to the Centre of the Earth: Mark Boyle's Atlas and Manual*, London 1970, 'Appendix 19, Human, Social', unpaginated.

52 Jay Landesman and Tony Cox, 'Two Views of DIAS', *International Times*, 14–27 Oct. 1966, p.9.

53 Boyle 1970, 'Appendix 8, Animal', unpaginated.

54 Ibid.

55 Mark Boyle, untitled statement in *Control*, no.1, 1965/66, unpaginated.

56 In July 1964 Trocchi organised a weekend meeting at a Quaker commune near Reading to explore mutual action between Project Sigma and the Philadelphia Foundation's anti-psychiatrists. The weekend was attended by Latham and Nuttall.

57 *Film* was close in type to the performance that Latham and Nuttall had intended to perform at the International Poetry Incarnation.

58 John Latham, 'Publishment of Skoob', supplement to *John Latham: Assemblages*, exh. cat., Bear Lane Gallery, Oxford 1963.

59 In 1963 Metzger, with the kinetic artist Marcello Salvadori, announced the founding of the Centre for Advanced Creative Studies in Hampstead and the following year Medalla, with Keeler and Guy Brett, joined Salvadori. Later that year Keeler and Medalla opened their flat as a 'Showroom for the Avant-Garde' (Salvadori later returned to Hampstead, with the idea of a centre linking art to science and industry). In 1965 this show room moved to premises on Wigmore Street as Signals. Its magazine had, however, been launched the previous year. Signals and Indica gallery were the two galleries in London that concentrated mainly in showing kinetic art.

60 Stephen Bann, 'Unity and Diversity in Kinetic Art' in Stephen Bann, Reg Gadney, Frank Popper and Philip Steadman, *Four Essays on Kinetic Art*, St Albans 1966, p.61.

61 Guy Brett, *Exploding Galaxies*, London 1995, pp.52–3.

62 Guy Brett, *Force Fields: Phases of the Kinetic*, exh. cat., Hayward Gallery, London 2000, p.32.

63 Gustav Metzger, 'David Medalla: Cloud Canyons: Bubble Machines 64', *Signals*, no.2, Sept 1964, p.8.

64 Stephen Willats, statement in *Visual Automatics and Visual Transmitters*, exh. cat., Museum of Modern Art, Oxford 1968, unpaginated: 'A game of prediction is set up where the observer tries to impose an order, and work out the probability of an occurrence of events.'

65 Stephen Willats, statement in *Control*, no.1, 1965/66, unpaginated. Other contributors to early issues of Control include Roy Ascott and Mark Boyle in no.1; Anthony Benjamin, Stroud Cornock, Mike Kenny and Tom Phillips in no.2; and Joe Tilson, Noel Forster, Archigram, John Latham and John Sharkey in no.3.

66 The Free School had been founded in 1965 as a forum for alternative education led by the photographer John Hopkins (a close friend of Miles who together were involved in the founding of *IT*) alongside the anti-psychiatrist Berke and poets such as Fainlight and Neil Oram. Though largely unsuccessful (it had closed by 1967) it prepared much of the ground for the creation in 1968 of the even more short-lived London Anti-University by the Philadelphia Foundation's Institute of Phenomenological Studies.

67 The publication of Al Hansen's *A Primer of Happenings & Time/Space Art*, New York 1965, was a stimulus to much similar activity in London, especially following his presence at DIAS.

68 Flyer announcing the opening for the Anti-University of London, 12 February 1968.

69 *The Anti-University of London*, mimeographed course-catalogue, 1968. For Berke's part in the Anti-University and the Free University of New York, see Joseph Berke, *Counter-Culture*, London 1969, pp.12–34 and 212–81.

70 *The Anti-University of London*, course and catalogue (printed by Trigram Press) 1968

BRUCE LACEY, THE WOMANISER 1966
Adrian Glew

1 *Bruce Lacey: An Exhibition of Humanoids and Constructions*, exh. cat., Arts Council Gallery, Cardiff 1967.

2 Ibid.

BRITISH ARCHITECTURE IN THE SIXTIES
Simon Sadler

The author wishes to thank Iain Boyd Whyte, Simon Bradley, Monica Cherry, Clive Fenton, Jonathan Hughes, Mary Richards, Adam Sharr and Jan Wagstaff for their advice in the preparation of this essay.

1 See Susan Buck-Morss, *The Dialectics of Seeing: Walter Benjamin and the Arcades Project*, Cambridge, Mass. 1989.

2 See, for instance, J.M. Richards, 'Introduction', *Architecture Today*, London 1961; Robert Maxwell, *New British Architecture*, London 1972; and Miles Glendinning (ed.), *Rebuilding Scotland: The Post-war Vision, 1945–1975*, East Linton 1997.

3 See Anthony Jackson, *The Politics of Architecture: A History of Modern Architecture in Britain*, London 1970; Nicholas Bullock, *Building the Post-War World: Modern Architecture and Reconstruction in Britain*, London 2002.

4 A phrase used by Mark Crinson and Jules Lubbock, *Architecture, Art or Profession?: Three Hundred Years*

of Architectural Education in Britain, Manchester 1994, p.116.

5 See for instance Andrew Saint, *Towards a Social Architecture: The Role of School-Building in Post-War England*, New Haven and London 1987. A Nottinghamshire-designed school garnered a major prize at the 1960 Milan Triennale.

6 Miles Glendinning and Stefan Muthesius, *Tower Block: Modern Public Housing in England, Scotland, Wales and Northern Ireland*, New Haven 1994, p.1.

7 Ibid.

8 Lionel Esher, *A Broken Wave: The Rebuilding of England 1940–1980*, London 1981, p.55.

9 Glendinning and Muthesius 1994, p.2. The statistic is for 1963–7.

10 Ibid., p.4.

11 Esher 1981, p.57.

12 See Jonathan Hughes, '1961', in Louise Campbell (ed.), *Twentieth-Century Architecture and its Histories*, London 2001.

13 See for instance Tim Benton, 'The Housing Question: The Exemplary Case of Roehampton', in *Rassegna (The Reconstruction of Europe after World War II)*, Bologna 1993; and Reyner Banham, *The New Brutalism*, London 1966.

14 Elain Harwood, *England: A Guide to Post-war Listed Buildings*, London 2000, 1.26, unpaginated.

15 Compare with the close-up images of biological matter at the Smithsons' 1953 *Parallel of Life and Art* exhibition.

16 On Roger Mayne, see Hughes in Campbell 2001; see also Robert Elwall, 'The Specialist Eye', in *Site Work: Architecture in Photography since Early Modernism*, London 1991.

17 Nicholas Taylor, 'The Failure of Housing', *Architectural Review*, Nov. 1967, p.359, quoted in Glendinning and Muthesius 1994, p.310. (A replacement image for housing in the seventies was nonetheless found, that of the 'village in the city'.)

18 See Esher 1981, pp.64–5.

19 See Benjamin Franks, 'New Right/New Left', in Jonathan Hughes and Simon Sadler (eds.), *Non-Plan: Essays on Freedom, Participation and Change in Modern Architecture and Urbanism*, Oxford 2000.

20 See Elain Harwood, 'White Light/White Heat: Rebuilding England's Provincial Towns and Cities in the Sixties', in 'The Sixties', *Twentieth Century Architecture*, no.6, London 2002; and Hughes, in Campbell 2001.

21 See Esher 1981, p.65.

22 Harwood 2002, p.63.

23 Ibid., p.68.

24 The Steering Group, 'To: The Right Honourable Ernest Maples, MP, Minister of Transport', paragraph 40, in Colin Buchanan et. al., *Traffic in Towns: A Study of the Long-term Problems of Traffic in Urban Areas*, London 1963.

25 Oliver Marriott, *The Property Boom*, London 1967, pp.272–3. See also Hughes, in Campbell 2001.

26 Esher 1981, p.54, f.f.

27 See Harwood 2002, p.62.

28 See Sandy McCreery, 'Westway: Caught in the Speed Trap', in Iain Borden, Joe Kerr, Alicia Pivaro, Jane Rendell (eds.), *Strangely Familiar: Narratives*

of Architecture in the City, London 1996.

29 See Harwood 2002, p.63.

30 Esher 1981, p.64.

31 See Esher 1981, p.67.

32 Quoted in Charles Jencks, *Modern Movements in Architecture*, Harmondsworth 1985, p.254.

33 For commentary on the 'avant-garde', see Royston Landau, *New Directions in British Architecture*, London 1968, and Philip Drew, *Third Generation: The Changing Meaning of Modern Architecture*, New York and London 1972.

34 The White Heat concept originated in a speech by Harold Wilson to the 1963 Labour Party Conference.

35 See J. Stanley Matthews, *An Architecture for the New Britain: The Social Vision of Cedric Price's Fun Palace and Potteries Thinkbelt*, Ph.D. dissertation, Columbia University, 2002.

36 See Esher 1981, p.66.

37 See Simon Sadler, 'The Brutal Birth of Archigram', in 'The Sixties', *Twentieth Century Architecture*, no.6, London 2002.

38 See Peter Smithson, interview with Graham Whitham, 22 Nov. 1982, in David Robbins (ed.), *The Independent Group: Postwar Britain and the Aesthetics of Plenty*, Cambridge, Mass. 1990, p.37.

39 Harwood 2000, p.5.

40 See for instance Glendinning and Muthesius 1994, p.220.

41 See Gavin Stamp, 'I Was Lord Kitchener's Valet or, How the Vic Soc Saved London', in 'The Sixties', *Twentieth Century Architecture*, no.6, London 2002, p.131.

42 See for instance Christopher Booker, *The Neophiliacs: A Study of the Revolution in English Life in the Fifties and Sixties*, London 1969, p.47.

43 Quoted in Booker 1969, p.26.

44 This powerful metaphor derives from musician John Lennon and is reflected upon in Jonathon Green, 'All Dressed Up: The Sixties "Youth Revolution" in retrospect', in 'The Sixties', *Twentieth Century Architecture*, no.6, London 2002.

RICHARD HAMILTON, SWINGEING LONDON 67, 1968–9

Lizzie Carey-Thomas

1 Robert Fraser quoted in the *Evening Standard*, 8 June 1967, p.8.

2 William Rees-Mogg, 'Who Breaks a Butterfly on a Wheel', *The Times*, 1 July 1967.

3 *Richard Hamilton*, exh. cat., Whitworth Art Gallery 1972.

4 First published in the *Daily Sketch*, 29 June 1967.

5 Richard Hamilton quoted in Harriet Vyner, *Groovy Bob: The Life and Times of Robert Fraser*, London 1999, p.163.

6 Robert Fraser quoted in 'You Can Walk across it on the Grass', *Time Magazine*, 15 April 1966, p.30.

7 Robert Fraser quoted in the *Daily Express*, 17 Oct. 1969.

LIST OF WORKS

Dimensions are given in centimetres, height before width

David Annesley
Swing Low 1964 (fig.34)
Painted steel
128.3 × 175.9 × 36.8
Tate. Presented by Alistair
McAlpine (later Lord McAlpine
of West Green) 1970

Archigram
*Instant City – in a field
(Exhibition Model) (1968/1994)*
1968/1994
Mixed media
50 × 50 × 100
Lent by Archigram Archives

Archigram [Peter Cook]
All works lent by Archigram
Archives

*Plug-in City Study – Overhead
View* 1964
Print off ink on tracing drawing
with added colour film
100 × 70

*Plug-in City Capsule Tower –
Tower elevation and plans,
elevation and details of capsules*
1963
Prints with added colour film
mounted on board
100 × 70

*Plug-in City University Node –
Elevation* 1965
Prints with added colour film
mounted on board
100 × 70

Archigram [Ron Herron]
Walking City, New York 1964
(fig.109)
Collage of vehicles in New York
East River
23.5 × 53.5
Lent by the Ron Herron
Archive

Manzak 1969
Three collages
28 × 35.5, 21 × 26, 19.5 × 25
Lent by the Ron Herron
Archive

Gillian Ayres
Distillation 1957 (fig.6)
Oil and house paint on board
213.4 × 152.4
Tate. Purchased 1973

David Bailey
Young Ideas Go West: TWIST
1962 (fig.64)
Digital C-Type mounted on
aluminium
187 × 126
Lent by the artist

Robert Fraser and Friends
Photograph
25.5 × 25.5
Victoria and Albert Museum

A Box of Pin Ups 1965 (fig.71)
36 half-tone photographic
prints
36.8 × 31.7
Victoria and Albert Museum

Clive Barker
Splash 1967 (fig.22)
Mixed media
86.4 × 35.6 × 35.6
Tate. Purchased 1970

Pip Benveniste
Eventual (extract) 1968
16 mm film transferred onto
DVD
Courtesy Pip Benveniste

Peter Blake
On the Balcony 1955–7 (fig.4)
Oil on canvas
121.3 × 90.8
Tate. Presented by the
Contemporary Art Society 1963

Tuesday 1961
Enamel, wood relief and collage
on board
47.6 × 26.7 × 3.8
Tate. Presented by E.J. Power
through the Friends of the Tate
Gallery 1974

Self-Portrait with Badges 1961
(fig. 52)
Oil on board
174.3 × 121.9
Tate. Presented by the Moores
Family Charitable Foundation
to celebrate the John Moores
Liverpool Exhibition 1979

The First Real Target 1961 (fig.14)
Enamel on canvas and collage
on board
53.7 × 49.3
Tate. Purchased 1982

The Beatles 1962 1963–8
Acrylic on hardboard
121.9 × 91.4
Lent by St. John Wilson Trust

Beach Boys 1964
Screenprint on paper
53 × 30.8
Tate. Presented by Rose and
Chris Prater through the
Institute of Contemporary
Prints 1975

The Masked Zebra Kid 1965
Acrylic, enamel, collage
and assemblage on wood
55.2 × 26.7 × 3.8
Tate. Purchased 1974

Derek Boshier
Special K 1961 (fig.18)
Oil, pencil and offset
lithography on canvas
121.5 × 120.4
Tate. Lent by Penelope
Rosenberg 2001

The Identi-Kit Man 1962 (fig.44)
Oil on canvas
183 × 183.2
Tate. Purchased 1971

Pauline Boty
The Only Blonde in the World 1963
(fig.55)
Oil on canvas
121.9 × 152.4
Tate. Purchased 1999

Frank Bowling
Who's Afraid of Barney Newman?
1968 (fig.1)
Oil on Canvas
234 × 122
Lent by the artist

Mark Boyle and Joan Hills
*Son et Lumière for Insects, Reptiles
and Water Creatures* 1966
(fig.87)
16mm film transferred onto
DVD
Lent by the Boyle Family

Burning Slide Projection
Prints from original
transparencies (before
and after)
Lent by the Boyle Family

Neave Brown
*Alexandra Road Housing Estate
1967–1969* (fig.100)
Balsa wood model
78 × 195.9 × 160
Drawing of typical section,
ink on tracing paper
61.8 × 85
Lent by the artist

Anthony Caro
Sculpture Two 1962
Painted steel
259 × 208 × 361
Tate. Lent by Mr and Mrs
Donald Gomme 1992

Patrick Caulfield (fig.31)
Black and White Flower Piece
1963
Oil on board
121.9 × 121.9
Tate. Purchased with funds
provided by the Knapping Fund
1991

CLASP
Primary School (fig.96)
Photographic print
Courtesy RIBA Library,
Photographs Collection

Bob Cobbing
The stencil of the invitation
to and program of the
Destruction in Art Symposium,
1966, gradually destroyed
on a duplicator and printed
at each stage (fig.90)
Lent by the artist's estate

Bernard Cohen
Early Mutation Green No. II 1960
(fig 12)
Oil and house paint on canvas
183.5 × 213.4
Tate. Presented by E.J. Power
through the Friends of the Tate
Gallery 1962

Floris 1964 (fig.28)
Oil and tempera on canvas
183 × 183.4
Tate. Presented by the Friends
of the Tate Gallery 1969

Harold Cohen
Before the Event 1963 (fig.27)
Tempera and oil on canvas
249 × 293
Tate. Purchased 1986

Michael Cooper
Grosvenor Square 1968
Gelatin silver print
38 × 57
Victoria and Albert Museum

*'You Are Here' exhibition, Robert
Fraser Gallery* 1968
Gelatin silver print
27.5 × 40.6
Victoria and Albert Museum

John Cowan
Flying High (Jill Kennington) 1966
(fig.61)
Silver print
149 × 10
Lent by Philippe Garner

Ivor Davies
Anatomic explosion in a house
1966
16 mm film transferred
onto DVD
Courtesy The Pixel Foundry
Artist's Archive

Robyn Denny
Golem I (Rout of San Romano)
1957–8 (fig.9)
Oil and mixed media on board
151.8 × 243.8
Tate. Purchased 1972

Life Line I 1963 (fig.11)
Oil on canvas
213.4 × 182.9
Tate. Purchased 1965

Antony Donaldson
Take Five 1962 (fig.21)
Oil on canvas
152.8 × 153.3 × 2.2
Tate. Purchased 1963

Barry Flanagan
aaing j gni aa 1965 (fig.75)
Mixed media
170 × 145 × 145
Tate. Purchased 1969

Robert Freeman
With the Beatles 1963
Photograph
Private Collection

Hard Day's Night design 1964
(fig.70)
Photograph
Private Collection

Ernö Goldfinger
Odeon at Elephant and Castle
1965
Model
103 × 61.7 × 75
RIBA

Trellick Tower, Paddington 1968
(fig.97)
Photograph courtesy RIBA
Library Photographs Collection

John D Green
Julie Christie 1967
Bromide print
50 × 40.4
National Portrait Gallery

William Green
Untitled 1958 (fig.40)
Bitumen on board
91.7 × 89.2 × 0.4
Tate. Purchased 2002

Richard Hamilton
Hommage à Chrysler Corp. 1957
(fig.5)
Oil, metal foil and collage
on wood
122 × 81
Tate. Purchased with assistance
from the National Art
Collections Fund and the
Friends of the Tate Gallery 1995

$he 1958−61 (fig.45)
Oil, cellulose paint and collage
on wood
121.9 × 81.3
Tate. Purchased 1970

*Towards a definitive statement
on the coming trends in men's
wear and accessories (a) Together
let us explore the stars* 1962
(fig.57)
Oil, cellulose paint and collage
on wood
61 × 81.3
Tate. Purchased 1964

*Hugh Gaitskell as a Famous
Monster of Filmland* 1963
Collotype on paper
38.5 × 37.5
Tate. Purchased with assistance
from Anne Best 2003

Interior II 1964 (fig.51)
Oil, cellulose paint and collage
on board
121.9 × 162.6
Tate. Purchased 1967

My Marilyn 1965
Screenprint on paper
51.8 × 63.2
Tate. Presented by Rose and
Chris Prater through the
Institute of Contemporary
Prints 1975

Swingeing London 67 (f) 1968−9
(fig.112)
Acrylic, collage and aluminium
on canvas
67.3 × 85.1
Tate. Purchased 1969

Jann Haworth
Calendula's Cloak 1967 (fig.24)
Cloth, stand and hoop
172.7 × 116.8 × 116.8
Arts Council Collection,
Hayward Gallery, South Bank
Centre, London

F.H.K. Henrion
Stop Nuclear Suicide 1963
Offset lithograph
Victoria and Albert Museum

David Hockney
The Third Love Painting 1960
(fig.26)
Oil on hardboard
118.7 × 118.7
Tate. Purchased with assistance
from the National Art
Collections Fund, the Friends
of the Tate Gallery, the
American Fund for the Tate
Gallery and a group of donors
1991

*Tea Painting in an Illusionistic
Style* 1961 (fig.19)
Oil on canvas
198.1 × 76.2
Tate. Purchased with assistance
from the National Art
Collections Fund 1996

Man in Shower in Beverly Hills
1964 (fig.48)
Acrylic on canvas
167.3 × 167
Tate. Purchased 1980

Howard Hodgkin
Mrs Nicholas Monro 1966−9
(fig.38)
Oil on canvas
127 × 121.9
Tate. Purchased 1969

Patrick Hodgkinson
Brunswick Centre, 1959−70
Sectional perspective drawing
Pencil on tracing paper
54 × 100
Model by Jeremy Dixon
122 × 103 × 4
Photographs by Richard Einzig
Lent by the artist

*Perspective, winter garden
flat drawing*
Photo-mechanical drawing
and collage
371 × 1157
RIBA

Concourse cross section
Photo-mechanical drawing
and collage
992 × 693
RIBA

John Hoyland
No.22, 20.2.62 1962 (fig.32)
Oil on canvas
172.7 × 172.7
Tate. Presented by the
Contemporary Art Society
1964

Gwyther Irwin
Letter Rain 1959 (fig.8)
Collage on board
183 × 91
Lent by the artist

Allen Jones
Man Woman 1963 (fig.29)
Oil on canvas
214.6 × 188.6
Tate. Presented by the
Contemporary Art Society
1968

Phillip King
Tra-La-La 1963 (fig.76)
Plastic
274.3 × 76.2 × 76.2
Tate. Presented by Alistair
McAlpine (later Lord McAlpine
of West Green) 1970

R.B. Kitaj
The Murder of Rosa Luxemburg
1960 (fig.25)
Oil and collage on canvas
153 × 152.4
Tate. Purchased 1980

Kurt Krens
Sinus Beta (extract) 1966
16 mm film transferred
onto DVD
Courtesy of LUX

Bruce Lacey
The Womaniser 1966 (fig.25)
Mixed media
150 × 165 × 73
Tate. Purchased with funds
provided by the Knapping Fund
2001

Gerald Laing
Skydiver VI 1964 (fig.20)
Oil on canvas
203.2 × 146.7
Tate. Purchased 1984

Denys Lasdun
Keeling House 1954−7 Model.
Balsa and plastic
56.5 × 47.5 × 47.5
Denys Lasdun Archive on
loan to the Royal Institute
of British Architects
Model by Philip Hand
Photograph by Tom Bell
courtesy Denys Lasdun Archive

**Denys Lasdun and Partners
Architects**
*University of East
Anglia 1962−8* (fig.106)
1: 2500 Overall scheme drawing
Pen and ink on tracing paper
76 × 104.5

*South Elevation of West
Wing. Copy drawing of Student
Residencies* 1964
Print on tracing paper
78.5 × 103
Photographs by Richard Einzig
Denys Lasdun Archive on loan
to the Royal Institute of British
Architects

Barry Lategan
Twiggy 1967
Photograph
Lent by the artist

John Latham
Burial of Count Orgaz 1958
Mixed media
121.9 × 91.4 × 21.6
Tate. Purchased 1976

Film Star 1960 (fig.10)
Books, plaster and metal
on canvas
160 × 198.1 × 22.8
Tate. Purchased 1966

Liliane Lijn
Liquid Reflections 1968 (fig.92)
Plastic, wood and mixed media
83.8 × 139.7 × 114.3
Tate. Purchased 1973

Iain MacMillan
*Robert Fraser Gallery (exhibition
installation shots)* 1967
Photographs
Lent by the artist

Gered Mankowitz
Rolling Stones 1965
Photograph
45.8 × 45.6
National Portrait Gallery

Jimi Hendrix 1967
Photograph
43 × 42.3
National Portrait Gallery

Roger Mayne
*Aldermaston March, Day 1
− Turnham Green* 1958 (fig.63)
Silver print
25.4 × 37.5
Lent by the artist

*Aldermaston March, Day 1
− Turnham Green* 1958
Vintage Silver Print
33.7 × 29.2
Lent by the artist

*Aldermaston March, Day 2
− Near London Airport* 1958
Silver print
28 × 42
Lent by the artist

*Bertrand Russell speaks
at Polaris Demonstration,
Trafalgar Square* 1961
Silver Print
38 × 57
Lent by the artist

Parkhill Esate, Sheffield 1961
Silver Print
37.5 × 25.4
Lent by the artist

Street Scene, Sheffield 1961
Vintage Silver Print
38 × 57
Lent by the artist

Deck, Parkhill Estate, Sheffield
1961
Silver Print
30.5 × 45.7
Lent by the artist

*View looking down, Parkhill
Estate, Sheffield* 1961
Silver Print
38 × 57.2
Lent by the artist

Delivering milk, Deck, Parkhill Estate, Sheffield 1961
Silver print
25.4 × 37.5
Lent by the artist

Footballers, Parkhill Estate, Sheffield 1961
Silver print
30.5 × 45.7
Lent by the artist

Gordon McCullen
The Economist Building
Ink and coloured crayon
159 × 195, 209 × 189.
205 × 210
RIBA

Don McCullin
The Guv'nors 1958 (fig.62)
Gelatin silver print
48.2 × 58.4
Lent by the artist

Two Soldiers with Viet Cong 1964 (fig.72)
Gelatin silver print
21 × 30.8
Victoria and Albert Museum

Dead Vietnamese Soldier, Hue 1968
Gelatin silver print
30 × 20
Victoria and Albert Museum

Wounded Child, Hue 1968 1968
Gelatin silver print
25.8 × 39
Victoria and Albert Museum

Rushing Wounded Marine to safety 1968
Gelatin silver print
25.8 × 39
Victoria and Albert Museum

A Mad Day Out with The Beatles 1968 (fig.73)
Gelatin silver print
50.8 × 40.6
Lent by the artist

David Medalla
Cloud Canyons No 3
1961/2004
Mixed media
Lent by the artist

Gustav Metzger
Recreation of first public demonstration of auto-destructive art
1960/2004
Hydrochloric acid, white nylon, glass, found objects
300 × 250 × 100
Lent by the artist

Nicholas Monro
Martians 1965 (fig.23)
Painted fibreglass
121.9 × 91.4 × 61
Lent by Rupert Power

Lewis Morley
Christine Keeler 1963 (fig.66)
Bromide print
50.8 × 41.3
National Portrait Gallery

Joe Orton 1965 (fig.67)
Bromide print
50.8 × 41
National Portrait Gallery

Grosvenor Square Protest 1968
Photograph
24.1 × 35.1
Victoria and Albert Museum

Terry O'Neill
Jean Shrimpton and Terence Stamp 1964
Bromide fibre print
National Portrait Gallery

Yoko Ono
Cut Piece 1964/Performed 1965, New York
Film by Maysles Bros.
Transferred to DVD
Lent by the artist

Eduardo Paolozzi
Was This Metal Monster Master – or Slave? 1952
Collage mounted on card
36.2 × 24.8
Tate. Presented by the artist 1971

Real Gold 1950
Collage mounted on card
35.6 × 23.5
Tate. Presented by the artist 1971

Windtunnel Test 1950
Collage mounted on card
24.8 × 36.5
Tate. Presented by the artist 1971

I was a Rich Man's Plaything 1947 (fig.43)
Collage mounted on card
35.9 × 23.8
Tate. Presented by the artist 1971

It's a Psychological Fact Pleasure Helps your Disposition 1948 (fig.49)
Collage mounted on card
36.2 × 24.4
Tate. Presented by the artist 1971

Lessons of Last Time 1947
Collage mounted on card
22.9 × 31.1
Tate. Presented by the artist 1971

Yours Till the Boys Come Home 1951
Collage mounted on card
36.2 × 248.5
Tate. Presented by the artist 1971

Sack-o-Sauce 1948
Collage mounted on card
35.6 × 26.4
Tate. Presented by the artist 1971

The Ultimate Planet 1952
Collage mounted on card
25.1 × 38.1
Tate. Presented by the artist 1971

Peter Phillips
The Entertainment Machine 1961 (fig.42)
Oil on canvas laid on wood
182.9 × 182.9
Tate. Purchased 1976

Motorpsycho Tiger 1962 (fig.17)
Oil, pencil, ink and transfer on canvas and wood panel
205 × 152 × 1.8
Tate. Lent by Penelope Rosenberg 2001

Tom Picton
Destruction in Art Symposium 1966
(figs. 77–8, 81–4, 86, 93)
Photographs
Lent by the artist's family.

John Plumb
Edgehill 1962 (fig.46)
Acrylic and mixed media on hardboard
181 × 121.9
Tate. Presented by E.J. Power through the Friends of the Tate Gallery 1962

Cedric Price, Lord Snowdon and Frank Newby
London Zoo Aviary 1962–4 (fig.108)
Photographs courtesy RIBA Library Photographs Collection

Bridget Riley
Fall 1963 (fig.30)
Emulsion on hardboard
141 × 140.3
Tate. Purchased 1963

Tim Scott
Peach Wheels 1961–2 (fig.33)
Mixed media
121.9 × 137.2 × 91.4
Tate. Presented by Alistair McAlpine (later Lord McAlpine of West Green) 1970

Peter Sedgley
Yellow Attenuation 1965 (fig.36)
Acrylic on board
121.9 × 121.9
Tate. Purchased 1965

Colin Self
Bomber No. 1 1963 (fig.50)
Print and mixed media on paper
39.6 × 57.6
Tate. Purchased 1983

Leopardskin Nuclear Bomber No. 2 1963 (fig.59)
Painted wood, aluminium, steel and cloth
9.5 × 80 × 42
Tate. Purchased 1993

Guard Dog on a Missile Base, No. 1 1965 (fig.60)
Drawing on board
55.6 × 76.2
Tate. Purchased 1974

Richard Seifert with George Marsh (partner)
Centre Point
Model. Mixed Media
83 × 65.5 × 55.5
Courtesy of Paul Stanford (the Blackmoor LP)

Richard Smith
Gift Wrap 1963 (fig.13)
Oil on canvas
201.9 × 529 × 80
Tate. Purchased 1975

Alison and Peter Smithson
House of the Future 1956
Pencil and ink on tracing paper
96 × 75.5
Victoria and Albert Museum

The Economist Building
1959–1964
Photographs courtesy RIBA Library, Photographs Collection

The Economist Building, Elevation drawing, Bury Street
Graphite on tracing paper with ink stamps
75.7 × 44.2
RIBA

Ian Stephenson
Parachrome 1964 (fig.37)
Oil on canvas
213.4 × 213.4
Tate. Purchased 1964

James Stirling and J Gowan Architects
University of Leicester, School of Engineering. North Elevation
1960
Drawing. Ink on paper
100 × 71
University of Leicester Collection
Photographs by Richard Einzig, courtesy Arcaid

Joe Tilson
Vox Box 1963 (fig.15)
Painted wood
152.4 × 121.9 × 7
Tate. Purchased 1976

Transparency, Che Guevara D 1968
Screenprint and mixed media on plastic
121.9 × 121.9 × 5.1
Tate. Presented by the artist 1976

Transparency I: Yuri Gagarin 12 April 1961 1968 (fig.56)
Screenprint and mixed media on plastic
121.9 × 121.9 × 5.1
Tate. Presented by the artist 1976

Transparency, the Five Senses: Taste 1969 (fig.39)
Screenprint on vacuum-formed sheet of perspex
147 × 147 × 5
Tate. Presented by Marlborough Graphics through the Institute of Contemporary Prints 1970

S-Semiologie 1969
Screenprint and mixed media on paper
101.6 × 689.6
Tate. Presented by Rose and Chris Prater through the Institute of Contemporary Prints 1975

V – Vietnam Courier 1969–70
Screenprint on paper
75 × 50.1
Tate. Presented by Rose and Chris Prater throughthe Institute of Contemporary Prints 1975

Muhammad Speaks 1970
Intaglio print on paper
79.7 × 53
Tate. Presented by Marlborough
Graphics through the Institute
of Contemporary Prints 1975

Ronald Traeger
Twiggy (contact sheet) 1967
Cibachrome print from
a tranparency of a vintage
contact sheet
39 × 25.5
National Portrait Gallery

William Tucker
Anabasis I 1964 (fig.35)
Plastic and Perspex
149.2 × 109.9 × 21.3
Tate. Purchased 1970

William Turnbull
5 x 1 1966
Painted steel
184.1 × 53.3 × 55.9
Tate. Presented by Alistair
McAlpine (later Lord McAlpine
of West Green) 1970

David Wedgbury
The Who
Photograph
29.2 × 29.3
National Portrait Gallery

Robert Whitaker
*George Harrison at Chiswick Park,
"Way Out"* 1966 (fig.74)
Photograph
91.5 × 61
Lent by the artist

The Beatles (Butcher's Cover) 1966
Cibachrome print
51 × 40.6
Lent by the artist

Stephen Willats
Visual Field Automatic No.1 1964
(fig.91)
Wood, Perspex, paint
and electric circuits
190.5 × 119.3
Tate. Purchased with funds
provided by the Knapping Fund
2004

Colin St John Wilson
The Cornford House, Cambridge
1965–7
Photographs
Lent by Colin St John Wilson

The Wilson House, Cambridge
1965
Photographs
Lent by Colin St John Wilson

Copyright credits
All works © the artist/
photographer or the artist/
photographer's estate, with
the following additions:

Peter Blake © Peter Blake 2004.
All Rights Reserved. DACS

Pauline Boty © Whitford Fine
Art

Patrick Caulfield © Patrick
Caulfield 2004. All Rights
Reserved, DACS

Richard Hamilton © Richard
Hamilton 2004. All rights
reserved, DACS

Ron Herron © 2004
by Ron Herron courtesy
of the Ron Herron Archive

Dom Sylvester Houédard: By
kind permission of Prinknash
Abbey

Allen Jones © Allen Jones, RA

Gerald Laing:
www.geraldlaing.com

Lewis Morley © Lewis
Morley, Lewis Morley Archive/
Akehurst Creative Management

Eduardo Paolozzi © Eduardo
Paolozzi 2004.
All Rights Reserved, DACS

© Colin Self 2004. All Rights
Reserved, DACS

Joe Tilson © Joe Tilson 2004.
All Rights reserved, DACS

fig.47 © Apple Corps Ltd 2004

fig.70 courtesy the artist/
© Bruce Karsh

Photographic Credits
Courtesy the artist/
photographer 2, 54, 62,
64, 71

Courtesy the artist's estate 61,
85, 87, 90

Photograph courtesy of the
Cecil Beaton studio archive,
Sotheby's 69

A.Behr/ Denys Lasdun Peter
Softley Associates 98

The Bridgeman Art Library/
Kunsthalle, Tübingen,
Germany 3

Richard Einzig/ arcaid.co.uk
106–7

Robert Freeman/ *Sunday Times*
archive 53

Arts Council Collection,
Hayward Gallery, London/
Derek Balmer photography 24

Courtesy the Ron Herron
Archive 109

Hulton Archive/ Getty Images
80

Courtesy the Institute of
International Visual Arts 1
ITN Archive 41

By courtesy of the National
Portrait Gallery, London 65–7

© Roger Mayne 95

Courtesy North Lanarkshire
Archives 104

Photograph: Clay Perry 88

Courtesy the Picton family
77–8 80–4, 86, 93

© Rex Features/ Photo David
Graves 110

RIBA Library photographs
collection 96–7, 99–103, 105,
108

Tate 4–7, 9–15, 18–22, 25–34,
36–7, 39, 42–6, 48–52, 55–7,
59–60, 75–6, 89, 94, 111–12

Tate Photography/ David
Lambert 16, 17, 91

Tate Photography/ Gillian Selby
35, 92

Tate Photography/ Rodney
Tidnam 38, 40

INDEX